A Slight Epidemic

The Government Cover-Up of Black
Plague in Los Angeles

What Happened and Why It Matters

Frank Feldinger

SILVER LAKE PUBLISHING

LOS ANGELES, CA ◆ ABERDEEN, WA

A Slight Epidemic
The Government Cover-Up of Black Plague in Los Angeles... What
Happened and Why It Matters

First edition, 2008
Copyright © 2008 by Frank Feldinger

Silver Lake Publishing
101 West Tenth Street
Aberdeen, WA 98520

For a list of other publications or for more information, please call
1.360.532.5758. Find our Web site at **www.silverlakepub.com**.

Library of Congress Catalogue Number: Pending

Feldinger, Frank
A Slight Epidemic
The Government Cover-Up of Black Plague in Los Angeles... What
Happened an Why It Matters
Pages: 212

ISBN: 978-1-56343-885-1
Printed in the United States of America.

Contents

Acknowledgments

First and foremost, my endless thanks to Dr. William Deverell, Director of the Huntington-University of Southern California Institute on California and the West. His boundless generosity with the fruits of his scholarship, research and eloquence made my own book possible.

Without the extraordinary abilities of George Fogelson—researcher *sine qua non*—this book would have been not much more than a rehash of Dr. Deverell's work. George found the one thing I felt my book needed and couldn't find for two years, a hero of the 1924 Plague. His discovery of the nearly forgotten Nora Sterry, brought to light an astonishing character of courage and humanity whose innovations in education were a half-century ahead of their time. George's work also led me to Donna Samoreno, the one person with firsthand knowledge of the crushing emotional effect pneumonic plague had on one of the only two people to survive it. She discovered some of the most crucial documents in determining when the cover up began and how high it reached.

Despite having interviewed Dr. Shirley Fanin often during her long and estimable service as Los Angeles County Health Commissioner, she agreed to talk to me anyway. When I first considered writing a book on the plague in L.A., I asked Dr. Fanin why so little had been written on the subject outside of technical journals. She replied with the most galvanizing words in the journalist's lexicon: "Official cover-up."

Dr. Fanin gave me access to some of the most illuminating and incriminating documents from 1924 and 1925 which are referred to in this book; with great prescience she saved them from the shredder when County and City Health merged in the 1960s. Dr. Fanin also displayed remarkable forbearance as she explained to me the fundamentals of immunology, epidemiology, virology and physiology; Black Death for Dummies.

Dace Taub, Librarian of the Regional History Collection at USC's Doheny Memorial Library, performs her magic routinely. She could find and deliver 80-year-old documents which were obscure even then in the time it took me to settle comfortably into a work space.

A Slight Epidemic

Jennifer Watts of the Huntington Memorial Library and Alan Jutzi of the Rare Books department provided access to unique materials in what must be the most gorgeous setting any researcher ever enjoyed.

Christine Pearson, Dr. Kenneth Gage and their colleagues at the Centers for Disease Control and Prevention know that all journalism teachers lie when they persist in saying, "There are no stupid questions." Nevertheless, everyone at the CDC responded to mine swiftly and completely. CDC's published research has been, in my opinion, the most objective and thoughtful in the matter of avian flu.

Dr. Frank Sorvillo, chief epidemiologist for L.A. County Health also provided comprehensive answers, many of which still were shorter than my questions.

The Sterry brothers—Charles and Steven—introduced me to the wildly divergent cast of characters who inhabit their family tree; heroes and villains, community pillars and cage rattling lefties. The Sterry family has produced generations of men and women entitled to wear the banner of Hell-Raiser.

Edith Morales at Claretian Missionaries provided me with just about everything known of Father Medardo Brualla, the martyred saint of the Black Plague. Ms. Morales helped to make flesh his noble spirit.

My techno-hero Sandy Corner kept the computer running and Tina McGilton kept *me* running when I was paralyzed.

Pat Wheeler, my friend and confidant—and ex-wife—and our friend Harry Rusli kept my inner life as calm and simple as it's ever likely to be. A matchless contribution.

Finally, very special thanks to publisher, former editor and friend Jim Walsh who, in the time it took me to produce this small book, fathered two children and moved his corporate headquarters twice, the second time some 800 miles from me.

—Frank Feldinger

Preface

When the one great Scorer comes to make His mark against your name,

He counts not if you won or lost,

But where you laid the blame.

[Attributed to various cynical writers, with apologies from at least one to Grantland Rice.]

The most widely-reported news stories in the U.S. during 2005—after Iraq—were the devastation inflicted on New Orleans by Hurricane Katrina and the threat of devastation if Avian flu becomes transmissible person-to-person. Attendant with Katrina are continuing accusations of government incompetence at all levels, the triumph of self-interest over public safety and institutionalized racism that caused unnecessary deaths and the destruction of venerable neighborhoods.

With Avian, or "bird" flu, come allegations of a cover-up by the Chinese government and admonitions of an inevitable and murderous pandemic which President George W. Bush says could require him to quarantine large swaths of the country. The president, therefore, has entrusted our lives to the Department of Homeland Security—the same agency that helped turn New Orleans into a sinkhole.

All the political implications of Katrina and a killer epidemic converged in Los Angeles in 1924 and 1925 during the last epidemic of

A Slight Epidemic

Black Plague in the United States. There were dozens—perhaps scores—of needless deaths, quarantines imposed by armed thugs and ethnic neighborhoods razed to no purpose beyond bigotry and voracious greed, their residents disposed without any compensation. And yet the catastrophe virtually is unknown outside of single-sentence references in medical journals and single chapters in a few regional histories; the news blackout and cover-up of the Los Angeles plague was orchestrated by city government and the press on behalf of boosterism and special interests.

Also, newly-discovered evidence points to the inescapable conclusion that criminal acts—including negligent homicide and will full violations of state and federal safety laws—were perpetrated by L.A.'s top health officials, the very men entrusted with safeguarding the public.

Newly-uncovered evidence also indicates that overt criminal acts were perpetrated by the very officials entrusted to safeguard the public.

As was demonstrated so alarmingly during and after Hurricane Katrina, prejudice, cronyism and rigorous denial of truth never go out of political vogue—regardless of how many people perish as a consequence. In fact, the Bush Administration could have grafted the Los Angeles Black Plague experience to its own three-step response to crises:

1) deny the danger,
2) downplay the damage and
3) blame the victims.

The history of natural disasters has a nasty habit of repeating itself.

1 Golden State, Black Death

Of course we control the press of Los Angeles, but what are we going to do with outside papers? If we formally recognize an epidemic, Eastern papers will exaggerate it and our summer tourist business will be ruined.

—Remarks at a meeting of the Health & Sanitation Committee of the Los Angeles Chamber of Commerce as quoted by *The Nation,* December 9, 1925

We had ... a slight epidemic of pneumonic plague.

—William Lacy, President of the board of directors, Los Angeles Chamber of Commerce in an article titled "The Truth About Los Angeles" in the December, 1924 issue of *Los Angeles Realtor*

Sunday, September 28th, 1924. Noon.

It is 82 degrees in Los Angeles. Despite the heat, the air is brilliantly clear; visible air pollution occurs only a few days a year when the smudge pots are lit to protect the citrus groves further east from unseasonable cold.

But, in East L.A., the temperature percolates up to 91. The crushing heat is held in place by a caustic cloud of industrial pollutants that

never leaves the Macy Street district...except when it rains. It would be cooler under the shade of trees if there were any trees but there aren't; the poisoned air kills just about anything that tries to grow in the tiny spaces unoccupied by homes or businesses.

The air is motionless and suffocating, like depression. It's much too hot to do anything after Mass so about two dozen residents of the Macy Street district and the adjacent Belvedere Gardens district gather—as they often do—on the porch of the boarding house run by Lucina Samarano and her husband Guadalupe, at 742 Clara Street.

The tidy, two-story home projects a threadbare stateliness. It is one of the few occupant-owned properties in either of the two Hispanic districts and one of even fewer which has indoor plumbing and central heating.

Guadalupe is employed during the day at the nearby gas works. Lucina oversees the operations of the boarding house which she received in a divorce settlement. The Samaranos are in their second trimester of pregnancy with their first child and Lucina is praying for a little girl. Her three young sons from a previous marriage—ages 7, 10 and 12—are on the porch along with 4-year-old Raul, Guadalupe's son from his first marriage. His other three children—two girls and a boy—from that marriage are away at Catholic boarding school in Burbank.

Another half-dozen members of the Samarano clan—grandparents, cousins and an uncle—are on the porch along with friends and the Jimenez brothers, Mike and Jose, who rent a room in the house.

Among the friends are Jesus Lajun and his 15-year-old daughter Francisca from just down the block at 700 Clara. People always enjoy hearing the histrionic Jesus spin his *fabulistas*. He's a highly regarded storyteller in the neighborhood and today's yarn is about his recent adventure tracking down the terrible smell in the Samarano house.

"La casa entera hedeo como mierde!" The men guffaw and the women titter behind their fans at the overripe simile. Father Medardo Brualla, the white-haired assistant pastor of Our Lady of Angels Church, blushes and tries to cover the ears of little Raul, sitting on his lap.

Even Guadalupe and Lucina smile at hearing their home described as a "shithouse." An all-weather stench is a fact of life in Macy Street. Besides the fetid Los Angeles River, Nora Sterry—the Anglo principal of Macy Street grammar school—says, "The meat packing houses so polluted the air with poisonous gasses as to make breathing disagreeable at times because of disgusting odors."

"The whole house stunk," Jesus Lajun continues. "Upstairs, downstairs, everywhere." He stalks the porch theatrically, stopping to sniff members of his audience like a dog in his search for the source of the malevolent reek.

Jesus works on the railroads snaking around the docks of the newly re-opened and greatly expanded Port of Los Angeles. For a nickel, the Pacific Electric's Big Red Cars whisk Jesus and other Mexican-American workers from East L.A. to the harbor in less than 20 minutes—including stops—a time inconceivable in 21st Century Los Angeles.

"I even dug up some of the floorboards," he goes on. " I suspected 'Lupe and Lucina buried the bodies of boarders they murdered for their money!"

His audience roars with laughter at the irony: The Samaranos are well known for helping out any relative, neighbor or newcomer in need.

"Then my nose led me to a corner underneath the house."

Here, Lajun pauses for dramatic effect. "And there, behind some boxes was a dead rat, grande como un pero gordo!" he says, holding his hands two feet apart to indicate the size of the rat. His audience nods eagerly and laughs—rats in the district do tend to be better fed than most dogs—and applaud the story's denouement.

Lajun basks in their appreciation as he scratches absently at the bug bite on his leg. But that only drives the poison in deeper.

Friday, October 3rd, Early Evening

Dr. Giles Porter of the Los Angeles City Health Office comes to 700 Clara Street, in the Macy Street district. It's the home of Jesus Lajun. Both Jesus and his 15-year-old daughter, Francisca, are ill with sore throats, temperatures of over a hundred degrees and head and backaches. Additionally, Francisca is coughing spasmodically and her throat rattles with each breath.

Jesus has a large, excruciatingly painful swelling on his groin.

Dr. Porter dismisses the swelling as "venereal disease." He sees nothing unusual in the patients' other symptoms that he believes are consistent with flu. His report on Francisca reads, "the child was not considered to be in serious condition."

When Porter departs 700 Clara Street, Lucina Samarano—the pregnant mistress of the boarding house half a block away—comes over to nurse father and child.

A Slight Epidemic

There are two major forms of Plague which can invade the human body, both create a biblical mortification of the flesh and both are caused by the bacillus known—since the early 1900s—as *b. yersinia* after Alexandre Yersin, the Swiss bacteriologist who, in 1895, first proved that bubonic plague is a disease of rodents which is transmitted by the fleas which feed off them. Prior to Yersin, the bacillus was known as *b. pestis*, Latin for "plague."

When bitten by a plague flea, the lymph node nearest the bite tries to fight off the invader. An agonizing pustule grows—often to goose-egg size—over the wound, a swelling known to the ancient Greeks as a *bubo*. Hence, *bubonic plague*.

The throbbing bubo is accompanied by vomiting, crippling headaches and blazing fevers which can go from 98.6 to 105 in a few hours. As the lymph system collapses, blood congeals in the extremities causing limbs to turn black as in Black Death or Black Plague. Finally, the organs fail.

With modern antibiotics, bubonic plague is fatal only about 15 percent of the time. Left untreated, it kills about half its victims. The good news is that bubonic plague isn't contagious except by touching infected blood or tissue.

But if the bubo bursts subcutaneously—or if *b. yersinia* enters the blood stream in any other way—it will travel to the lungs where it becomes the swiftest and most prolific killer in history, *pneumonic* plague.

The most contagious of all diseases, pneumonic plague can be spread by breathing, sneezing or coughing and the evil droplets will hang in the air—still poisonous—for 20 minutes and more. It can be contracted just by touching the bedding or clothing used by a pneumonic plague victim.

As the lungs fill with fluid, the body becomes starved for oxygen and the skin darkens, another type of Black Plague. Even with immediate medical attention pneumonic plague nearly always is fatal. Death occurs in as little as 24 hours and seldom more than 96.

It's generally believed that the great plagues of history began with bubonic but quickly became the pneumonic form, the Black Death which periodically wipes out a quarter of the world. (For a more comprehensive historical overview of plague, see Chapter 8).

Sunday, October 5th

Francisca Lajun's fever spikes to 106. She's rushed to Los Angles County General Hospital—known locally as "General Hospital"—but she dies in the ambulance. A physician identified only as "Dr. Webb" performs an autopsy and under "Cause of Death" he writes, "Double pneumonia."

Under "Race" he writes "Mexican."

Saturday, October 11th

Jesus Lajun dies of what Dr. Porter had diagnosed as "venereal disease" and "flu." Now, under "Cause of Death," a Dr. Grant writes "bronco-pneumonia."

It should have been clear at this point—or at least suspected—that Jesus Lejun died of bubonic plague and, if that's what his daughter originally contracted, it has morphed into the far deadlier and highly contagious pneumonic version.

The Los Angeles City Health Department's Annual Report for 1924 salutes Dr. Giles Porter—who made the first two fatal misdiagnoses—for "the wonderful work ... in making the clinical diagnosis" of plague.

Had he actually done so—and had critical quarantine laws been enforced—the plague might have ended with no more than two people dead and a single house isolated. Instead, The 700 block of Macy Street is a Hot Zone and it's rapidly widening. But it will be weeks before anyone in authority will acknowledge the danger.

In the meantime, dozens—perhaps scores—of people will die needlessly and neighborhoods ... *ethnic* neighborhoods ... will be put to the torch.

2 Year of Wonders

I see a city of more precious mold...
With silver paved and all divine with gold.

—*John Dryden,* Annus Mirabilis

Surely never a city, at least of this bulk and magnitude, was taken in a condition so perfectly unprepared for such a dreadful visitation.

—*Daniel Defoe,* A Journal of the Plague Year

1924 is the Year of Wonders in The Village of Our Lady of the Angeles. The population surges to over one million, making it the fastest growing—and fifth largest—city in the U.S. The greatly expanded Port of Los Angeles, encompassing three cities, reopens for business; before the end of the year, it will surpass San Francisco and Seattle as the West Coast's busiest harbor.

In 1924, the studio that will become **MGM** establishes itself in Los Angeles, completing the relocation of the entire film industry that began two decades earlier beneath the hills to the north and west of downtown L.A. Within a year, motion pictures will become the biggest industry in the state, employing some 35,000 people in Los Angeles County alone.

Charlie Chaplin, a friend of Chamber of Commerce cofounder Frank Garbut (who owns the Los Angeles Athletic Club), will write, "There was a young man who used to sit around the club lounge, a lonely fellow named Valentino who had come to Hollywood to try his luck but wasn't doing very well."

That will change in 1924 when Valentino stars in *Monsieur Beaucaire* and establishes the gold standard for the Latin Lover.

In 1924, residential real estate is soaring at an 80 percent annual rate; prices for commercial real estate are rising at a 40 percent clip. Twenty-two high-rise office buildings will be completed in 1924, all of them around the 12-block downtown grid centered on Pershing Square. Developers and speculators are opening offices in the boxy, Art Deco buildings—determined to make the dusty streets of Southern California into a paradise, sold a quarter of an acre at a time to people suffering the immoderate winters of the East...particularly the Midwest.

For the first time, in 1924, the California oil industry—now centered in Southern California—eclipses agriculture as the state's biggest earner. The oleaginous boom creates a bizarre marketing device; crude oil is used to promote home ownership. One development calls itself "Petroleum Gardens" and promises the home-buyer that if he doesn't make a killing reselling the house, he'll make it when oil is discovered underneath.

And it happens often enough to seem plausible.

Welcome to the Boomtown

With petroleum comes the auto industry. Ford, Studebaker, General Motors and Willys (original makers of the Jeep) open plants in and around Los Angeles in 1924—and so do tire manufacturers: Goodyear, Firestone and U.S. Rubber.

Los Angeles is second to Detroit in making cars. And *first* in buying them: Car ownership goes from 100,000 in 1919 to four times that in the Year of Wonders and, from now on, the id of Los Angeles will be driven by the ego of the automobile.

In 1924 the city becomes the nation's leader in home ownership, the quintessential American dream. Los Angeles also leads in urban sprawl; the new "bedroom" communities are replicating like cancer cells based on the radical idea of "commuting" to work.

And in 1924 there is plenty of work as industrial output tops the one billion dollar mark, making Los Angeles America's most modern commercial metropolis.

It isn't just Easterners attracted to the region's warm weather and overheated economy. Nearly 30,000 Mexican-Americans now live here, making the city second only to San Antonio as the largest Hispanic community in the United States. Most of these immigrants actually have come from other U.S. cities; and most have lived in the States at least five years. Many of their children are native-born citizens.

Newly arrived Mexicans from south of the border also are flocking to the city their ancestors named. By the end of the decade, the Mexican-American population will be the largest in America, topping 100,000.

Not everyone is pleased with this ethnic diversity. University of California zoologist Samuel J. Holmes admonishes that the pressure of the burgeoning Mexican population will be so intense that "Americans" will cease reproducing.

And Los Angeles has its fair share of bible thumping bigots. Evangelist Bob Shuler publishes a magazine which, according to author Kevin Starr, "ran a spirited defense of the Ku Klux Klan ... [but] hated Jews, Catholics, movies, evolution, jazz and dancing." The reverend writes in *Bob Shuler's Magazine*, "Los Angeles is the only Anglo Saxon city of a million population left in America. It remains in a class by itself as the one city in which the white, Christian idealism still predominates."

In 1928 voters will elect as mayor John Porter, "a used car parts salesman from Iowa and a former member of the Ku Klux Klan," writes Starr in his well-regarded history *Material Dreams*.

Even many social scientists of the day dismiss "Mexicans" as "docile, indolent and backward."

These, of course, are ideal character traits for the large growers and industrialists who welcome the influx of cheap, compliant labor. Unions, on the other hand, see Mexican-Americans as the stumbling block to organizing and, in the Year of Wonders, Progressive Party labor leaders unite with reactionary racists to lobby Congress for closing the border with Mexico.

Defending open immigration is Harry Chandler, owner of several million acres of Southern California and publisher of the virulently anti-union *Los Angeles Times*, the city's most widely read daily newspaper.

In the 1920s (just as in the 1990s and early 2000s), ranking members in both houses of the U.S. Congress come from the former Confederate states. So, Chandler's opinions address the political leaders in language they can understand.

"Mexicans," he tells the Committee on Immigration, "do not intermarry like the negro with white people. They don't mingle. They keep to themselves. That's the safety of it."

Racial Perspectives of the Day

In Angeleno-speak, "Mexican" connotes race, not country of origin. And the Congressional representatives endorse Chandler's view and leave open the border with Mexico. Instead they vote to restrict immigration of a different "race"—Jews.

Political Scientist Daniel Tichenor writes that Congress in 1924 was responding to a warning from the State Department that "filthy Jews" who are "unassimilable" will inundate America so Congress passes the National Origins Act. It's a quota system based on which immigrants got here first: i.e., Northern Europeans. Congress divides the rest of the world into 47 "Races or People" among them "Hebrews."

The Act also reaffirms implicitly the virtual ban on Asian immigrants becoming naturalized citizens. As Nora Sterry—principal of an inner-city L.A. school—notes, in 1924, "[only] those Orientals who are born in this country and live here until twenty-one years of age and those children of native born Chinamen ... are all *ipso facto* full fledged American citizens".

(In 1933, *Reichsfuhrer* and SS chief Heinrich Himmler will order his subordinates to study the National Origins Act along with America's eugenics laws to see how they might be adapted to Nazi racial policies. And, starting in the late 1930s, the National Origins Act will doom Europe's Jews desperate to find a safe haven from the Nazis).

The same immigration debate rages today across the United States and for much the same purported reasons: Illegal aliens—largely, Hispanics—take jobs from Americans, depress wages, spread crime and disease and refuse to assimilate.

Proponents of constructing a wall along our border with Mexico denied the legislation was racist; they insisted it was a matter of "national security." Still, none of them proposed to build a fence between the United States and Canada, the one border across which terrorists actually *have* entered the U.S.

Due to Harry Chandler's activism and intervention in 1924, Mexicans continue to stream legally into Los Angeles through the 1920s. Skilled Aztec bricklayers and tile setters build the new homes in the new developments. The *un*skilled Mexican workers put on the finishing touches, the landscaping and the signs reading "Whites Only." Racial covenants come with the communities.

Essentially, there are only two districts—"district" being Angeleno-speak for "ghetto"—in which Hispanics may live. The first is called Macy Street and lies at the southeastern edge of the city; it is more than two-thirds Mexican-American and has some 3,000 residents. The second, which lies adjacent to Macy Street, is called Belvedere Gardens. An unincorporated area just beyond the city limits, Belvedere Gardens has some 25,000 residents—almost all Hispanic.

The Geography of Macy Street

The reason that "Mexicans ... keep to themselves" as Harry Chandler puts it is because they're kept physically isolated from the white population. The Macy Street district essentially is a residential concentration camp. It is bordered to the east by the Los Angeles River, an effluent theme park of garbage, human and animal waste, the bloated carcasses of horses and mules and the vermin that gnaw on them.

Between the residents and the fetid river are the Wilson and Cudahy meat packing plants, their corrals and the Los Angeles Gas & Electric works. To the south and west are the oil companies and the brick, lumber and metallurgy businesses that have recently moved in to take advantage of the burgeoning labor pool.

The rail yards of the Southern Pacific comprise most of Macy Street's northern border, along with the two city streets where L.A.'s Chinese population is shoehorned. (The district is 14 percent Chinese—about 450 people—with the other 700 or so residents a polyglot of Italians, Syrians, Japanese, Spaniards, French, Austrians, Germans and even a score or more Anglo Saxons and Anglo-Irish).

The incursion of industry into the district has driven up rents while intensifying overcrowding; all of the Macy district's 4,500 residents are crammed into a fifth of a square-mile.

And, despite all of this, some Mexican-Americans awould rather live in the Macy Street district than farther out in the country.

Belvedere Gardens also is bursting at the seams as new immigrants continue to pour in.

A Slight Epidemic

The church to which the vast majority of people belong—Our Lady of the Angels—is in the downtown Plaza beyond the district. The one house of worship in Macy Street is a Baptist mission.

"Only by opening a hanging panel—indistinguishable from other panels in the fence—can one leave (the Chinese section of Macy Street) for the city beyond," writes Nora Sterry in 1924.

Nora Sterry is the Anglo principal of the Macy Street elementary school and her house-to-house survey of the district for her master's thesis describes the execrable living conditions:

> Of 307 freestanding homes, 104 had no inside toilets, ten had no indoor sinks, 99 homes have no bathtubs, 119 have no electricity and only three have gas connections. There are no indoor bathrooms and none comply (sic) with the city's sanitary code.

The dwellings are held together by nails and faith. They are dangerously substandard even by the city's laissez-faire building codes. Of the 307 private homes, 111 are

> in urgent need of repair, the most common of which are broken windows, defective plumbing, rotten woodwork and inadequate toilet facilities ... The walls and floors of the majority of houses are so infected with vermin as to render personal cleanliness practically impossible.

There is another source for vermin: The district is the center for wholesale horse and mule yards and together with the corrals of the two large packing houses "offer a special menace," according to Sterry. She goes on to note:

> There is little attempt to regulate them in accordance with existing (laws) and filth abounds with resulting swarms of flies and other insects ... Yet in these corrals hundreds of men sleep at night as well as the horses.

The business plan for Anglo property owners is simple: As industry continues to encroach on Macy Street and new immigrants continue to pour in, living conditions deteriorate even further but rents continue to rise. Nearly one-third of the houses have illegal apartments which are rented out—and even sheds without floors or windows are leased as "apartments." And the 30 actual apartment buildings are subdivided like rabbit warrens; to enter some living units requires going through other apartments.

Leaky roofs and broken windows produce another ongoing health hazard: Mold. Macy Street has much in common with New Orleans in the mid-2000s aftermath of Hurricane Katrina. Except that no one in authority in 1920s Los Angeles even suggests taking action to alleviate the lethal and illegal conditions.

Even fundamental city services are absent. Only four of Macy Street's actual streets—the ones which take residents to jobs beyond the district—are well-paved and regularly cleaned. The others, Sterry fumes, "are never inspected by the Department of Streets and Sanitation and are always littered with rubbish and filth."

And there are other violations on which the city turns its back. "A number of blind pigs [after-hours taverns] and opium dens are easily recognizable to everyone but the local police."

Sterry concludes her survey:

> The buildings are models of all that is undesirable. Our city housing and health regulations, while not wholly adequate, in general prohibit the existence of such conditions but practically no effort is made at enforcement, presumably because the interests owning the district, which with its company buildings is of high rental value, are unwilling to have their income interfered with and are too powerful to oppose.

Fewer than 50 Mexican-Americans—and no Chinese—own their own homes in Macy Street. The bulk of the land is owned by a mysterious front corporation that is widely alleged—but never proven—to be controlled by *Times* publisher Harry Chandler.

So, he may have had a direct incentive to keep the immigrants flowing into southern California.

Pathogens and Politics

Amid such unremitting squalor, the districts are hot houses of communicable diseases. Diphtheria, typhus, smallpox, tuberculosis and scarlet fever regularly sweep through the ethnic communities. But in 1924 Los Angeles, these contagions are considered a function of race, not economics. Mexicans, Asians and blacks get sick *because* they are Mexicans, Asians and blacks.

And that belief reinforces the political expedience of segregating the "colored" races through geography.

Samuel Holmes, the Berkeley zoology professor, accuses Mexican-Americans of being—not the victims—but the vectors, or carriers, of disease. He writes:

Mexicans will increase our mortality, increase our infant mortality, by the means of spreading various epidemics throughout our population and, in general, deteriorate the physical welfare of the people. I do not believe there is any doubt about that.

In his book, *Becoming Mexican American*, George Sanchez quotes a "Protestant pamphlet" of the day that reads in part:

Every time a baby dies the nation loses a prospective citizen, but in every slum child who lives the nation has a probable consumptive and a possible criminal.

In Los Angeles, the infant mortality rate in the Mexican American community is three times that of Anglos. And this health statistic, more than any other, reflects the hygiene and sanitary conditions under which people live their daily lives.

Plagues Have *Always* Been Politicized

The attitude that Black Plague is a consequence of race began in the Dark Ages and will not substantively change even after 1953, when the World Health Organization states flatly:

There is no convincing evidence to show that a natural immunity to insect-borne plague exists in man...or that certain races are less susceptible to this type of infection.

(The attitude that crime is a consequence of race also hasn't changed much. In 2005, William Bennett—President Reagan's Secretary of Education, the first President Bush's antidrug czar, self-described "Christian moralist" and compulsive gambler—will declare that crime could virtually be eliminated if America aborted every black baby).

Yet, even in the horrific slum that is Macy Street, startlingly bright spots are emerging in the Year of Wonders.

At the Macy Street school, illness is plummeting and scholastic achievement is on the rise. A half century before there would be terms such as "school lunch program," "day care," "ability grouping," "tracking" and "special ed," Nora Sterry has implemented all these innova-

tions and more in her tiny corner of Los Angeles. And she's done it without a penny from the Los Angeles County Board of Education.

She and her staff must have been terrifically excited about the prospects for the new school year, 1924.

Daniel Dafoe's *A Journal of the Plague Year* and John Dryden's *Annus Mirabilis* describe the happy convergence of two massive disasters: The 1665 Black Plague in London which officially took 67,000 lives—Dafoe claims it was over 100,000—and was cauterized by the great fire of 1666 which reduced most of London to feathery ash, killed fewer than a dozen people—again, that's an *official* count—and burned out the rats and the fleas which feed off them and transmit the plague to humans.

The Black Death and a cleansing fire also come to Los Angeles in 1924—but there will be no Phoenix chronicled in prose or poem. Instead, the ugliest episode in the history of Our Lady of the Angels will be obliterated from the city's official memory through lies and criminal malfeasance.

A handful of plutocrats working in concert with public health officers and elected officials will see that it is so.

3 Outbreak!

Your health conditions here have been deplorable for a long time.

—Dr. Walter Dickie, California State Health Officer, to the Los Angeles City Council and the board of directors of the L.A. Chamber of Commerce, November 15th, 1924

Thursday, October 15th, Early Evening

Lucina Samarano, who owns the boarding house at 742 Clara Street—and who nursed both Jesus and Francisca Lajun—falls ill with a high fever. She's cared for by another neighbor, Jessie Flores, who is a young practical nurse in the district.

Friday, October 16th, Early Evening

Lucina Samarano's condition worsens over 24 hours. Jessie Flores can't do anything more for her and asks neighbors for help. Lucina Samarano is taken to General Hospital spitting up blood and burning with fever.

Saturday, October 18th

Father Medardo Brualla from Our Lady of Angels Church administers the last rites to Lucina Samarano.

Sunday, October 19th, 11:50 a.m.

After being sick for just three-and-a-half days, Lucina Samarano dies in General Hospital. The six-month fetus she's carrying is stillborn. The cause of the 39-year-old's death is listed as "acute myocarditis" (heart disease) and no autopsy is performed.

The bodies are released to Lucina's husband, Guadalupe. A wake with an open coffin is held for Lucina at their home, Father Brualla presiding. Extended family and friends attend, including everyone who was on the porch that last Sunday in September.

Guadalupe Samarano infects everyone who gets close enough to offer condolences.

Wednesday, October 22nd

Guadalupe Samarano falls ill. So does 21-year-old Jessie Flores, the nurse who attended Lucina Samarano.

Friday, October 24th

Jessie Flores and Guadalupe Samarano are rushed to General Hospital—Flores in a friend's car, Samarano by ambulance.

Samarano's friend and neighbor, Thomas Vera, helps Samarano in and out of the ambulance—which is driven by Emmet McLauthin. McLauthin and his brother Frank run the ambulance service out of their home on Hope Street.

Flores and Samarano are both diagnosed with severe pneumonia. No one at General Hospital has connected their illnesses with the recent death of Lucina Samarano.

Sunday, October 26th

"Ego te absolvo a tuis pecatis in nomine patri et fili et spiratu sancti," Father Medardo Brualla intones over nurse Jessie Flores, though

he must have wondered what sins this exemplary young woman could have committed.

She struggles feebly for each rasping breath, her chest barely rising and falling. Father Brualla dabs holy oil on her feet; they carry the body to sin. Then he packs up his cruets and prayer missal and walks to the male section of the pneumonia ward to offer extreme unction to Guadalupe Samarano.

By the time he goes back to look in on Jessie, the young nurse is dead. At 2:45 p.m., so is 37-year-old Guadalupe Samarano. His cause of death is put down as "a peculiar pneumonia."

The Priest Begins to Sense Something More

As Father Brualla leaves General Hospital, he pulls his cassock tightly around his slender frame. It's still quite warm but he feels an icy douche of fear throughout his entire being. He would never question the findings of a physician—especially an Anglo doctor.

But Father Brualla is an educated man. And he senses there's something more dangerous than pneumonia moving through his parish.

Born in Aragon, Spain, on December 7, 1875, Brualla joined the Claretian Missionaries, Sons of the Immaculate Heart of Mary, in 1900. In another age, the Claretians might have been called "liberation theologians" for their social activism in service to the poorest of the poor. The founder of the Order, St. Anthony Mary Claret, established trade schools and credit unions for his congregants in Africa, Cuba and South America so they could free themselves from the bondage of rich landowners and predatory merchants.

Father Brualla himself served in West Africa and then in Baja, Mexico, before fleeing for his life during the Mexcian socialist revolution of 1914.

A darkness of spirit clings to white-haired priest like his cloak on this velvet California night. It's caused by something Anthony Claret had written about his mission in Cuba. There, his parishioners died of a disease seemingly identical to the one killing Father Brualla's flock. But in Cuba, the doctors didn't call it "peculiar pneumonia" or "flu" or "meningitis" or "venereal disease."

They called it *el Muerto Negro*. The Black Death.

Father Brualla shudders again, genuflects quickly and murmurs Psalm 91.

> There shall no evil befall thee, neither shall any Plague come nigh thy dwelling.

Whatever comes, he thinks, I will serve His children.

Sunday, October 26th, 6 p.m.

Dr. Lawrence Parsons, a pathologist at Los Angeles County General Hospital, performs an autopsy on Guadalupe Samarano. He confirms the finding of "double pneumonia" and performs no bacteriological exam.

Nevertheless, the morgue at General Hospital is ordered quarantined—suggesting that someone in authority is afraid of disease transmission through blood or tissue. The effects of this decision will only make the outbreak worse.

As a consequence of the quarantine, no more autopsies will be performed on people who die of "peculiar pneumonia" for five crucial days. No further cultures will be taken. No one will even look for *b. yersinia*, the plague bacterium.

Monday, October 27th, noon

Guadalupe Samarano's body is released to family members so they might hold another wake at 742 Clara Street.

The people interviewed for this book—historians, epidemiologists for Los Angeles County, researchers at the Centers for Disease Control and the former Los Angeles Health Commissioner—are in accord that the lethal misdiagnoses (including one still to come where a case of Black Plague will be dismissed as "inebriation") were honest mistakes.

However, during the time that most of those interviews were conducted, the most convincing evidence of an official and criminal cover up hadn't yet come to light.

Dr. Frank Sorvillo, epidemiologist for Los Angeles County, even offered a modern example of how easy it is to misdiagnose Plague:

> In 2004, a veterinarian developed a bubo in his armpit and high fever after being scratched by a cat. "Now, you'd think a vet would know that cats can be infected with and spread plague. But he never suspected

it because he didn't expect it". (The veterinarian's doctor identified the disease and treated his patient with antibiotics. The vet survived. The cat died).

Dr. Kenneth Gage, research biologist for the Centers for Disease Control and Prevention even has a plausible explanation for not recognizing Jesus Lajun's bubo for what it was:

> There are various infections that can cause swelling of the lymph nodes. So, from the standpoint of a physician in the 1920s, they've never seen this disease. It's not surprising (they wouldn't recognize plague). We still have a problem with that in the western U.S. where we still have about a 1 percent fatality rate.

Still.

There are all those dark patches on patients' skin caused by dead tissue or oxygen-starved blood, the very discoloration that has proclaimed the disease as Black Death for 15 centuries.

There's also the incident of the anti-plague serum manufactured under license by a Philadelphia pharmaceutical firm.

Alexandre Yersin, the Swiss bacteriologist who linked the plague bacillus to fleas, cultured *b. yersinia* and injected lab animals with it until he came up with a serum, also named for him. Yersin claimed it was effective in more than half the cases. Regrettable as that figure may be, it would still compare very favorably with Los Angeles where the death rate of those exposed to plague will be over 90 percent.

Kenneth Gage of the CDC doubts the Yersin serum was anywhere near 50 percent effective:

> Some of that data suggest that some of these early treatments might have reduced the death rate a little bit but I don't know.... What they would do with these serums was a passive transfer where you inject the antibodies from a host who survived the infection to another person then hope that person has enough antibodies to fight off the disease. The FDA would never approve those things now; they weren't very efficacious at all.

Former Los Angeles County Health Commissioner Dr. Shirley Fanin also dismisses the Yersin serum as so much snake oil:

> To be effective, you would have to have a hyper-im-
> mune subject to extract the serum from before anti-
> bodies could be made [and] there was no one immune
> to pneumonic plague in Philadelphia.

Professor William Deverell, whose superlative book *Whitewashed Adobe* is the most comprehensive account of Anglo-Hispanic relations in Los Angeles disagrees:

> Had the order been made to put that serum to work
> in the neighborhoods at the top of that [outbreak], it
> would have saved lives.

Sadly, the question is moot.

By October 27th, the plague has killed five people, all Mexican-Americans, and even though it's apparent that some physician at L.A. County General Hospital knows or suspects Black Death, no one orders the serum from Philadelphia. And no one will order it until the disease becomes an epidemic.

Someone Knew *Something*

Potent evidence also suggests that both the Director of L.A. County General Hospital and the City Health Officer were criminally negligent for failing to carry out their legally mandated duties if pneumonic or bubonic plague were even suspected:

- they never imposed a quarantine around the suspected foci (areas) of plague;
- they never notified county, state or federal officials of the possibility of plague and
- they allowed plague-ridden bodies to be released to the victims' families.

The entire unsavory episode resonates with racism. Certainly, the physicians were no more prejudiced than other whites at that time and probably a great deal less so. After all, they were well-educated men who had dedicated their lives to public health in which caring for the poor is implicit.

Still.

Under heading RACE on Mexican-American death certificates the doctors write MEXICAN—even if the victim was born in the United States or was a naturalized citizen. Even the physicians seem to see plague as a disease of "race"—not living conditions.

So, if the physicians did not see what they did not expect to see, then it must hold that they saw what they *did* expect to see in "Mexicans." Drunkenness, sexually-transmitted disease and a generally low standard of health which was typical of the race and no cause for a general alarm.

So none was raised. And when the disease became epidemic, only one Anglo responded with demonstrable courage and empathy.

Nora Sterry, the school teacher, was—quite literally—one in a million.

4

La Passionaria
of Macy Street

*The grateful residents of Little Mexico testified their apprecia-
tion with a gold medal, a decoration which Miss Sterry may
wear as proudly as heroes of battle wear the Congressional
Medal of Honor. It was won as their medals were won—by
extraordinary heroism above and beyond the call of duty.*

—Los Angeles Times, *November 19th, 1924*

Nora Sterry was born to raise hell, even though she was born in
Kansas. Her mother Louise and older sister Ruth were leading suffrag-
ettes who—after relocating to Los Angeles in 1896—helped win the
vote for women in 1919. Louise also organized the Woman's Political
League and the Woman's City Club and, with Ruth, cofounded a day
care center for poor working women which would later become L.A.'s
Children's Hospital.

Until her death in 1931, Louise served on the city's Welfare Com-
mission and as a director of the Southern California Red Cross. (The
obituary for this pioneer feminist which ran in the *Los Angeles Times*
lists her dead husband's achievements before hers and refers to Louise
only as "Mrs. Clinton Sterry" and never by her given name).

Ruth Sterry was one of the first female reporters at the *Los Angeles*

Herald and was a poet of some note; one of her works was printed in an anthology whose other contributors included Vachel Lindsay, Edwin Arlington Robinson and Willa Cather.

Neither Ruth nor Nora ever married; but each was a single mother. In 1903, when she was 24 and just starting out as a teacher, Nora adopted an orphaned Belgian girl. Ruth adopted the son of an impoverished Russian Jewish widow; she named the boy William Churchill Sterry. (William's wife was a leader in the Save-San-Francisco-Bay movement and a gadfly member of the Belmont, California City Council. Her obituary ran under the headline, "Eve Sterry: Hellraiser").

All three Sterry women worked as nurses during the First World War. A picture of Nora in her uniform shows a plump, pale young women with a complexion like Wheatena, large eyes and a shy, diffident smile. The diffidence is misleading.

A Woman Ahead of Her Time

Thirty years before President Franklin Roosevelt saw "One-third of the nation ill-fed, ill-clothed and ill-housed" Nora Sterry saw nearly *all* her Macy Street students that way.

She began her chronicle of their living conditions in her first year in the district, 1903, waiting for the opportunity to do something about them, something practicable. By 1913, she was principal of the school and poised to unleash her manifesto:

> The purpose of the school is not to teach defined subjects, nor to have a smoothly running plant but to reorganize the entire lives of pupils so they become American citizens, not merely in outward form but in spirit and understanding. Democracy itself depends on its success. This is not the commonly accepted standard for the measure of educational values.

Long before anyone else addressed the issue of nature versus nurture in education Nora declared, "All phases of education are conditioned by the environment."

And the environment in Macy Street was appalling.

Among the major air polluters, she named was the Southern Pacific railroad. "There is always a heavy cloud of smoke hanging over the district from the ever passing trains making the air full of soot and all things grimy to the touch."

She also condemned the railroad for leaving its mountainous collection of animal droppings from the corrals and meat packing plants in open gondola cars which drew clouds of flies and added to the year-round stink so dense it had almost a corporeal feel as if it could cling like rotten flesh to anyone who breathed it.

Attacking the Southern Pacific, even in the halcyon days of the Progressive movement, was a courageous thing to do, considering Nora's father was chief counsel for the Western region of that railroad. Clinton—later *Judge* Clinton—Sterry was part of the defense team in the landmark antitrust case *Northern Securities v. United States* (1904) in which justice John Marshall wrote that "the only purpose (of Northern Securities) was to eliminate competition."

Northern Securities was a holding company whose principal owners were financier J.P. Morgan, James J. Hill—majority shareholder of the Great Northern Railroad—and E.H. Harriman, barn boss of the Southern Pacific.

Clearly, the social activist gene descended through the distaff side of the Sterrys: Nora's two brothers became senior partners in Gibson Dunn & Crutcher, the whitest of L.A.'s white-shoe law firms. When brother Norman died, his obituary in the State Bar journal described him as "Stern, brusque ... occasionally in error but never in doubt. His vocabulary was vigorous, colorful, earthly and uninhibited by the niceties of social custom."

In other words, even *other lawyers* thought he was an asshole.

Knowing that all school boards are hostile to fresh thinking, Nora sought to implement her ideas using language the board wouldn't find objectionable:

> Filth and squalor are not insurmountable obstacles to harmonious and useful living, but they are barriers which many may never scale. ...Most vicious of all, they [students] have acquired the belief that failure is possible and that education is a matter of advancement along lines closed to them.

By national standards, two-thirds of her 626 students were below the academic norm; and the major reason for failure to achieve, she concluded, was because "Mexican attendance is always poor. Most have missed 14 percent of school days."

And the two major reasons for all that absenteeism, she concluded from her house-to-house survey, were:

1) students with working parents who stayed home to care for family members and
2) chronic illness due to malnutrition and inadequate hygiene.

As to the former, it wasn't just younger siblings for whom her students had to stay home. She wrote, admiringly: "It would never occur to a Mexican to send a homeless child to a public institution. No matter how poor or how crowded the homes, an orphaned child can always find a place!"

In the Macy Street school there were 20 orphans all living with relatives or friends.

So Nora invented day care on the cheap. She added childcare to the home ec classes for fifth grade girls (Macy Street accepted grades 1-6) and, the next year, those girls worked in the classroom the teachers converted into a nursery. This work was a teaching tool:

> The nursery teaches regular habits of cleanliness, regular naps, wholesome meals, lessons in games and English. Older girls assist to learn cooking, bed making and housekeeping.

Nora and her teachers begged milk, food, toys, diapers and blankets from anyone who would listen—and she charged parents ten cents a day to house their kids. Unless the parents couldn't afford the dime, in which case it was free if the mother worked several days a month in the nursery or the father performed needed work around the school.

Grassroots Progressive Reform

Then Nora attacked malnutrition—from which 162 of her 626 students suffered. "Malnutrition," she wrote, "is a harbinger of many debilitating, sometimes lethal, diseases."

Nora, along with teachers and some of the children's fathers, converted a hallway into a cafeteria. They built a modern, well-equipped kitchen with used equipment donated by local businesses and food supplied by Catholic Charities and L.A. County Charities.

"The meals were prepared and served by the girls' cooking classes" and students could receive two hot meals a day for which "a nominal charge of a nickel was made but all the children who desired the food were fed regardless of their ability or willingness to pay."

Like the day care, the meals were *quid pro quo*; students who couldn't pay would "sing for their supper" by doing chores around the school.

Nora began stockpiling canned food and canning fresh. She noted:

There are many times when emergency provisions must be given a family.... It is not always possible to secure prompt help through public agencies. Sometimes the family is not technically eligible to County Charity assistance. Sometimes the office is closed on an official holiday when school remains open.

This device for bypassing bureaucracy would prove a lifesaver during the first semester of 1924.

As word of Nora's innovative techniques spread, so much food was donated that she opened a grocery store in the school which became more of a general store for her ill-fed and ill-clothed students. Clothing collected by the PTA was repaired—or donated fabrics were made into new clothes—in the school's sewing room.

All adult women could receive food and clothing for their children if they "paid" for it by working in the nursery, school kitchen or the sewing room.

But Nora felt she got the best of the deal:

In addition to a tax of work assigned in the school, the recipient must go through the process of "buying" as though in an American store, asking for the different articles in English and also presenting a written list [in English].

In Macy Street, where students came from 17 nationalities, speaking 12 different languages, this was no mean achievement.

Not Just Malnutrition

Malnutrition was the biggest factor contributing to chronic illness but it wasn't the only one. In her survey, Nora also counted: 52 cases of eye, nose and throat conditions; 31 active cases of tuberculosis; and the usual number of communicable diseases brought on by poor hygiene and close proximity. From this, she concluded:

In the majority of cases living conditions would prevent the exercise of proper [health] care but in addition to material circumstances which militate against

precautions there is a profound parental ignorance of the simplest laws of health and sanitation," Nora pronounced. "If they are to be strong and well it is the school that must make the provisions ordinarily made at home".

So, the teachers at Macy Street began regular weighing and measuring of the children's growth, daily inspection of skin, eyes and hair and regular dental examinations "with such subsequent treatment in the [city] clinic as necessary and the education of the parents in their proper home care."

For preventative care, "The little children are given daily drill in the use of a toothbrush and in the washing of face and hands."

What Nora Sterry seemed proudest of was her contribution to a community that had practically no indoor plumbing. With donated tools, materials and labor, she built at the school:

a first class plunge [pool] with showers attached and here every child who does not bathe regularly at home is required to take at least one bath a month. After a teacher inspects them, they get a swimming lesson. The older people of the neighborhood may use the plunge on certain evenings.

There was nothing Nora could do about the malevolent odor from slaughterhouses, stockyards, refineries and freight cars full of manure; it penetrated every corner of every home and business—searing the children's eyes and enraging their throats.

Still, in 1924, Nora would note with satisfaction:

...71 children in three years have been cured of tuberculosis in a special class held on the roof of the building where the air is as free from smoke and dust as the district permits though at best atmospheric conditions are unwholesome.

Other sick children would spend the school day in a makeshift infirmary under the care of a specially trained teacher. Those kids got three meals a day with frequent rest periods between their studies:

Such contagious skin troubles as impetigo [a bacteria infection which causes blistering and oozing] and scabies [another infectious disease caused by mites burrowing under the skin] have decreased with each year, a condition due to their regular bathing and feeding.

By the Year of Wonders, Nora Sterry could, with pardonable pride, claim:

> In general, their [the students'] health is safeguarded to such an extent that there are far fewer epidemics among them than occur in [Anglo] schools.

Nora also took a radical approach to education itself and spoke repeatedly and derisively about what is the bane of teachers today: Standardized testing. In 1922, she had written:

> We have been inclined to regard the pupil as isolated from the society in which he lives. The graded system of the public schools is founded on the theory that children in schools are somehow cut off from all other influences and interests and that [the school] need not relate itself to any part of their outside lives. The educational gain of one is measured by comparing his accomplishments in a given line with those of other children regardless of conditioning factors beyond the school walls ... a given age has been arbitrarily established as normal for each level. In our tests of his mental capacities we have commonly measured him against individuals of different groups ... and we have made little effort to judge his relationships in relation to his opportunities.

Five decades before "cultural deprivation" became a school issue, Nora Sterry set out to conquer it: "It is the business of the school so to direct each pupil that he may discover his own talents and find ample opportunities for their exercise."

Her first astounding success was getting the California State Board of Education to exempt Macy Street school from standardized testing during the school years 1922-23 and '23-'24.

"The first order, was grouping children by familiarity with English, scholastic achievement and emotional development rather than strictly by age." This was what today would be called "ability grouping." But, in a lesson that modern educators could follow, Nora pressed on from that grouping:

> The content ... is practical citizenship. It is education for daily life in the home and the community. Our American standards are stressed with practicable meth-

ods of realization. These things are not presented as facts to be memorized out of books but as activities in school which may be repeated outside and by means of which habits and attitudes may be established ... The only materials which have educative value for him are those which he uses.

To that end, Nora subordinated the three *R*s to the teaching of what to do with them: "Arithmetic in the lower grade has grown out of the children's interest: Things which have to be measured, goods must be bought for the doll house from the school toy store...."

A Practical Curriculum

Even in first grade, books were considered literature to be read for the pleasure of the student or even for profit—extra work equaling some small reward—but never for drill.

Every primary room had a large doll house, which the kids—boys as well as girls—had to furnish and a doll family for whom to care. "A wide variety of other materials are furnished including cloth for the making of dresses, aprons and the like for themselves ... and for their mothers."

Nora introduced weaving classes where children made rugs, pillows and curtains for their own homes or to sell in the school store:

There is an excellent workshop in which real furniture—tables, chairs, cupboards, etc.—is made both in the day school and the evening (adult) school. Boys do much repair work around the school. They also are encouraged to bring broken furniture from home to mend in the shop.

And everything—*everything*—was conducted, if haltingly, in English. Nora's belief in language immersion was clear:

The [English] vocabulary is most easily acquired when it is needed to talk about something interesting, when the words are associated with some meaning not in the teacher's mind but in the child's.

Writing was taught the same way. "It is astonishing to a teacher versed on other methods to see how quickly and easily the forms (writing, spelling, composition) are acquired when a child has use for them."

And, in time, Nora even found a use and place for standardized testing: "The third grade is now writing compositions at the fourth and fifth grade level."

No opportunity to enrich the learning experience was overlooked. "Organized games during the day are part of the curriculum, chosen for their usefulness in teaching cooperation, loyalty and unselfishness."

In a place of no parks, no grass and no trees Nora and her teachers created wholesome activities with what little was available.

"The playground is a valuable contribution to community education. This is open from dawn till 9 o'clock at night, a teacher being present on school days for the greater part of that time," she wrote.

Seventy years later, President Bill Clinton tried—unsuccessfully— to convince Congress that the "Midnight basketball" programs were a cheap, partial alternative to drugging and gangbanging. He didn't have Nora Sterry's no-nonsense approach to teaching social interaction as well as basic skills.

At the school, social studies taught students the history of Southern California, the U.S. and the world at large—but also "the history of their district and they are interested in the different people represented."

In a sharply segregated city, the Macy Street school taught inclusion.

And not just to its students:

> Twice a month adults put on a general entertainment based on their country of origin, usually dancing or a concert or a film. Once a year, students and parents create an international bazaar with handicrafts, national dishes, music and art [with] the money going into the school fund.

Nora employed other devices to involve parents in their children's education:

> The school maintains a circulating library, games are taught in school which may be played at home and all school entertainments to which admission is charged are free for parents who attend with their children.

Knowing how grade schoolers love diversions, Nora established weekly assemblies for chorus singing, story telling and the new craze— motion pictures.

She managed to bring the movies in just as practically as she ar-

ranged the rest of the school. And she described it all in an offhand manner that, to this day, shames familiar excuses for mediocrity:

> The projector was acquired through a rummage sale and, each year, students discuss what knew piece of equipment they'd like and how to pay for it.

A Focus on Self-Reliance

Everything students received—hot food, decent clothes, swimming lessons, entertainments, a well-kept campus—they paid for in some way. Nora believed firmly in the value of self-reliance:

> To learn to earn their own way as they go, to depend on their own exertions for the satisfaction of their own wants is a lesson second to none in importance and one that can better be learned by practice than through any study of books.

In June of 1924, at the end of Macy Street's two-year exemption from standardized courses for standardized testing, grades were up, written and spoken English skills were *way* up and, in a few cases, even IQ points were up—due, Nora concluded, to ability grouping. Absenteeism and health problems continued to plummet.

The total cost for all of Nora Sterry's imaginative programs had been $5,000 for the two school years—about four bucks a student—which was paid for by donations from individuals, enthusiastic teachers, organizations (the PTA, Catholic Charities and L.A. County Charities), local businesses and...by the kids' own industry in Nora's "workfare" programs within the school.

Not one cent came from the Board of Education. Nora declined any personal credit. And her strategy for implementing the radical program was as practical as the curriculum she developed: "No radical change was effected at any time, modifications being introduced gradually as the reason for them became clear."

She submitted her Master's thesis in May 1924. She had spent 21 years as the Boswell of Macy Street—chronicling the atrocious and illegal living conditions and successfully challenging institutional prejudice, indifference and ignorance.

She must have been gratified when she received her degree for the thesis paper—*The Sociological Basis For the Reorganization of the Macy Street School*—which became the standard she and her handful of foot

soldiers carried into battle.

She and her teachers had every expectation of more triumphs in the school year beginning in September 1924.

But, in that Year of Wonders, there was a darkness looming ahead. It would drive the Macy Street district into crisis. And disturb the fragile improvements that Nora Sterry was creating, using her school as the catalyst.

5 Beautiful but Damned

He was astonished to see a gram-negative staining bipolar bacillus resembling the plague bacillus. He realized that he was sitting on a keg of dynamite and should keep his mouth shut until he could talk to the appropriate people.

—Helen Eastman Martin, M.D., *The History of the Los Angeles County Hospital (1878-1968)*

Tuesday, October 28th

Physician George Stevens of the City Health Department calls L.A. County General Hospital to report that some highly contagious disease is running through the Macy Street district. He and another doctor, Elmer Anderson, have treated patients with nearly identical symptoms: Raging fevers, chest and back pains, bloody sputum and darkening of the skin over the chest and limbs.

Stevens requests that the hospital set up a quarantine ward separate from the pneumonia ward. Hospital Superintendent Dr. N.N. Wood immediately implements Stevens' suggestion.

Back in the Macy Street district, two of the borders at 742 Clara Street—brothers Mike and Jose Jiminez—fall ill and fear something

evil in the house itself. They quickly pack up their meager belongings and move to 730 Date Street, a few blocks away.

Another border, Eulogio Peralta, moves even farther away.

What Peralta and the Jiminez brothers are doing is what people have done since medieval times—trying to outrun the plague. It's a natural reaction; the terror Black Death evokes hasn't diminished in three millennia. But this natural reaction only hastens the spread of the disease.

Wednesday, October 29th

In the early morning, Mary Costello—one of the nurses at L.A. General Hospital who cared for Guadalupe Samarano and Jessie Flores—calls in sick. Costello has a high fever and sharp pains in her back.

A few hours later, in the early afternoon, Father Medardo Brualla administers the last rites to Fred Ortega, 26. Ortega was another border at 742 Clara Street.

Around 4 p.m., Dr. Emil Bogen—a resident physician at the General Hospital—receives a phone call from Dr. Elmer Anderson, who requests an ambulance be sent to 343 Carmalita Street in the unincorporated district of Belvedere Gardens near the dividing line between Los Angeles County and the Macy Street district.

Later, Bogen will write, "Dr. Anderson had just seen a Mexican patient who appeared to be critically ill" of some disease—either meningitis or Spanish influenza, Anderson suspects.

That is cause for some concern. The 1918 pandemic of Spanish flu—a form of what, today, is known as "bird flu"—killed as many as 80 million people worldwide and 600,000 in the U.S. It had been the deadliest epidemic in American history.

So Bogen decides to ride out in the ambulance to see for himself. He is careful to wear a sterile facemask when he enters the home. He will write:

> In the middle of the room, an old Mexican woman was lying on a large double bed crying between paroxysms of coughing, while along the wall was a couch on which was seen a Mexican man of about 30 years of age, restless and feverish but not coughing ... It was learned that the man had been stricken the preceding day with a severe pain in the front of his chest and along the entire spine, and had a fever, which at that

time was 104 degrees and a few reddish spots on his chest. The old woman had apparently been stricken in the same manner, but she been coughing for the past two days, expectorating a bloody sputum ..."

The 80-year-old woman is Maria Samarano, mother of Guadalupe—who died three days earlier with the same symptoms. The stricken man is her other son, 25-year-old Victor...Guadalupe's brother. Also living in the house—and also sick—is Juliana Herrera, the late Lucina Samarano's 63-year-old mother.

However, Herrera's symptoms do not seem to be life-threatening and she remains home while Maria and Victor Samarano are taken in the ambulance to the new isolation ward at L.A. County General Hospital.

Dr. Bogen stays in the Macy Street neighborhood to observe what is going on. The news doesn't take long to arrive. A neighbor of Maria Samarano tells him that other people in the district are ill. He leads Bogen to a nearby house where, after donning a new cotton face mask, the physician finds:

a young man in bed, suffering with a high fever and pain the chest and back, but no other symptoms ... his wife, also feverish, stated that she was feeling better than previously, while in the front room, a young girl ... with her head in her hands and with a flushed face, insisted she was not sick, only a little tired.

The man and wife are Jesus and Maria Valenzuela (a different doctor will identify them as brother and sister), cousins of Guadalupe Samarano. The young woman is 18-year-old Maria Samarano, Guadalupe's niece. Dr. Bogen does not order an ambulance for them and doesn't link them to any of the other strange deaths at General Hospital.

The next day, however, Jesus Valenzuela is rushed to the hospital with suspected "meningitis" and, two days after that, he's dead. Both young women also will be admitted to the isolation ward and will die three days later.

As evening sets in, Dr. Bogen is taken to other locations. Eventually, he visits the boarding house at 742 Clara Street—the "House of the Dead" as locals are already calling it.

In the house, he finds the four orphaned sons of Lucina and Guadalupe Samarano, all desperately ill: four-year-old Raul, Guadalupe's

son from his first marriage, and Lucina's three sons from her earlier marriage, seven-year-old Gilberto, 10-year-old Roberto and 12-year-old Alfredo. (The identities of the four boys are garbled and confused in most official reports. In fact, the reports give all four boys the surname Samarano.)

"The four boys were brought to the hospital that same night and during the following day, six more cases were admitted from the neighborhood," Bogen writes. One of the new half-dozen is Lucina Samarano's 16-year-old cousin, Horace Guiterrez.

Continuing his diary, Bogen writes: "Soon after admission, they developed signs of a severe pneumonia with bloody expectoration and marked cyanosis."

Cyanosis is when the skin turns dark because of the lack of oxygen in the blood. It's one reason pneumonic plague is called "The Black Death."

Nevertheless, staff of the hospital diagnose all the new cases as "epidemic meningitis."

Roberto Samarano—who seems in the worst shape of the four boys—is treated with a Mercurochrome solution administered intravenously.

In those decades before antibiotics doctors at General Hospital try everything conceivable to treat the rush of dying patients. Some are injected with alcohol, morphine or caffeine. Others are given quinine or digitalis, a medication made from the leaves of the foxglove plant which has been used to treat heart patients since the 1700s.

Thursday, October 30th

In the morning hours, three of the new cases of "suspected epidemic meningitis" die. They are 10-year-old Roberto Samarano—he had failed to respond to the Mercurochrome drip—his mother's cousin, 25-year-old Hector Guiterrez—he, too, failed to respond to the Mercurochrome drip—and Fred Ortega, one of the borders at the Samarano home. Ortega failed to respond to the Mercurochrome drip, too. Doctors continue to administer the drip, anyway.

As the morning progresses, three more patients are admitted to the hospital's improvised isolation ward.

The new patients' symptoms are nearly identical to those of the patients who died that morning. But the preliminary diagnoses include typhus and pneumonia.

A World Away, the Chamber Board Meets

Across town—and a world away from the impoverished blocks of the Macy Street district—the weekly meeting of the board of directors of the Los Angeles Chamber of Commerce is convening.

The first item of business is a posthumous salute to Frank Wiggins, the former Secretary of the Chamber, supervisor of exhibits and the man whose heroic mendacity practically invented 20th Century Los Angeles.

"It was he who devised unique and effective means of advertising climactic conditions and the agricultural possibilities of Southern California" reads the printed salute to Wiggins and boosterism. It goes on to note:

> His dynamic energy and vigor led to this magic trans-
> formation of Los Angeles from a city of 50,000 when
> he became Supervisor to over one million.

The success of these numbers can't be denied by anyone on the Chamber board.

The new secretary announces that, on Wednesday, the entire 12,000-plus Chamber membership voted to christen 1925 "The Frank Wiggins Year."

Paul Hoffman, a board member who owns the local Studebaker dealership and a chain of gas stations in Los Angeles, announces that:

> The School Board will name certain schools for Mr.
> Wiggins and I have asked the Board to advise me so
> that appropriate ceremonies might be had in connec-
> tion.

Mr. Hellman, from a prominent Jewish family which with a former governor, founded Los Angeles's first locally-owned bank in 1871, believes that the board should be kept advised of which schools may be designated "Wiggins" schools so that they may be "properly located."

Next on the agenda, a special committee reports on the powerful Progressive Party's call for businesses to close for half a day on Saturday—creating a 44-hour workweek.

"The committee reported that it had given the matter most serious and mature consideration and the unanimous feeling of the committee was" that hell will freeze over and Satan play ice hockey before we support something like *that*.

The board then votes to "extend an invitation to Mr. [Harry] Chandler of the Times-Mirror Company to discuss" the fact that he had just goosed up the rent on the Chamber's offices from $2,250 a month to $3,000 after learning that the Chamber is planning to build its own facility. Chandler is a hard-nosed business man.

Near the end of the meeting, Board President William Lacy announces that A.G. Arnoll is the new secretary to the board of directors. Arnoll writes in the minutes that his appointment is greeted with "hearty applause."

That applause still echoes across the decades.

At the same time the Chamber directors are lunching, so is Dr. George Maner. He's eating in the cafeteria of Los Angeles County General Hospital—where he is chief pathologist. A resident approaches him to report a peculiarly virulent form of pneumonia that he's seen in a couple of patients, Guadalupe Samarano's brother Victor and Lucina Samarano's 16-year-old cousin, Hector Gutierrez.

"Possibly you're dealing with pneumonic plague!" Dr. Maner jokes.

The resident persists, asking Maner to examine Hector Guiterrez.

So, the pathologist ventures into the isolation ward, gets a sample of sputum from the boy and takes it back to his laboratory to make a smear. When he looks at the slide under a microscope, he is stunned at what he sees.

It's a bipolar bacillus that looks dangerously like the *bacillus yersinia* —a.k.a. *bacillus pestis*—which, for the past three decades, has been known to cause the Black Death.

It looks like his joke wasn't … a joke.

Confirming the Conclusions

Dr. Maner calls his predecessor as chief of pathology, Dr. Roy Hammack. Hammack had once served in the Philippines—where he treated cases of the Black Plague. Hammack responds at once. Fifteen minutes later, he's looking through Dr. Maner's microscope. Hammack, described by a colleague as a "taciturn Scotsman," looks up and exclaims, "Beautiful! Beautiful but damned!"

Next, Dr. Maner calls in Dr. Luther Powers, the 71-year-old City Health Commissioner. A few hours later, Powers examines the evidence of plague pneumonia—but wants to see more tests. He says the slides showing the bacillus were poorly prepared and he refuses to accept Maner's and Hammack's diagnosis of plague.

"Well," Maner snaps back at the older bureaucrat, "when the harbor is quarantined and there's a big quarantine in the whole Los Angeles area, then you'll believe it!"

Dr. Shirley Fanin, former LA County Health Commissioner says Dr. Powers couldn't accept even the possibility of Black Death. She says:

> Politically, I'm sure that's what he wanted to believe. Part of his responsibility was to know and trust his laboratory but I'll bet you [his] first reaction was to think, "My God, I don't want to put up with this! Let's find some other reason [for the wave of deaths].

Seeming to follow the sort of political impulses that Fanin describes, Powers does notify the City's quarantine division that there appears to be a "return of [Spanish] flu" in a virulent form in the Macy Street District.

But young Dr. Maner is incorrect in his prediction; old Dr. Powers never has to admit he was wrong when he denied the mountain of plague evidence. At 2:35 p.m. the next day, the City Health Commissioner drops dead of a heart attack.

Strange Responses Afoot

Thursday evening, hours after Dr. Maner called in his colleagues, Maria Samarano—Guadalupe's 80-year-old mother—dies of pneumonic plague in the hospital's isolation ward. Hers is the fourth such death of the day...but the word "plague" doesn't appear on any of the death certificates.

Someone from the City Health Office's Quarantine Division calls his opposite number at County Health to request white quarantine cards. He specifies he wants the *white* ones, the ones which don't state the nature of the disease causing the action.

These are designed to prevent panic among either the people being quarantined or the general population.

Off the record, the caller says it looks like a return of the "flu pneumonia."

In 25 days, the Black Death has killed eight people and infected nine more—with the same symptoms. Those symptoms have been misdiagnosed as anything from "venereal disease" to "epidemic meningitis"—from "heart failure" to "peculiar pneumonia" and from "inebriation" to "bronco pneumonia."

No one is willing to admit formally—or even, it seems, privately—that there is plague in Paradise.

Friday, October 31st

Around 9 a.m. Eastern Standard Time on Holloween day, the United States Public Health Service in Washington, D.C.—forerunner to the Centers for Disease Control and Prevention—learns there is plague in Los Angeles. But it learns this in a convoluted way: The assistant superintendent at L.A. County General Hospital has started telegraphing various city, state and national health authorities, inquiring as to where he might purchase the anti-plague serum developed by Alexandre Yersin.

The U.S. Public Health Service's senior surgeon in Los Angeles—who received a copy of the wire—calls the General Hospital to inquire if there is plague in the city. No one he talks to will confirm it.

The same morning, Mary Costello—the 32-year-old nurse who cared for Guadalupe Samarano and Jessie Flores in the pneumonia ward—is admitted to the isolation unit complaining of back, chest and head pains. She also has a high fever and is spitting up blood. She's hooked up to an IV drip of a Mercurochrome solution.

In the early afternoon, Dr. George Stevens—who works for the City of Los Angeles Health Department—visits 742 Clara Street, where another border, Joe Bagnola, is critically ill with what Stevens suspects is a "severe type of influenza pneumonia."

Stevens takes a sputum sample from Bagnola and one from Ruth San Ramon—who lives across the street—and sends them to his lab which, that same day, confirms *bacillus pestis*. (Local health authorities will continue to use the older name for killer germ throughout the plague epidemic.)

While those samples are being tested, Dr. Elmer Pascoe is appointed Acting City Health Commissioner to replace the late Luther Powers.

At the same time, the U.S. Public Health Service surgeon in L.A. finally confirms with County General Hospital superintendent N.N. Wood that there is, indeed, Black Plague in the region. He immediately wires a coded message to Acting Surgeon General M.J. White in Washington:

Eighteen case ekkil [pneumonic Plague]. Three suspects. Ten begos [deaths]. Ethos [situation bad]. Recommend federal aid.

Why the Government Hesitated

Legally, according to the principles of federalism enshrined in the United States Constitution, a state health authority must first *request* federal involvement. This hasn't happened, of course. No one at the local or state level has even *acknowledged* the outbreak.

Acting Surgeon General White sends a telegram to his senior surgeon in San Francisco, James Perry, to proceed directly to Los Angeles where he is to investigate the situation quietly and keep his findings exclusive to the U.S. Public Health Service.

The battle against the plague has not yet been joined and already turf wars are breaking out.

This is a disturbingly familiar reaction—even to the present day. As this book was being written, a headline in the *Los Angeles Times* read: "Levees Weakened as New Orleans Board, Federal Engineers Feuded." Earlier, the *Wall Street Journal* ran a front-page story under the headline: "Local and Federal Authorities Battle to Control Disaster Relief." That article explained that aid to victims of Hurricane Wilma has been delayed, misdirected and misappropriated due to the ongoing pissing match between rival agencies. It quoted one Florida official referring to his federal counterparts as "spies."

In the disastrous aftermath of 2005's Hurricane Katrina, federal agencies argued that the problems proved that states were incompetent to respond to large-scale disasters. An absolutely gorgeous metaphor for the hostility between federal and local authorities occurred on the second anniversary of Katrina: President George W. Bush called for a moment of silence to commemorate the storm victims while—at the same time—New Orleans Mayor Ray Nagin called for the city's bells to toll.

Back in 1924, Surgeon General M.J. Smith and James Perry would have recognized these intramural scuffles.

The one official who *isn't* notified about the Macy Street outbreak is the first person whom—by law—should have been.

Dr. Walter M. Dickie is the Secretary of the State Board of Health, the top field-general in California health and a veteran of the 1900-1906 plague outbreaks in and around San Francisco. Dickie, who

lives in Los Angeles, learns about the Macy Street outbreak and the problems at County General Hospital when he picks up the October 31st issue of the *Fresno Republican*. (He's traveled north to Fresno to investigate an increase in smallpox reports.)

In a story reported by the Associated Press, Dickie reads about a "strange malady" which has killed "nine Mexicans" who attended the funeral of Lucina Samarano. He immediately fires off a telegram demanding to know what caused the death of Lucina Samarano. A city health official wires back a model of cost-saving brevity:

L.S. death caused by b. pestis.

How does the unnamed respondent know this? According to all reports, no blood or tissue samples have been taken from Lucina Samarano, no autopsy has been performed and the 39-year-old mother's "Cause of Death" reads "myocarditis"—or heart disease. Also, her body was released to her husband for a public wake, a criminal violation of health regulations in a case of death by *b. pestis*.

Still, Halloween day is the first time anyone has conceded—in writing—that the Black Death is abroad in the city.

Word Spreads

Around 5 p.m. that afternoon, Dr. J.L. Pomeroy—Los Angeles County Health Officer—receives a phone call at his home. His secretary tells him that City Health suspects pneumonic plague has broken out in the Macy Street district.

There have been "several" deaths there due to an extremely deadly form of pneumonia. Also, there are two suspected cases in the community just east of Macy—the unincorporated Belvedere Gardens district. That's Pomeroy's bailiwick.

He returns at once to his office.

There, Dr. Pomeroy receives a call from County General Hospital. The city's bacteriologist has a positive diagnosis in the 742 Clara Street cases. It's pneumonic plague.

A biblical pestilence has descended on the City of the Angels.

Pomeroy calls County Chief Quarantine Officer Carl Williams at home. Pomeroy tells Williams to meet him at the Constable [nowadays, we'd say *Sheriff*] station in Belvedere Gardens.

Williams arranges for armed deputies to meet them as well.

Around 8 p.m., a cousin of the Samarano family comes to the rectory of Nuestro Senora de Los Angeles Church. He asks Father

Brualla to come to the General Hospital—Arthur Guiterrez, Lucina Samarano's cousin, is asking for the last rites.

Father Brualla gathers his cruets of oil and prayer book but, before he leaves, he presses a cold towel to his face.

He's been running a fever all day.

Arthur Guiterrez dies before Father Brualla can get to County General. But the priest arrives in time to deliver the sacraments to 23-year-old Ruth San Ramon. She's a nurse and she tended to her younger sister—practical nurse Jessie Flores—when Jessie was dying.

As he walks through the isolation ward, the Spanish priest hears the moans of the dying rising faintly like murmured prayers. There are more of them now. Almost a dozen.

The Quarantine Begins

Around 9 p.m., while Fr. Brualla is still making his rounds at the hospital, County Health Officer J.L. Pomeroy and Quarantine Officer Carl Williams and their armed deputies proceed to 343 Carmelita Street. It's the home of the late Maria Samarano, the 80-year-old mother of the late Guadalupe Samarano. (Pomeroy mistakenly identifies her as "May" Samarano).

Her other son, Victor, is dying at County General Hospital.

Three other families live in the small home. Pomeroy questions them and learns that Victor and his late wife had attended the wake and funeral of Victor's brother, Guadalupe (whom Pomeroy mistakenly notes as Victor's sister-in-law, Lupe).

Pomeroy immediately places the house under quarantine and posts armed guards.

This is the first time that anyone has linked any of the deaths and illnesses to the house at 742 Clara Street.

Next, Pomeroy and Williams walk two blocks to another extended family home at 246 Mariana Street. This is where Jesus Valenzuela and his wife live with Jesus' mother. Jesus died of Plague five hours earlier; now 18-year-old Maria Valenzuela—variously identified by doctors as Jesus' wife and as his sister—is critically ill.

Pomeroy calls for an ambulance to take the young woman to County General Hospital. Then, according to Pomeroy's notes:

> Her mother, Guadalupe [sic] Valenzuela, was vomit-
> ing but as she as well as a son and daughter [actually,
> a cousin, 18-year-old Maria Samarano] were apprecia-

bly under the influence of liquor, I was not concerned about her condition. The next morning, however, her temperature was 105 degrees and I sent her to the General Hospital and she died of pneumonic Plague November third.

Eventually, Pomeroy extends the quarantine to several more homes where there was contact—five in all. He conscripts 75 police officers to assist the Constable's quarantine guards; and he throws a *cordon sanitare* around the entire street extending into the Macy Street district within the city limits.

As County Health Officer, he has no authority to do any of this.

According to former Los Angeles County Health Commissioner Shirley Fanin: "The *state* retains the power of quarantine, so you cannot legally quarantine anything without state permission."

And so far, no one senior in the Los Angeles medical establishment has even tried to communicate with the State Health Officer, Walter Dickie.

By exceeding his authority, J.L. Pomeroy probably saves hundreds, and perhaps thousands, of lives. But Pomeroy also confirms the prejudice that plague is a disease of race.

In his annual report to the State Board of Health, Pomeroy will write that the armed guards he ordered to enforce the quarantine were

the only effective method of quarantining Mexicans. We worked as quietly as possible so as not alarm the Mexicans who we feared would scatter.

Shirley Fanin acknowledges that Pomeroy's remark is racist but tries to put it the context of the day: "This was one of those things where we drift into characterizations where all Mexicans run back to Mexico when they get scared." She adds:

It's based on an observed phenomenon: When people have close ties to another neighborhood, state or country, they'll go there temporarily in times of trouble, especially if they don't want to be quarantined.

The hardheadedness that allowed Pomeroy to take the first constructive action to contain the outbreak allowed him to make casual assumptions about "Mexicans" that sound bigoted to modern ears.

But Pomeroy's admonition about plague victims fleeing the area comes too late: Three borders at 742 Clara Street have already escaped to places outside the quarantine zone.

November 1st, midnight

County Health Officer J.L. Pomeroy extends the quarantine to include all of the Macy Street district as well as the "Mexican" sections of Belvedere Gardens. He asks the Los Angeles Fire department to supply the rope to cordon off the *entire* quarantine zone.

About 4,000 people live within the zone.

Pomeroy also places more armed guards at the front and back of any home known to have had a plague victim. No one is allowed in... or out.

This quarantine-within-the-quarantine certainly slows the spread of the disease but it dooms healthy people, too. According to Dr. Frank Sorvillo, chief epidemiologist for Los Angeles County Health Services:

> People inside a household who have the disease, their die is cast; if they have pneumonic plague, they're going to die. The incubating cases, they're also going to die. But those confined to the home who are not yet exposed to the disease have a far greater chance of catching it. They were forced to potential exposure by the quarantine. But in 1924, they didn't have the ability to tell the difference between those who were not exposed and those who were in early incubation. They had no choice; they had to quarantine everyone who could have been exposed to the plague.

Pneumonic plague can be spread like any cough or cold; by breathing in or touching the droplets a victim sneezes, coughs or exhales and those droplets can hang in the air—still deadly—for nearly half an hour. In other words, pneumonic plague can be spread if someone coughs into a tissue "and the droplets dry then someone picks up the tissue to dispose of it. That can aerosolize the bacteria," says Dr. Sorvillo.

So, the quarantine-within-the-quarantine is sound medical practice if someone had thought to order vaccine for the people locked into plague homes.

It's been 28 days since Dr. Giles Porter examined Jesus Lajun's hugely swollen bubo and pronounced it "venereal disease." And 28 days since he diagnosed 15-year-old Francisca Lajun as having "flu." Both are dead of Black Plague. It's been two days since the top health

official in the city of Los Angeles refused to believe what he saw under a microscope, *b.yersinia.*

Tonight, on Halloween, County Health Officer J.L. Pomeroy looked at two sick women—one who was vomiting blood— and diagnosed inebriation. Both of these women soon will be dead of Black Plague.

When Halloween gives way to November 1st, there are 12 people dead, 19 more dying...and the worst is still to come. In the days, weeks and months ahead, estimates of the number of victims will vary from newspaper to newspaper and even from edition to edition.

Similarly, the surnames of both Hispanics and Anglos will be butchered along with their familial relationships—even in the official reports.

In the end, it will be impossible to determine precisely how many people were stricken with Black Plague and how many died.

The Scope of the Scandal

In modern political scandals (at least since Watergate), the key question has been, what did he know and when did he know it? The same questions can apply to the local-government management of the Macy Street plague outbreak.

All official government and medical documents say plague was confirmed on October 30th by chief pathologist Dr. George Maner and immediate and effective action was implemented by County Health Officer Dr. J.L. Pomeroy on the 30th and 31st.

But that's an official deception.

Former Los Angeles County Health Commissioner Shirley Fanin wrote part of her Master's Degree thesis on the Macy Street plague outbreak and saved many of the 1924 documents from the shredder. She says, "I think that most of the data show that they were onto the fact that this was Plague well before the first of November."

Some of that data are obvious: N.N. Wood, superintendent of General Hospital quarantined his morgue on October 26th and established a new isolation ward two days later.

Some of the data are stunningly contradictory. State Health Officer Walter Dickie published a pamphlet in 1926 called *Plague in California, 1900-1925.* In it he writes that the first Los Angeles case was a "Male Mexican, age 55 years, (who) was taken ill October 1." He is obviously referring to Jesus Lajun.

Dickie goes on to write, that Lajun suffered

with a slight femoral bubo associated with constitutional symptoms, diagnosed October 1 as a venereal bubo. This patient was located October 31, at which date a culture was made from the sinus site of the old bubo. This showed bipolar staining organisms, and a guinea pig inoculated with the pus died in 12 hours.

Since Jesus Lajun died on October 11th, Fanin says:

Clearly, he [Dickie] is saying that the [pus] was taken before or just after Jesus died, preserved, and then tested on that later date [October 31st].

But nearly a year earlier—on June 27th, 1925—in his monthly update on the battle against the plague in Los Angeles, Dickie wrote this about Jesus Lajun:

Later, toward the middle of the month [October] is when the bubo was still discharging a small amount of pus and the test was made from that. A guinea pig inoculated with this culture ...was reported to have died of Plague.

Observes Dr. Fanin, "Here he seems to be suggesting that [Jesus Lajun] was *alive* when the sample was drawn and tested."

That's the key to where and when the cover-up began.

Again, Jesus Lajun died October 11th; so, following Dickie's time line, the unnamed physician who inoculated the lab animal would have known that Lajun died of bubonic plague no later than October 12th. That's *17 days* before the quarantine began.

Seventeen days during which the world's swiftest, deadliest disease was allowed to spread unchecked.

When the unknown doctor found *b. pestis* in the lab animal—if he even *suspected* Jesus Lajun died of plague—state and federal health regulations were supposed to kick in like overdrive. The doctor would have to alert N.N. Wood, Superintendent of L.A. County General Hospital. Wood, in turn, was mandated to notify City Health Officer Luther Powers, County Health Officer J.L. Pomeroy, State Health Officer Walter Dickie and Acting Surgeon General White of the U.S. Public Health Service.

Doctors Powers and Wood—the two highest ranking health officers in Los Angeles—fulfilled none of their obligations to notify other

health officials. Pomeroy's account of the epidemic claims he wasn't told that plague was even suspected until October 31st. Dickie says he read about the outbreak on the same day in a Fresno newspaper. The Surgeon General learned there was plague in Los Angeles from a telegram addressed to one of his underlings from L.A. County General Hospital inquiring into the availability of plague serum.

The Keys to the Cover-Up

City Health Officer Powers disregarded other actions he was legally *required* to take at the first hint of either bubonic or pneumonic plague. First, he should have immediately quarantined Jesus Lajun's home and had health workers canvas the Macy Street district to determine who had contact with either Jesus or his daughter Francisca.

That would have led Powers first to 742 Clara, the boarding house of Lucina Samarano who nursed both Lajuns, and then to the apartment of nurse Jesse Flores, who cared for Lucina before she was hospitalized. Then, Powers immediately would have had to quarantine both structures as the *foci*—or localized areas—of the infection. Simultaneously, he was required to alert the County and State Health Officers and the Surgeon General if Dr. Wood hadn't done so already.

Powers did none of these things.

N.N. Wood's legal dereliction also went far beyond failing to notify other health officials. The head of L.A. County General Hospital was obliged to bring in the county coroner to ask the Samarano family for permission to cremate Lucina's body as a safety precaution. If the family refused, then someone from either Wood's staff or the county coroner's would place Lucina Samarano's body in a casket and seal it. Her burial would be private, only immediate family members would be allowed to attend—along with a representative of the coroner's office to insure that no one opened the casket.

Dr. Wood did none of these things. Mrs. Samarano's body was released to her husband who held a public wake with an open coffin where he spread his incubating plague to about 20 people.

It seems almost certain that Dr. Wood was notified that there was plague in the city before October 30th. Why else would he quarantine the morgue on October 26th and establish an isolation ward on the 28th? How else did one of his staff know to answer Dr. Dickie's October 31st question about Lucina Samarano's cause of death ("L.S. died *b. pestis*")?

Officially, she died of "acute myocarditis" on October 19th and no autopsy was performed.

A convincing argument can also be made that Los Angeles Health Officer Luther Powers knew there was Black Death and that he denied it twice:

1) on or before October 13th when an unidentified researcher— or County General chief Dr. N.N. Wood—would have alerted him that pus from Jesus Lajun's bubo killed a lab animal with plague; and then again

2) on October 30th when both his current and former chief pathologists examined the samples drawn from Hector Guiterrez and told Powers it was *bacillus yersinia*.

It would seem a simple matter to establish who knew what and when by examining the death certificates of Jesus Lajun and his 15-year-old daughter, especially where they state " Cause of Death." Death certificates are legal documents and—especially in the case of communicable diseases—are a permanent record.

But a search of county and state agencies came up empty; the death certificates of Jesus and Francisca Lajun have vanished from all official files.

A subsequent attempt to examine the records of Los Angeles County General Hospital, where most of the victims—including the Lajuns— were admitted was equally unsuccessful. All the plague files from 1924 and 1925 had "been lost over the years" according to one spokesperson and, according to another, "All records are destroyed after seven years."

The death certificates of Lucina Samarano, her husband Guadalupe and nurse Jessie Flores—the other three victims who perished before chief pathologist George Maner confirmed the finding of *b. yersinia*— do exist. But they have been altered.

Lucina no longer died of "acute myocarditis" nor her husband and Jesse Flores of "peculiar pneumonia."

As of July 8, 1925—the date stamped on the three death certificates indicating that they have been revised—the victims died of "pneumonia plague."

It is perfectly legal to amend a death certificate, *if* the original document is attached to the new one. But, in the cases of the Samaranos and Jessie Flores, they aren't. Also, the physician who changed the original document must sign his name. These three death certificates, however, are not signed.

A Slight Epidemic

They are stamped with the name of City Health Officer Dr. Luther Powers who, when he purportedly stamped them, had been dead for nine months.

(The amended death certificates do confer on the three decedents a status rigorously denied them in life: Under "Color or Race" they are no longer "Mexican;" now they are "White"—even though all three were born in Mexico.)

And there is a family history of the plague. Raul Samarano, the four-year-old son of Guadalupe and Lucina, was the only person on the porch of the boarding house that first afternoon to survive the Black Death.

He married an Anglo-German woman named Dorothy Zimann whose father Kurt ran the Western Pharmacy in Los Angeles for many years. Back in the 1920s (long before she'd met Raul) Dorothy's father told her and her mother: "Stay out of the [Macy Street] area. They're saying it's a bad case of influenza but it's plague."

So, it seems more than a few people knew there was plague—but no one in authority would admit it.

The evidence is purely circumstantial but there's a lot of it: Dr. N.N. Wood, the superintendent of County General Hospital, knew that people were dying of plague no later than October 26th—and probably two weeks before that. It is equally certain that Dr. Luther Powers knew it, too, and at the same time.

Among the charges of which the two physicians could be accused are criminal negligence and more than two- dozen counts of negligent manslaughter. By keeping silent, they condemned to death between 25 and 34 people. Probably more.

The obvious question is why? Why would Powers and Woods ignore their professional responsibilities especially when they knew such criminal malfeasance had to end in a tragic and wholly unnecessary loss of life?

The simplest answer, in the case of the 71-year-old Dr. Powers, is that he was close to retirement having served as LA's top doctor for 32 years. The last thing he would have wanted as his valedictory was a scorching outbreak of Black Death.

As for Wood, future events will illuminate his self-absorption, his obduracy and his compelling mediocrity as a public health administrator.

One possible reason for not notifying Washington of the outbreak: If Surgeon General White believed there was plague anywhere near

the Port of Los Angeles, international maritime agreements required him to take one of two equally Draconian measures:

1) he could close the harbor to all traffic going in or out; or
2) he could impose a limited quarantine that would require all inbound ships to be fully inspected and fumigated and their crews isolated for 10 days. All outgoing vessels would have to be inspected and they would have to fly the international yellow quarantine flag which meant that they would be as welcome in most ports as...well...the plague.

Either alternative would have been to shut down the West Coast's busiest harbor—either immediately or by strangulation.

The San Francisco Outbreak Had Been a Disaster

Then, too, well within the memories of Drs. Powers and Wood was the example of San Francisco—where public health officials identified the very first case of bubonic plague in the continental U.S. and took immediate action.

And they were destroyed for it.

The third and last great pandemic—international epidemic—of Black Death came roaring out of Hong Kong in 1894. It hit the Territory of Hawaii in December 1899 and landed in San Francisco in 1900, the Chinese Year of the Rat.

It was the first recorded outbreak of Black Death in North America.

On Tuesday, March 6, 1900, a 41-year-old salesman named Wong Chut King died in San Francisco's Chinatown. Dr. A.P. O'Brien, a city health officer, and Dr. W. H. Kellogg, a young city bacteriologist, performed a postmortem based on their concerns over King's appearance—a bubo on the thigh, fever sores on his lips, dark blotches on his skin.

Under the microscope, clusters of germs with round tips turned pink when stained, the telltale sign of *b. pestis*.

As with the Macy Street district in Los Angeles several years later, San Francisco's Chinatown in 1900 was a Petri dish of disease—20,000 souls segregated in 12 short, dilapidated blocks.

"The case was proven bacteriologically to be Plague," Kellogg wrote later, when he was he director of Bureau of Communicable Diseases for the California Board of Health:

and the (city) Board of Health ... placed the entire
district known as Chinatown in quarantine, the quar-
ter being roped off and police placed on guard.

By international agreement, the next step would be a quaran-
tine the Port of San Francisco, the city's biggest employer and cash
cow. In an essay in *The American Journal of Public Health* published in
1920, Dr. Kellogg describes what happened instead:

They (newspapers, politicians, businessmen, judges,
the governor) launched a campaign of vilification
against the Health Board and the Federal quarantine
officer (Dr. Joseph Kinyoun) ... that, for unexampled
bitterness, unfair and dishonest methods, probably
never had been and never again will be equaled. The
campaign of denial of the presence of Plague and of
resistance to the Board of Health became a political
issue of the most violent character.

Newspapers printed scurrilous cartoons: The doctors trying to keep
the city safe were depicted as rats raiding the treasury for their own
enrichment; another cartoon showed the doctors as snakes—each with
the name of a physician who diagnosed plague or supported the quar-
antine.

Yet another paper printed the names of all the doctors on the State
Board of Health and excoriated them in an editorial:

[These] individuals ... should be made to stand forth
as the perpetrators of the greatest crime that has ever
been committed against the city.

The San Francisco Clinical Society, an organization of faculty and
graduates of a medical college—which will be defunct by 1920—
passed a resolution carried on the front page of most daily newspapers
which read:

Of the eleven suspected cases reported by the local
Board of Health, no two deaths have occurred in the
same house and no focus of infection has ever been
discovered. No clinical history of any suspected case
of Plague has been secured and no diagnosis of a liv-
ing case has ever been made.

> The health of the supposed infected district has never
> been better and the death rate lower during the past
> three months, when Plague is claimed to have existed,
> than in any previous year in San Francisco. ...no cases
> of Plague exists [sic], or has ever existed, in the city of
> San Francisco.

The city sued to lift the quarantine claiming it was discriminatory against the Chinese. And a federal court agreed.

Then a group of attorneys, hired by Chinese businessmen, sought to enjoin the Board of Health from interfering in the "free movements of these [Chinese] people."

That judge sided with the Chinese, too, claiming there had never been a proven case of plague. Perhaps that was because the lawyer for the Board of Health was not permitted to testify or submit evidence.

In the Port of San Francisco, it was business as usual.

When the Surgeon General of the United States appointed a special commission of doctors to investigate, California Governor Henry Gage accused him of "ignoring state authorities in the matter." The state legislature rushed through a law giving unprecedented power to the State Board of Health—which Gage turned into a political game of stack-a-quack.

The bacteriologist for the State Board of Health was removed and replaced with two bacteriologists who were unable to find any evidence of plague. Gage fired another member of the Board and appointed in his place the president of the soon-to-be-disaccredited medical college that had taken out the ads in San Francisco newspapers.

Joseph Kinyoun, the federal quarantine officer, a graduate of the Pasteur Institute in Paris and the founder of what would become the National Institutes of Health, also was forced from his job.

Nevertheless, the U.S. Surgeon General's commission found six new cases of plague within three days of its arrival in the City by the Bay. By then, it was too late. Black Death would flare up occasionally in San Francisco until 1909 and kill at least 200 people—that the city formally acknowledged. The real number will never be known.

Public officials have been undercounting plague deaths at least since the London epidemic in 1665.

Making matters worse, Chinese residents in San Francisco were known to hide their dead rather than subject them to what they considered the barbarous practice of autopsy.

With plague an established fact, Governor Gage eased off a bit on his own former, disgraced health workers, asking rhetorically:

> Could it have been possible that some dead body of a Chinaman had innocently, or otherwise, received a post mortem inoculation ... by someone possessing imported Plague bacilli...?

He went on to propose a new state felony—punishable by a life sentence—for anyone developing plague cultures or making slides from any plague case within the state.

(In a rare moment of lucidity, the state legislature refused to pass another Gage bill—that would have outlawed all plague research, diagnosis and treatment in California).

Not since the Catholic Church burned Giordano Bruno for teaching that the earth wasn't the center of the universe had science been subjected to such a spectacle of naked institutional stupidity.

See No Evil, Hear No Evil...

The public excoriation of the original health officers (many of whom served without pay) destroyed professional reputations, impugned personal integrity and tarnished—or ended—honorable careers. Only Wilfred Kellogg survived the purge; and that was because he was just about the only competent bacteriologist left in San Francisco. He helped form the new plague-fighting team that included Dr. Walter Dickie—who would bring his field experience to Los Angeles in 1924.

At the end of his 1920 expose of the plague in San Francisco, Dr. Kellogg asked, "Are these things possible today?" He answered his rhetorical question by quoting—presciently, as it turned out—an article in the *Los Angeles Times* during the time of the San Francisco outbreak:

> Such cases [of plague] still appear in tropical countries where filthy conditions prevail ... There is no more danger of bubonic Plague becoming epidemic in a climate like that of California, where people are cleanly [sic] than there is of seeing cactus sprouting on cement sidewalks.

The political and institutional powers that built West Coast cities simply wouldn't acknowledge the possibility of epidemic outbreaks in

the dense living conditions that resulted from the steady influx of people into their boomtowns.

Doctors or public health officials who tried to tell hard truths could lose their jobs and reputations.

Los Angeles City Health Officer Luther Powers and General Hospital Superintendent N.N. Wood knew that any announcement of Black Plague would be greeted with the rabid enthusiasm of a lynch mob. The reaction in their city would be at least as harsh and irrational as San Francisco's especially if it came to closing the Port of Los Angeles. So both physicians would have had good reasons to be fearful especially since both served on the Southern California Hospital Council with members of LA's shadow government, the most powerful force in the city.

6 No *Little* Plans

NO LITTLE PLANS

—Title of the official history of the Los Angeles Chamber of Commerce

The Chamber of Commerce at that time is the most powerful political entity in Los Angeles. More powerful than the City Council.

—History Professor William Deverell

Otis [and the Chamber of Commerce] promoted an image of Los Angeles that dominated the popular imagination at the turn of the century and is alive to this day ... obsession with climate, political conservatism and a thinly veiled racialism, all put to the service of boosterism and oligarchy.

—Kevin Starr, *Inventing the Dream: California Through the Progressive Era*

American history is pretty much the story of stealing told in chronological order. Behind many venerable family fortunes is a museum

of felonies and this incontrovertible fact can be seen in sharpest relief in Los Angeles where economic depredations are so gross and so recent that nobody tries very hard to cover them up with philanthropy and revisionist history.

"Old money" in Los Angeles seldom can be traced back more than a couple of generations to a federal indictment.

In many Western cities—Las Vegas and Houston come to mind, along with Los Angeles—having money is all that matters, how you got it is morally irrelevant. Predatory greed is its own reward.

For example: Consider Edward Doheny, the tempest in the Teapot Dome scandal. In 1924, Doheny was accused of paying huge bribes to buy oil leases on federal land in Southern California. Doheny was acquitted in a Los Angeles court—on a technicality and after two trials—of paying the $100,000 bribe which Interior Secretary Albert Fall was convicted of accepting

Fall went to prison. Doheny got a ritzy street named after him. And this book—like many—would not have been possible without access to the archives stored in the Doheny Library at the University of Southern California.

The Origins of the Chamber of Commerce

The Los Angeles Chamber of Commerce itself was spawned by a massive land fraud created, in part, by some of its charter members. According to its official history, the Chamber was

> Organized in 1888 to combat the effects of disastrous land speculation, the Los Angeles Chamber of Commerce was born of the need for an organization that would give central planning and coordinated direction to a campaign of recovery.

Like Jesus, the Chamber of Commerce was born in a stable—this one at the corner of First Street and Broadway. To fulfill what they saw as their mandate to manage L.A.'s economy, the founding fathers had to embody the Chamber's credo, "Vision to see, Faith to believe, Courage to do."

Some of them were Civil War veterans and at least 13 of the 43 original members were veteran land speculators. A.E. Pomeroy (no relation to the County Health Officer) was credited with using his property development and water companies to found the cities of Long

Beach, Gardena, Hermosa, Burbank and La Puente; J.B. Lankershim's ranch alone encompassed more than 100,000 acres; Harrison Gray Otis—the Chamber's Second Vice President and Harry Chandler's father-in-law—amassed millions of acres of Southern California.

Otis also owned the ferociously conservative, antiunion *Los Angeles Times*, the city's most widely read newspaper.

The Chamber's First Vice President, William H. Workman, also was the Mayor of Los Angeles, a future city treasurer and a developer who was credited by a local newspaper with establishing "the first planned settlement for white residents east of the L.A. River."

His official portrait shows a meticulously dressed man with a thick head of perfectly groomed silver-gray hair, large intelligent eyes surmounted by leaden caterpillar brows and a narrow face framed by an impeccably trimmed salt-and-pepper beard.

He looks like a Schnauzer.

Workman called his segregated community Boyle Heights and also gave the name (Boyle) to his son—who would follow closely in the footsteps Workman *pere* couldn't cover up.

As president of the Los Angeles City Council and chairman of the all-important Finance Committee, Boyle Workman will steer the legislation that results in the destruction of Macy Street and other ethnic districts during the Black Plague contagion. His relationship to the Chamber of Commerce was like that of Louis XIII to Cardinal Richelieu—or George W. Bush to Karl Rove. Or Howdy Doody to Buffalo Bob Smith. The words come out of the public official's mouth ...but the thoughts originate elsewhere.

Other charter members of the Chamber included Frank A. Gibson, cofounder of what became TICOR Title Insurance, and Frank Garbut, one of the first wildcatters to strike oil in the Los Angeles basin. Garbut also is credited with the creation of Paramount Pictures and with bringing the 1932 Olympics to Los Angeles; he reportedly promised the International Olympic Committee that the city would build the 73,000-seat Coliseum in double-quick time for the Games. Which it did.

Garbut founded or greatly refurbished the watering holes for the city's emerging aristocracy: The Los Angeles Athletic Club, the Riviera Country Club and the California Yacht Club. (Railroad baron Henry Huntington and Col. Harrison Otis were both early members of the L.A. Athletic Club—along with Charlie Chaplin, Rudolph Valentino and then-lieutenant George S. Patton).

In 1889, the infant Chamber moved from the stable to a building next to Col. Otis' *Los Angeles Times*, a marriage of rapacious bedfellows that would endure for decades.

Like any Chamber of Commerce, L.A.'s had, as its first objectives, "to stimulate the migration of responsible citizens to Los Angeles and the marketing of the area's products in other parts of the country." Both were daunting prospects. The 1888 population of the city was 70,000—but about a thousand people a month were fleeing in the wake of the real estate crash and the widening ripple effect it had on the entire economy.

Reversing that trend would be impossible without the commodity all growth requires: Water. But Los Angeles is in a semiarid region bordered by deserts, mountains and the Pacific Ocean. Bringing water from a distant source must have seemed a preposterous undertaking to the Chamber men who met above the de Turk livery stable on October 15, 1888.

The chances of "marketing of the area's products in other parts of the country" (and in foreign countries) looked equally unpromising. To be a major exporter, Los Angeles would need a deep-water port and that would mean lobbying tight-fisted Washington—3,000 miles away—for federal money.

In its way, Los Angeles was about as dumb a place to put a city as New Orleans.

Willing a Harbor into Being

Yet, within the year of its founding, the Chamber would be hosting junkets for U.S. Senators, wining and dining them and taking them on cruises around the proposed harbor. Members harangued the War Department on the need for a deep-water port, culminating in the Secretary of War appointing a board to study the proposed site in the city of San Pedro, southeast of downtown.

In 1894, Los Angeles resident Stephen M. White was elected to the United States Senate. Soon, Congress was debating an appropriation bill; $400,000 to dredge San Pedro—the Chamber's choice for the port—but an astounding $2,900,000 to put the harbor in Santa Monica, a more suitable site. Senator White managed to keep the bill off the Senate floor until another survey could be taken and, in March, 1897, the new study favored San Pedro. Work on the harbor began the next year.

When the harbor exceeded its planned dimensions, extending to the city of Wilmington, the Los Angeles City Council simply annexed Wilmington along with San Pedro at the behest of the Chamber.

When the harbor needed enlarging in 1922, it was the Chamber which formed a Greater Harbor Commission and negotiated through City Hall a $15 million bond issue to double dock space and widen the channel. The measure was approved by voters after local newspapers vigorously campaigned for it.

By 1924, Los Angeles can—and incessantly does—boast of having the nation's busiest harbor after New York; half the traffic in the Panama Canal either originates in L.A. or is headed there.

Looking Farther Back

Not surprisingly, the surge in L.A.'s population and general prosperity was the consequence of an egregious land swindle, one that dwarfs the speculation bust that was the catalyst for creating the Chamber of Commerce in the first place.

A major city called Los Angeles was the dream of Fred Eaton, one of the first native-born anglos in the area. With his dark hair, steely gaze and swirling black mustache, Eaton has an unfortunate resemblance to the character of slave-master Simon Legree in the silent film version of *Uncle Tom's Cabin*.

By all accounts, Eaton crackled with greed and seethed with resentment for the newcomers who had grown rich in "his" town. Eaton was well equipped to indulge both his avarice and his umbrage: He had the compassion of a rattlesnake and the ethics of a grave robber. Recognizing that power and wealth were synonymous, he ran for mayor in 1898 and won.

Mayor Fred Eaton then met with William Mulholland, a Belfast-born Irishman, merchant seaman and autodidact hydraulic engineer. Mulholland was both a visionary and a man of indomitable spirit: stowing away on ships from New York to San Francisco, he *walked* the 47 malarial miles across the Isthmus of Panama to save the train fare.

In parched Los Angeles, power was conducted through water. And, by 1898, Mulholland was the chief engineer for the Board of Water Commissioners, a highly secretive body that answered to no one—not even the City Council.

In that year, Eaton took Mulholland on a 200-mile trip north in a one-horse buckboard, a journey that observers at the time noted could

be traced by the empty whiskey bottles thrown from the conveyance. At the end of the ride, Eaton showed Mulholland the verdant Owens Valley; he convinced Mulholland that, if Los Angeles were to grow, it had to build a 250-mile long aqueduct from the Owens River south, across the Sierra Mountains.

Mulholland recognized that he could actually build the longest aqueduct in the Western hemisphere by gravity. The entire journey is, literally, downhill—almost the same route he and Eaton had taken up to the Owens Valley.

As soon as the pair staggered back to the city, Mulholland began figuring out what needed to be done while Eaton began to figure out the most profitable method—for him—of doing it.

The Owens Valley Water Project may be the best-kept secret in the history of municipal government, especially considering its size and cost. Mulholland informed only a few select members on the Board of Water Commissioners. Mayor Eaton informed a few cronies on the City Council. Nobody had to tell board members of the Chamber of Commerce; their colleague — and City Treasurer — William H. Workman was shepherding the proposal through the City Council. Workman was the Chamber's *eminence rouge* for all things that required City Hall approval.

Eaton left office after one two-year term as mayor and, in 1904, he quietly bought options on Owens Valley land ... before plans for the aqueduct had been made public. At the same time, *Los Angeles Times* publisher and Chamber cofounder Harrison Gray Otis formed a front corporation with Henry Huntington, president of Pacific Electric Railroad, E.H. Harriman, president of the Southern Pacific Railroad and at least one Commissioner of the Water Board. This cabal secretly purchased tens of thousands of dry acres in the San Fernando Valley on the other side of the Santa Monica Mountains from Los Angeles.

At the same time, Otis and Harriman also were conspiring to take over the California Development Company, a private concern whose aqueduct brought water from the Colorado River to the San Gabriel Valley communities east of Los Angeles.

In his script for the movie *Chinatown*, screenwriter Robert Towne played with dates and personalities—but his story of a ruinous water swindle is substantively true. When the aqueduct idea finally was submitted to a public bond issue, Otis' *Times* and the other local papers ceaselessly promoted it on the front and editorial pages. The Chamber of Commerce—which had added to its rolls more land barons such as

Daniel Freeman and I.N. Van Nuys whose San Fernando Valley ranch sprawled for nearly 100 square miles—also stumped for the $23 million bond issue.

Voters—fewer than 75,000—approved the measure and some San Fernando Valley property exploded from $50 an acre to nearly $10,000 overnight. The conspirators turned tens of millions of dollars in profits as their soon-to-be well-watered land became valuable for homes, industry and agriculture.

Fred Eaton did rather well, too. From his initial $15,000 investment, he raked in nearly a half-million dollars selling some of his options to the City, hundreds of thousands more in commissions...and a 23,000-acre ranch in the bargain. He tried to sell the ranch to the City—his former employer—for $1 million; but even in Los Angeles, where nothing succeeds like excess, that was beyond the pale. Eaton's efforts to sell the ranch resulted in a minor scandal; and it is poetic justice that the ranch he couldn't sell sank in value as Los Angeles drained the Owens Valley.

When the Owens Valley aqueduct (later renamed the "California Aqueduct") opened in 1913, it terminated in the San Fernando Valley, making its precious liquid useless to Los Angeles—until the City annexed nearly the entire Valley. That's how L.A. became the only municipality in the world traversed by both a river and a mountain range.

The City Takes What It Needs

Annexation became the mechanism for the city's growth. Los Angeles refused to sell water to other municipalities ... unless they agreed to be become part of the City. So many desirable cities were annexed by Los Angeles that it more than doubled in area to over 450 square miles making it—then, as now—the biggest city in the world and the most under-policed city in America.

As early as 1910, the Chamber was using its muscle to bring the aircraft and auto industries to Los Angeles by prevailing on the City Council and County Board of Supervisors to ignore or eliminate pesky zoning ordinances. The Chamber sponsored the country's first air shows and air races.

By the late 1920s, Los Angeles was the center of the nation's aviation industry and more residents had pilot licenses than in any other

city. It was the Chamber of Commerce that pushed Washington to create what would become the Civil Aeronautics Authority.

During the same time, the Chamber militated successfully against state pension reform, the five-and-a-half-day workweek and a socialist candidate for mayor.

Building on an Image

The political juice of the Chamber of Commerce and its pivotal role in creating modern Los Angeles can be seen from its inception. But the *image* of the city as paradise on Earth—the driving force behind "the migration of responsible citizens" to L.A.—can be attributed mostly to one man, Frank Wiggins.

Wiggins ran a harness shop in Indiana when, in 1890, he astutely perceived that the buggy whip industry was due for a downward correction. That same year, his doctors announced he had a respiratory ailment and wouldn't live for more than a few months.

At age 37, Wiggins sold his business and moved to Los Angeles, intent on living out his remaining days in sunshine. But a curious thing happened: Wiggins regained his health almost immediately—he would live for another 37 years—and he credited the warm, dry weather of Southern California for his salvation. Wiggins joined the Chamber of Commerce and became an imaginative and tireless proselytizer for the City of Angeles.

It would both unfair and inaccurate to dismiss Wiggins simply as a booster or huckster...or even as a promoter. He was a True Believer and, like many converts, he was galvanized to spread the word—and the word he preached was that anyone who moves to Los Angeles will be born again physically, financially and spiritually.

Wiggins' enthusiasm for his new home was so convincing, so pure, that within his first year, he was elected the Chamber of Commerce's superintendent of exhibits.

The official history of the Chamber extols Wiggins for
> his continued efforts in this field [promoting Southern California and its products] which reached *pretentious* [italics in original] proportions, attracting nationwide fame for Los Angeles.

He shrugged off the shackles of good taste and utilized virtuous ostentation as a device to attract stolidly middle Americans. Wiggins' vision of Los Angeles would become Los Angeles.

Wiggins made international headlines at the 1893 Chicago Columbian Exposition when he uncovered his giant nutcase elephant. The two-story beast was constructed of a wire framework coated with nearly a half ton of California walnuts. The howdah—where passengers ride—was made of corn, wheat and barley and the girth strap, which held the howdah in place, was a two-foot wide belt of citrus fruit.

Later, Wiggins constructed a mate for the elephant that traveled the country to fairs and expositions. The edible pachyderm also was a huge draw when it attended the Hamburg Fair and the Guatemala Exposition.

After the Exposition, when the walnut elephant came home to L.A. and became a permanent exhibit at the Chamber's new headquarters, 10,000 people *a month* came to gawk.

Wiggins created a special exhibition train called "California on Wheels" that toured America touting the Southern California lifestyle Among its displays was a specially constructed pyramid of fruits and flowers from the Los Angeles area.

In *Sunset* magazine, E. H. Harriman's Southern Pacific Railroad promised "Oranges for health, California for Wealth"—another Wiggins slogan. (Wiggins was also a prime mover behind the formation of the Sunkist Citrus Fruit Cooperative).

By 1905, the Chamber of Commerce was distributing 55 pamphlets singing the praises of Los Angeles to nearly two million Eastern readers. A special pamphlet was created just for miners who hit pay dirt in the Klondike and might be convinced to move, along with their treasure, to a more temperate clime and society, a society which welcomed and greatly admired the newly rich whatever their scabrous backgrounds.

To pay for the all the promotions, Wiggins squeezed money from hotel owners to promote Southern California as a year-round tourist destination and pressured local newspapers to place colored advertising supplements in Eastern papers during the winter months.

Before his death in 1924—the Year of Wonders—Wiggins witnessed tourism in his adopted city soar to 1.5 million, half again the resident population.

This was no fluke; it was the result of two decades of steady work on the onetime Hoosier harness-maker's part.

Wiggins Storms the Chamber Board

In 1897, Wiggins was elected secretary of the Chamber in addition to his role as superintendent of exhibits; he went from acolyte to cardinal in less than seven years. He made up the slogan, "Los Angeles—Nature's Workshop" which appeared in any number of Chamber publications.

In his pamphlet, *Facts About Industrial Los Angeles: Nature's Workshop*, the word "typical" was employed with startling redundancy to reach Wiggins target audience of middle class Middle Westerners: Working class families live in neat bungalows which are "typical" homes shaded by "typical" orange and palm trees with "typical vegetation" growing in the yards on "typical" quiet streets. The men who live in these homes work in "typical clay products and glass plants" or in "typical textile plants."

Or, in one stunning oxymoron, a photo of "oil and oranges—a typical refinery."

During the plague outbreak, the word "typical" will be used as an apologia for destroying "typically" squalid ethnic neighborhoods.

What was marketed as "typical" Los Angeles was a clarion call to Midwesterners in thrall to the weather and to get away from Wall Street's price fixing and financial panics.

It's important to remember that Los Angeles is not a city because it has a natural, deep water harbor. Nor because it lays at the confluence of rivers or rail lines. Nor because it is a pleasant, verdant place where land is cheap. Los Angeles is a city because the Chamber of Commerce willed it.

The topographical conditions that pre-date the development of other great cities didn't exist in the Queen of the Angles. The old saw is that people move to Los Angeles to reinvent themselves; well, where else should they go but to a city that was invented for them by the Chamber of Commerce?

But Frank Wiggins left out two leavening ingredients as he concocted the confection that is Los Angeles: Humility and shame.

Wiggins arrived in Los Angeles when the city's population was a mere 50,000 and still in free fall. Ten years later, the population more than doubled and, by 1924, Los Angeles had over a million residents. In the decade of the 1920s, two million people moved to California; 1.2 million settled in Los Angeles County and 661,000 of them—a third of the State's total immigrant population—put down roots in

the city itself. And just as Wiggins planned, most of the new residents hailed from the Midwest.

Real estate—building, financing, selling, flipping — became L.A.'s most visible industry and topic of conversation. And it has remained so for four generations.

Triumph of Artifice...and First Signs of Trouble

In 1904, Wiggins presided over the opening of the first—ultimately, of eight — "permanent" headquarters for the Chamber of Commerce. The *Los Angeles Herald* praised the $3 million Greco-French atrocity in terms that could have been written by Wiggins himself— and might well *have* been:

> The cornerstone to the magnificent new building of the Los Angeles Chamber of Commerce is laid and the dream of the founders of this splendid organization has at last been realized. Under the blue dome of a cloudless sky and before an assemblage composed of loyal, patriotic people ...

Perhaps coincidentally, the new building at 130 S. Broadway also housed the business offices of the *Herald* and, later, the *Tribune*.

In his 1921 Annual Report to the Chamber, Secretary Wiggins wrote that Los Angeles County led all the nation's counties in the sale of its agricultural products, nearly 25 percent higher than number two. Wiggins and the Chamber became instrumental in pressuring Congress to enact national quarantine laws to prevent suspect fruits and plants from crossing state lines.

Like much of the Chamber's work, it affected all of California and resonated throughout the entire country.

Illness was inimical to Wiggins' world—where sunshine and health were synonymous. It was unpatriotic. Still, outbreaks of diphtheria, smallpox, typhoid fever, typhus and cholera were common in Los Angeles through the early 1900s. Those are communicable diseases that have their origins in poor hygiene and contaminated drinking water, so the poorest districts were hit especially hard—particularly those districts that bordered on...or drew water from...the putrid Los Angeles River.

But spending public money on public health was not something the Chamber of Commerce endorsed; so it wasn't a priority for the City Council or the County Board of Supervisors, either.

A Slight Epidemic

In its official history, the Chamber celebrates itself for its vital role in eradicating an outbreak of hoof-and-mouth disease in cattle during the Year of Wonders. There is no mention of the *other* epidemic that year which killed dozens of people and in which the Chamber also was a major player.

The city did hire a full-time rat catcher in 1922; but, in a measure Wiggins-like euphemism, the position was called "director of pest control."

Charles K. Stewart spent his first two years on the job at 116 Temple Street catching rats in the City Health Building. "The rats became so clever about our traps that they avoided our usual poison baits," he would later say:

> They even ate up food samples that our inspectors had (seized) for court cases. ...One morning, we discovered the rats had eaten the flower bouquet on a secretary's desk. That told us we were dealing with real dilettantes. So we baited our traps with carnation buds. Got the biggest haul of all time.

As late as 1922, the County Health Officer was the only full-time health worker in his office. He did have a nurse to assist him, but she was only part-time. His office equipment consisted of a single typewriter and, during the epidemic of Black Death, his vital communications—such as the No Shooting order to the quarantine guards—had to be written in long hand and passed around to his subordinates.

In 1924, the State Health Officer admonished the City Council and the Chamber's board of directors about the consequences of substandard housing:

> You have had ... practically about 90 percent of the smallpox [cases] in the state. You also have had numerous cases of typhoid fever. We expect typhus to break out among the Mexican people and in going over the area it's easy to see why you have it and why you're going to continue to have it unless these people are properly housed.

But the board of directors remained ominously silent on the subject of urban renewal—or its corollary of enforcing existing building codes. When the City Council finally took action, wasn't to create adequate housing, it was to destroy it.

7 Cover-Up

An ironclad rule was established that no matter concerning Los Angeles would be published by the local press unless it was officially endorsed by the board of directors of the Chamber of Commerce.

—William Boardman Knox, *The Nation*, December 9, 1925

We will print nothing we don't think is in the best interest of the city.

—George Young, Managing Editor, Los Angeles Examiner, to the Los Angeles Chamber of Commerce board of directors, November 3, 1924

Saturday, November 1st, *Dia de los Muertos*

The Macy Street outbreak makes the front page—of the second section—of the *Los Angeles Times*. The headline reads "Nine Mourners At Wake Dead/Funeral Guests Stricken by Strange Malady." The story includes no mention of Jesus Lajun and his daughter, who died before the funeral of Lucina Samarano.

A Slight Epidemic

Although it's been officially established for nearly two days that pneumonic plague is the cause of Lucina Samarano's death, the first paragraph of the story reads

> ...recently, city, county and government health authorities launched an investigation to determine the nature of the strange malady that carried off Mrs. Lucina, her husband and mourners at her funeral, all Mexicans.

On the jump page, the paper states, "The patients were removed to General Hospital under the technical diagnosis of Spanish influenza." Even the recent and deadliest epidemic in U.S. history plays better than Black Plague.

Around 8 a.m., L.A. County Health Officer J. L. Pomeroy telegraphs his plague report to the State Board of Health. Then he begins the absolute quarantine of the entire Macy Street district and the Hispanic section of the Belvedere district.

He closes movie houses, theaters, dance halls and schools. No one is allowed to leave the quarantine zone and no one is allowed in except for Health Department employees and, once inside, they can't leave either. They'll work and sleep in a Baptist church for 13 straight days. Those people who were working or visiting in the district and didn't leave before the quarantine slammed shut also are locked in.

The Baptist church also is where tens of thousands of trapped rats are being tested for Plague.

Pomeroy will later write in his annual report:

> Owing to the extreme virulence of the disease and fearing a general stampede of the Mexican population, I decided on military quarantine and ... I instructed [Chief Quarantine Officer Carl] Williams to make every effort to secure sufficient number of guards.

Williams' effort is expedience itself: He hires 200 unemployed veterans of the Great War and provides them with shotguns from the police arsenal. Ultimately, 400 armed men will patrol the expanding perimeters—and each will earn five dollars a day.

The average daily wage of a skilled male living in Macy Street is $4.31 a day. For women, it's under two bucks.

As the quarantine lines go up, some infected people are still out and about in the city. Around noon, Frank Perinlo—an Italian immi-

grant and recent arrival to Macy Street—is admitted to Los Angeles County General Hospital. The diagnosis is pneumonic plague.

That afternoon, Father Medardo Brualla goes to his Reverend Father Superior and says, "Father, I'm going to bed. I think I'm seriously ill. I think I've caught the disease of the people whose confessions I heard."

A doctor is summoned immediately but, by the time he arrives, Father Brualla is struggling for breath and coughing up blood. He asks for the Sacraments gasping, "I want to live well and I want to die well." Like many of the educated professionals who witnessed the early stages of the outbreak, Fr. Brualla hesitated to voice his concerns about what he was seeing. Now he is paying the ultimate price for his hesitation.

A few hours later, seven-year-old Gilberto Samarano, son of the late Lucina and Guadalupe Samarano, dies in General Hospital. He is the second of their boys to succumb to the Black Death.

Dr. Elmer Anderson, a city Health Department physician, has been treating the Samarano boys and when four-year-old Raul fails to respond to the Mercurochrome drip Anderson asks for—and receives—permission from Superintendent N.N. Wood to order the Yersin serum from Philadelphia.

That evening, 18-year-old Maria Samarano, a cousin of Guadalupe, dies in General Hospital. So does Guadalupe's 25-year-old brother Victor and his 58-year-old sister, Josepha Christianson. And his 51-year-old uncle, Efren Herrera.

By the end of this Saturday, two of the borders at the Samarano home also die: 26-year-old Fred Ortega and 30-year-old Joe Bagnola.

26-year-old Juana Moreno, a friend of the Samaranos from around the corner, dies. Two people who live in her building at 1716 Marengo Street are seriously ill: Her roommate, 24-year-old nurse Refugio Ruiz and Remedios Enriquez whom Ruiz had nursed.

Emmet McLaughlin, the 43-year-old ambulance owner who rushed Guadalupe Samarano to General Hospital, also dies Saturday. So does Thomas Vera who helped carry his friend Lupe in and out of the ambulance.

November 1st is the religious feast day that most Hispanic cultures celebrate as *Dia de los Muertos*—the Day of the Dead, which corresponds with what Anglo cultures call All Saints Day. In 1924 Los Angeles, the feast couldn't have come on a more appropriate day.

A Slight Epidemic

The Black Death claims ten lives on this November 1st—and none of the victims had been ill more than four days. It's obvious that the bubonic plague—which is spread by infected fleas—has become the far deadlier pneumonic plague, which is the most contagious disease on Earth.

Pneumonic plague is nearly 100 percent fatal. And seven new cases are reported today. Still, Dr. Anderson is the only medical authority to order the Yersin serum—and he's only ordered a few doses; not nearly sufficient even to begin inoculating those trapped in plague houses.

It's unlikely that anybody has noticed the irony of this day on which more people will die of plague than on any other.

The Day of the Dead.

Sunday, Novermber 2nd, Midnight

Dr. Pomeroy writes:
> We waited until midnight so as to give them [the residents] all a chance to get in, then we placed the guards and the quarantine was absolute.

Residents are not allowed to leave any dwelling where someone who had the plague was known to live. This is the same extreme measure taken in London in 1665. It does prevent the plague from spreading but it also condemns to death just about anyone living in that home who hasn't been infected yet

The day ends on what Pomeroy will say is "the last exposure to Plague."

He's wrong.

Acting City Health Officer Dr. Elmer Pasco is quoted in that morning's edition of the *San Francisco Chronicle* saying that the outbreak was "confined to the Mexican quarter in the northeasterly section of the city."

While the newspapers in Los Angeles were careful not to write in plain terms about the outbreak, the papers in San Francisco—which had survived its own outbreak of plague 20 years earlier—are more candid about what's going on 400 miles to the south. And the eastern U.S. newspapers use none of the elliptical language that the Los Angeles papers employ to mask the nature of the disease.

The *New York Times* and *Washington Post* quote Dr. Pasco as saying, "There is little doubt that the illness which caused the sudden deaths of these people is pneumonic Plague."

For his candor, Dr. Pasco will lose the political rat fight to become permanent City Health Officer.

The *New York Times* runs its L.A. plague story in the first section under the headline, "Pneumonic Plague Seen in 14 Deaths. Autopsy Surgeon Reports No Bubonic Symptoms."

In the last paragraph, the *Times* states, "All Los Angeles is awaiting definite announcement following this diagnosis." But only a limited number of people in Los Angeles even know there is an epidemic.

The *New York Times* also reports—but cannot confirm—that 12 new cases have been hospitalized. The Newspaper of Record can't confirm the number because, with the exception of Dr. Pascoe, nobody is talking—nobody at County General Hospital, nobody at County Health, nobody at County Quarantine.

And one telling detail: The *New York Times* article mentions that a two-week-old baby is dead from the plague. No such infant ever makes it into any official L.A. body count.

Back in L.A., the *Los Angeles Times* buries the story on page four under a small headline, "Fourteen In Funeral Party Dead/Four Other Persons Who Attend Rites Expected to Die of Pneumonia."

The lead to the story is

> The fatality list of victims among a group of Mexicans
> who attended the funeral of Mrs. Lucina Samarano
> increased yesterday from nine to fourteen.

The story goes on to say, "Acting City Health Officer Pascoe described the disease as a severe form of pneumonia" which, technically, is correct—but omits Pascoe's actual description of the disease as pneumonic plague.

Either Dr. Pascoe is giving one story to Eastern papers and another to the local press—which seems unlikely—or the *Los Angeles Times* is deliberately misquoting him.

There is no mention in any local paper about the death of non-Mexican ambulance driver Emmet McLaughlin. He doesn't even rate an obituary, a casualty of the war to suppress news of the outbreak.

At around 9 a.m. that Sunday, Medardo Brualla dies of pneumonic plague. Fr. Brualla had seen and done many things in his 49 years. His Father Superior writes:

> He breathed not a single complaint in his sufferings which must have been acute, judging by his labored breathing and the blood he vomited a number of times ... The nurse whom the doctor had sent assured us that he had never been at the bedside of anyone as patient as Father Brualla.

The coroner wants to cremate the dead priest as a health measure; but Brualla's Order arranges to inter him at its cemetery in the barren and wind-swept San Gabriel Valley, 20 miles east of his parish. It's an eerie funeral for the selfless Spaniard: Four men sent by the Department of Health bury Fr. Brualla in a sealed coffin during the dark of night. The only source of illumination comes from the full moon. There is no sacred music and the only sounds are the desert wind and muted voice of a priest reciting the liturgy.

It's the sort of shadowy, Gothic ceremony usually associated with killing vampires.

The Deaths Continue

Urlana Hurtado, 23, a friend of the Samarano clan who attended Lucina's funeral, dies after a four-day illness.

Mike Jimenez, who fled the boarding house with his brother before the quarantine, dies a few blocks away from 742 Clara Street. His body is nearly completely black because his lungs shut down, depriving the blood of oxygen. His brother Jose also is dying and his body is getting darker by the hour.

County Health Officer J.L. Pomeroy writes with satisfaction that, by 8 p.m. Sunday evening, "a sufficient number of guards had been secured to place the quarantine on a military basis and the organization was complete."

He credits County Quarantine Chief Carl Williams with establishing the quarantine

> in record-breaking time. He succeeded in organizing on a military basis a group of "pick-ups" in a manner which demonstrated unusual administrative ability on his part.

There are over 200 men enforcing the quarantine now—and soon that number will double.

Carl Williams' first order to his troops—handwritten because there is only one typewriter in the County Health office—is two words: "No shooting."

The order will be ignored practically from the moment it's issued. Out of boredom, the former soldiers will bang away at almost anything; soon cats and dogs, chickens, two donkeys and a goat will join the mounting death toll.

Around 9 p.m., there is a minor disturbance at the Macy Street guard station. Nora Sterry, principal of the local grammar school, tries to enter the quarantine zone.

"You can't keep me out" she protests to the guards, "Those are my children in there!"

As the guards politely but firmly lead her away, she turns to several newspapermen still on duty and yells, "If you see the American flag flying over the school yard you'll know I made it!"

Monday, November 3rd

The banner headline on the front page of the *Los Angeles Examiner* reads, "Wall Street Bets Millions on Coolidge." The plague story is carried on page 6, jammed into what's called a "well"—a center column, which few people read. It's wedged between an ad for Ralph's Grocery Store set in bold face and bigger type and a story—also set in bold—headlined "Czar Declared Alive in Russia".

It will not be a good day for accuracy in media.

The *Examiner's* wan headline reads, "Six More Die from Malady." The sub head is spun with dizzying velocity: "Officials Believe Virulent Pneumonia Outbreak Controlled."

The second sentence of the story mentions, "With one exception, all those who succumbed to the malady were Mexicans." The next sentence claims, "The total dead over a period of slightly more than two weeks was officially placed at 21 last night."

The medical Establishment still refuses to acknowledge the misdiagnoses of Jesus and Francisca Lajun. Also, the total body count now is 24 but one person may have died too late to make the early edition. On the other hand, deliberately undercounting the dead is a time-honored civic strategy.

The *Examiner* story goes on to say, "All the deaths occurred at General Hospital except for Father Brualla and ambulance owner-driver,

Emmet McLauthin." To distance him from the "Mexican pneumonia," the story adds that "McLauthin caught the disease while transporting a Mexican patient to the hospital."

The *Examiner* article concludes soothingly,

> Dr. Ebright, president of the State Board of Health, last night sent the following message from his San Francisco headquarters:

> The outbreak of virulent pneumonia calls for no hysteria on the part of the people of Los Angeles. It is serious, but the State Board has every hope of confining it to its present area.

The *Los Angeles Times* bulldog edition again relegates the story to the second section, next to a cartoon feature titled "As Artist Bob Day Views Industry."

The *Times* headline reads, "Seven are Dead From Pneumonia" which refers only to the number of people who died in the previous 24 hours. Nowhere in the story—which is three paragraphs long—is the total number of dead mentioned.

But the story is, once more, first section news in the *New York Times* which headlines, "Pneumonic Plague Takes 7 More Victims—Deaths at 21." The *New York Times* notes that the quarantine "around the affected portions of the Mexican section" is absolute, "save for employees of industrial concerns who will be permitted to pass out on permits and under observation."

That will hold true for five more days—when most Hispanic employees of hotels and restaurants will be summarily fired.

The L.A. plague story is the topic of the State Board of Health's weekly radio show 400 miles north in Oakland. The host refers to pneumonic plague as "the celebrated Black Death of the 14th Century in which one-quarter of the European population was destroyed."

The program discusses bubonic, septicemic and pneumonic plagues, the roles of the rat and flea and the steps Los Angeles is taking to contain the outbreak.

Only in Los Angeles is there a Black Plague blackout. The local media are doing as the Chamber of Commerce wishes.

Around 9 a.m., quarantine guards waiting for their graveyard shift to end cheer lustily and salute as the American flag is raised over Macy Street School. Little do they realize that the flag is a signal of their lax patrols.

Nora Sterry has slipped under the ropes and past the guns. She is beginning what will be two weeks of 19 hour days—five a.m. to midnight—of offering aid and support to Macy Street residents.

Her first task is to feed the people who had insufficient food supplies in their homes when the quarantine cut off the district. The school is better prepared for this contingency than the city. As Nora had said:

> There are many times when it is convenient and even
> necessary to have a supply of groceries on hand for
> distribution.

This was one of those times. The school store is stocked with canned goods, rice and beans. The hallway cafeteria will feed the nonresidents who were visiting in the district and can't go home and they'll sleep in the school nursery where there are blankets and mats for them.

Nora phones her teachers—in a hopeful sign, the phones still work—asking for volunteers to run the guarded perimeter and come help manage the school and store.

She walks the Macy Street district, asking students and parents to gather at the school to help cook and clean. She also conducts plague awareness and preventative health classes for those who haven't been locked into their own homes.

Naturally, any public gatherings would violate quarantine regulations—but no one of greater authority than the progressive-thinking grammar school principal is willing to enter the district to enforce those rules.

The First Casualty of War...and Epidemics

A few blocks away, the wheels of the mendacious L.A. establishment are turning. There is an emergency meeting in Mayor George Cryer's office. Federal, state, county and city health agencies are represented—along with a bacteriologist from U.C. Berkeley.

Also present, several directors from the Chamber of Commerce and executives from Los Angeles' two biggest dailies: Harry Chandler of the *Los Angeles Times* and George Young, managing editor of the *Examiner*. Young assures everyone that no paper in the Hearst empire would print anything "we didn't think was in the interest of the city." Chandler makes a similar pledge—and all the city's papers, except the Spanish language ones, will fall into line.

A Slight Epidemic

New Acting City Health Officer George Parrish, a loyal solder in the war against truth, reports. He's already replaced the outspoken Elmer Pascoe and, in the case of every Hispanic plague death, Parrish writes "Mexican" under "Nationality"—even if the decedent is an American citizen. He also lists each plague victim by his or her address—which directs attention to Macy Street and Belvedere Gardens and the uniquely "Mexican" nature of this outbreak.

Parrish apparently believes that doing so will minimize what he dismisses as

> the grossly exaggerated reports published in the Eastern newspapers, with the evident intention of stopping the ceaseless migration of tourists to this wonderful city.

He soon will be named the permanent City Health Officer.

Anyone in public health will say that education and public awareness are the keys to preventing the spread of any communicable disease. But in 1924 Los Angeles, public health is subordinate to private enterprise—and a conspiracy of silence will be effected with the active complicity of city, county and state health officers.

Instead of facts, health professionals like George Parrish will offer nostrums to terrified people whose friends and relatives are dying swift and terrible deaths. People are instructed to clean their homes. Nurses are instructed to tell parents within the quarantine zone that their children should gargle with a mixture of lime juice, salt and hot water—"as hot as they can stand it."

Those ingredients might have a salubrious effect on a sore throat but they're useless in fighting off pneumonic plague.

At the same time, Nora Sterry is telling people to disinfect their homes; and she opens the school shower room to anyone who wants to use it. She makes available the school's supply of strong disinfectants—which she keeps on hand to handle outbreaks of head lice.

Sterry's common-sense steps do much more to contain the outbreak as anything suggested by any government expert or implemented by any city or county agency.

It's decided at the mayor's emergency meeting that providing food, milk and other necessities to the thousands inside the quarantine areas will be left to the Los Angeles Board of Charities and Catholic Charities. A Spanish-speaking priest and social worker are dispatched to Hispanic districts to "reassure and calm anxious residents." But even

the *Los Angeles Times* will acknowledge later that it's Nora Sterry's presence that

> instilled new hope into the hearts of those of Little
> Mexico. She went among them and she comforted
> them ... Hysteria vanished, fear was banished and the
> sun shone once again on the humble homes of Little
> Mexico.

The *Times* coverage is crafty: It acknowledges Nora's heroism and effectiveness—but separates that from her criticism (both stated and implied) of the city's bumbling efforts.

Mayor Cryer agrees to dispatch six Public Health doctors and nurses to Macy Street to make house-to-house inspections looking for other cases of plague or contacts with victims. They won't actually go *into* the houses; they'll stand on the sidewalk and yell to what are called "inmates" in the language of the day.

Even the half-dozen health workers are inmates, confined to the Baptist Church on the border of the quarantine zone until the isolation is lifted. Head rat catcher Charles Stewart is there, too. For three weeks he will sleep on a table in a storeroom while directing an army of 200 men assigned to "rat-proofing" buildings in the quarantine zone.

At the November 3rd meeting, Dr. Walter M. Dickie formally takes control over all medical and preventative work throughout Los Angeles County. His work is to be coordinated with County Health Officer Dr. J.L. Pomeroy, another veteran of the San Francisco plague outbreak, and Dr. Elmer Pascoe, the former Acting City Health Officer whom Dickie has hand picked for his team.

Senior Surgeon James Perry, the U.S. Surgeon General's representative, is to be informed of all developments.

Nervous about the Port

Perry's presence in the mayor's office creates consternation among the Chamber of Commerce board members. The federal government has jurisdiction in just one place—the Port of Los Angeles, the Chamber's most profitable contribution to the city.

If Dr. Perry even suspects Black Plague near the harbor, the Feds will be obliged to impose a quarantine in accordance with international maritime law.

A Slight Epidemic

Arriving ships and their crews will be thoroughly inspected and fumigated—creating a nightmare bottleneck—and all departing vessels will have to fly the yellow quarantine flag, which will make them unwelcome in ports throughout the world.

The West Coast's busiest seaport effectively will be closed.

The health officers draw up a plan of attack to prevent *that* eventuality: Most of the initial inspection funds will be spent in and around the Port. Additionally, the quarantine-within-the-quarantine will continue; all "Mexican" dead—regardless of where they're from in the city—will be autopsied before being released for burial; all homes in the quarantine zones will be disinfected with petroleum spray or carbon monoxide; a force of men will be hired to trap and poison rats and to rat-proof buildings and

> the trapping of rats, mice and ground squirrels will begin immediately in order to establish the boundaries of the epidemic.

The boundaries include Macy Street and Belvedere Gardens Districts but also the Marengo Street, Pomeroy Street and South Hill Street districts—anywhere there are "Mexican homes" if not actual plague.

To the oligarchy in Los Angeles, the two are indistinguishable.

It is also decided to quarantine Japanese, Chinese and African-American districts—even though there is no evidence the epidemic has spread to those communities.

Targeted areas are gerrymandered according to their ethnic composition. According to the City's official account, *Los Angeles Pneumonic Plague Outbreak*:

> The Macy Street district ... included eight city blocks [actually, seven blocks] and housed 2,500 Mexicans ... The South Street District consisted of one large apartment house, occupied by Mexicans ... The Marengo Street District with several isolated Mexican homes ... the Pomeroy District with a few Mexican homes [and] The Belvedere Gardens District in Los Angeles County, with several blocks housing 500 Mexicans.

The Chamber of Commerce men eye Dr. Perry nervously, hoping that their plan will be enough to convince him to leave the Port of Los Angeles alone.

It is.

After the emergency session, Perry cables his boss in Washington, Acting Surgeon General M.J. White, with a summary—suggesting that the U.S. Public Health Service will act only in an advisory capacity to local authorities.

That is not what White wants. Writing in 1973, Arthur Viseltear of Yale University's Department of Epidemiology and Public Health, claimed that White wanted a greater and more publicized role in handling the epidemic. After the banner headlines of the L.A. plague appeared in newspapers nationwide, White found himself under pressure from the Secretary of Treasury, Congressional representatives and various health officials from several states demanding to know exactly what was going on in Los Angeles.

And the worst thing a bureaucrat—especially an Acting senior bureaucrat—can say is, "I don't know."

White responds to Perry, accusing his man in Los Angeles of not keeping him sufficiently informed so that Feds may take appropriate action.

Perry writes White a defensive response, claiming that there is some doubt among Los Angeles civic leaders that pneumonic plague even *exists* in the Macy Street district.

The gloves are off. Prof. Viseltear says that, from that time on, a sort of gangster mentality will persist in the struggle over turf. Perry, the senior federal health official in L.A., versus Dickie, the senior California officer; Washington versus Los Angeles; and state government versus federal—with nearly every player trying to snatch as much authority as he can while still covering his ass with both hands.

Viseltear quotes Perry as counseling White *against* action in L.A., in classic bureaucratic fashion:

> If the campaign [against the plague outbreak] succeeds, the State Board of Health will get the credit. If it fails, the National Health Service will get the blame.

As that Monday passes, the death toll inside the quarantine zone mounts. Guadalupe Valenzuela, a 52-year-old woman from Mariana Street in Belvedere Gardens, dies of pneumonic plague. Her son and daughter predeceased her.

And 27-year-old Peter Hernandez, a factory worker and frequent visitor to the Samarano's house, also dies of pneumonic plague.

Finally, Monday evening, an unknown staff member at L.A. County General Hospital orders the plague serum from a pharmaceutical company in Philadelphia—500 doses, according to one report.

But there are no stated plans to inoculate anyone *inside* the quarantine districts.

Frank Perinlo, the Italian laborer, dies of pneumonic plague. He had lived in Macy Street just 36 hours before falling sick.

Tuesday, November 4th (Election Day)

The bulldog edition of the *Los Angeles Examiner* page one headlines are, "Record Vote Forecast," "Millionaire Home Raided, 8 Jailed" and "D.W. Griffith Returning Here."

Besides election and crime news, the first section carries several gushing reviews of a new film, *Janice Meredith*. The movie stars W.C. Fields, Fatty Arbuckle and Marion Davies—mistress of the *Examiner*'s owner, William Randolph Hearst.

There is no mention of the epidemic in Macy Street.

The *Los Angeles Times* does cover the plague story, on the first page of the second section under the headline, "State to Fight Disease." The subhead reads, "War on Pneumonia Organized Here With Indications That Outbreak is Under Control."

In the body of the story, the *Times* places the body count at 25, four under the actual number. The first paragraph notes Mayor Cryer's meeting with health officials and lists most of the men who attended the emergency session—it omits mentioning the select members of the Chamber of Commerce.

L.A.'s shadow government prefers to lurk in the shadows.

In an astonishing non-sequitur, the *Times* reports:

> Three additional deaths were recorded yesterday [Monday], the first to occur since 11:30 a.m. Sunday and according to medical officials, an encouraging indication that the disease is under control.

Only in the dream world that the *Los Angeles Times* seeks to create are the deaths of three people in 24 hours from a reportedly undiagnosed malady seen as "encouraging."

The article also says that all three dead are "Mexicans"—including Italian Frank Perinlo. The reporter misspells his name, too.

In fact, Perinlo is the first person who can't be linked directly to the house at 742 Clara Street; and his death substantiates an assertion by history professor William Deverell that the actual number of plague deaths and their foci will never be known.

There is one daily paper in town not subservient to the Chamber of Commerce; it is the Spanish-language *El Heraldo De Mexico*. "They knew it was plague," says Deverell, and they carry the story on the front page in bold face type:

EPIDEMA EN LAS CALLE MACY/14 PERSONAS
MUERTAS DE PNEUMONIA.

The body of the story details the quarantine and the fact that "all 14 dead" attended the funeral of Lucina Samarano. The factual errors are unavoidable; spokesmen for the various health agencies stand by their deliberately inaccurate statements.

That afternoon, nurses begin canvassing the quarantine zones to determine whether there are new cases. They report to their findings to County General Hospital's Dr. Grant—the same physician who reported that Jesus Lajun's death from bubonic plague was caused by "bronco-pneumonia."

8 The Plague Is Always With Us

...and the hand of the Lord was against the city with a very great destruction: and

He smote the men of the city, both great and small, and they had emerods on their private parts.

—I Samuel 5:9

In the recorded history of humankind, no disease has inflicted more chaos, killed more people or aroused more paralyzing terror than the Black Plague. The First Book of Samuel—written about 1320 BC —relates the terrible pestilence visited upon the Philistines for swiping Israel's Ark of the Covenant at the battle of Aphek. The Old Testament even states that the Philistines saw a connection between the swarms of vermin that consumed their grain and the fiendishly painful swellings on the groin that they called *emerods*:

What shall be the trespass offering which we shall return to Him? They answered five golden mice and five golden emerods according to the number of lords of the Philistines.

Some biblical scholars believe that two of the 10 plagues Moses called down on the House of Egypt refer to bubonic or pneumonic plague. According to the Book of Exodus, Moses

> took ashes of the furnace and stood before Pharaoh;
> and Moses sprinkled it up toward heaven and it be-
> came a boil breaking forth with blains upon men....

And the death of the firstborn son in every house may refer to plague's especially deadly effect on the young, whose immune symptoms haven't developed fully. (It also targets the elderly because *they* have weakened immune systems).

Skipping ahead to the New Testament's Book of Revelation, Death rides his pale horse—spreading pestilence across the world.

What the ancients called *emerods* in Aramaic, the Hellenic-era Greeks called *buboes*—meaning, roughly, "swelling around the groin." Greek historians first recorded the symptoms of bubonic plague in 753 BC.

The Romans called the disease *pestis*, which is simply the Latin word for *plague*; and the modern world has inherited the word *pestilence* from this origin.

Hippocrates wrote about bubonic plague 500 years before Christ and claimed "Comets, auroras and particularly eclipses of the sun and moon were the cause and precursors of future pestilences."

The reaction of the city fathers in 1924 Los Angeles didn't seem much advanced from that cosmic diagnosis.

Factual Background on Bubonic Plague

Technically, the term *plague* refers to any highly lethal and highly contagious disease. But just as *vermin*—which means any objectionable animal—has become synonymous with rats and fleas so, too, has *plague* become identified with a disease of rats that is transmitted by fleas.

Black Plague originated in central Asia, the same place where black rats originated. Though the greatest killer of humans, plague is a disease of rodents. Fleas are the vectors, or the carriers, of bubonic plague.

In the beginning, the flea called *Xenopsylla cheopis* sucked blood from an infected rat, the *Ratus tattus* or black rat of the western Asian Steppes. The flea ingested the bacterium originally called *bacillus pestis*—but for the past century known as *bacillus yersinia*—and Black Plague went mobile.

When the host is dead or dying, the flea jumps to he next warm-blooded meal.

There are three types of Black Death that can affect humans:

1) **Bubonic plague** results from the bite of an infected flea. The Plague bacillus travels to the lymph node nearest to the bite where it reproduces like crazy. At the same time, the lymph node increases in size as the body attempts to fight the infection. The swelling grows from walnut sized to the size of a goose egg and is red, hot, extremely tender and hideously painful; that is the bubo.

 "If you get bit on the leg, you'll usually get the bubo on the big mass of lymph nodes in the groin. If you get bit on the arm, it'll be under the arm pit, if you get bit on the face, you'll get the bubo on your neck," says Dr. Shirley Fanin, former Los Angeles County Health Commissioner.

 Incubation is seven to 10 days, depending on the health of the infected individual. (In the case of the work-hardened Jesus Lejun, the first victim in Los Angeles, it took more than two weeks).

 Before the bubo is big enough to be noticed, flu-like symptoms appear including vomiting and blazing fevers which spike from normal to 105 degrees in just a few hours. Other symptoms include crippling headaches, intolerance to light, delirium and a rapid, irregular pulse.

 As the lymph system is disrupted, it causes blood clotting in the extremities nearest the flea bite which turns the limbs black hence the name Black Death or Black Plague. Finally, the organs fail.

 Modern antibiotics reduce mortality rates to 15 percent. Left untreated, however, bubonic plague is fatal in half the cases. The good news is that bubonic plague, as long as it stays in the bubo or the lymph nodes, isn't transmissible.

 If the flea deposits the bacillus directly into the blood stream or, if the pustule is not excised and drained, it can burst under the skin and get into the blood vessels, becoming a far more lethal form of plague, septicemic.

2) **Septicemic plague** also is contracted through a fleabite and, though rare, it causes blood poisoning that nearly always is fatal. Septicemic plague causes a condition called, *ecchymossis*; blood erupts out of the capillaries into the skin causing the tissue to die and turn black. This is another symptom giving rise to the appellation *Black*.

Septicemic symptoms occur two to six days after infection. Its symptoms are similar to bubonic plague and include circulatory collapse and hemorrhage.

If, as often happens, either bubonic or septicemic plague invades the lungs, it will cause the deadliest of all plagues— indeed, the deadliest of all diseases.

3) **Pneumonic plague** occurs when the disease invades the respiratory system, making it the only form of plague that's directly communicable from one human to another.

The severe coughing endemic to any form of pneumonia can spread the bacterium. It can be transmitted by breathing, sneezing, touching infected blood or tissue and, according to the World Health Organization, even by touching clothing or bedding recently used by someone with pneumonic plague.

Pick up a tissue or handkerchief into which someone with pneumonic plague coughed or sneezed and the bacteria can become aerosolized, malevolent little droplets with a lifespan of up to a half-hour.

Incubation is the quickest of all three plagues. Death usually comes within one to four days and, even with modern antibiotics, pneumonic plague is nearly 100 percent fatal. As the lungs fill with fluid, the body becomes starved for oxygen and the skin darkens. That's another source of the name *Black Death*.

Plague can erupt suddenly wherever there are fleas. And fleas can feed on anything in the Order Rodentia (from the Latin "to gnaw") which comprises 34 families such as tree rats, wood rats, black rats, Norwegian rats, roof rats and every type of mouse—a total of 354 genera and 1,685 species, more species than all other mammals combined. And all of them quickly reproduce more flea food: A single pair of rats can breed a community of 2,000 in a year

But rats and mice aren't the *only* means of transmission. Pet cats, ground squirrels, flying squirrels, prairie dogs, chipmunks — all can be infected with plague and can spread it to others through their fleas.

Historical Outbreaks

The Justinian Plague in the 6th Century AD is the first historically documented plague pandemic. (A pandemic is a disease occurring in

epidemic form throughout an entire country or countries.) So, the Roman Emperor Justinian's very success in spreading his Byzantine empire was implicit in its demise.

Plague-bearing mice from Egypt (plague already was rampant throughout the Middle East) brought the disease from port to port and, ultimately, in 542 to Justinian's capital, Constantinople—where it killed 70,000 people in one year.

From Constantinople (now called Istanbul), the plague booked passage to Europe aboard trading vessels and warships. In the next 50 years, the Justinian Plague killed an estimated 100 million people in Asia, Africa and Europe—where it claimed 20 percent of the population, mostly during the first four years of the pandemic.

The Justinian Plague almost brought world trade to a halt and was prelude to the Dark Ages. It would be some 220 years before the outbreak burned itself out completely.

This bears noting: Plague outbreaks among human populations tend to last a long time. Hundreds of years, in some cases.

The second major pandemic originated in China around 1332. The Mongols carried the plague to the Crimea in 1341—where they used Black Plague in the first attempt at biological warfare. When Mongol soldiers began dying of plague while besieging a city, their leader had the corpses of his soldiers catapulted over the city walls.

It's highly unlikely the tactic worked; but what the Mongols *did* accomplish was to spread the Black Death to Genoan traders in the area. The traders fled by ship back to Italy in 1347, arriving with a manifest of furs, silks and plague-bearing rats.

In the next 15 years, according to the physician Galen, plague wiped out a third of Italy's population.

This is the pandemic that periodically ravaged Europe for the next four centuries. It was also the outbreak that confirmed the names "Black Death" and "Black Plague."

According to the World Health Organization, that outbreak claimed an estimated 50 million lives worldwide, half in Asia and Africa and the other 25 million in Europe—between a quarter and a third of the total population—mostly during its first two decades.

To better comprehend the enormity of that statistic, a comparable calamity in the United States today would have to kill between 75 and 100 *million* people.

In Paris, one in three perished. There were so many unburied corpses in Marseilles that streets became impassable for commerce.

A Slight Epidemic

During the "Babylonian Captivity"—when the Catholic Church was headquartered in Avignon from 1309-1377—so many bodies went unburied that Pope Clement VI consecrated the Rhone River and turned it into a 400 mile-long cemetery.

In Moscow, 127,000 died; in Venice and Naples, the figure was 300,000 each; and, in Florence, it was 100,000 dead out of a population of 130,000. In Vienna, 123,000 out of 210,000 inhabitants died and, for all of Germany, nearly a million-and-a-half perished.

And that was *still* far fewer than the casualties in France, England, Russia, and Spain. The death toll in Iceland was 60 percent; Greenland and Cyprus were said to have been nearly depopulated.

Most doctors at the time also were clerics; for many, their first duty as physicians was to make certain the patient had been baptized and then to administer last rites.

Moreover, the Vatican had insisted for centuries that prayer and holy relics were God's own medicines; anything else was the work of the Devil. The Church also taught that suffering itself led to salvation. So Christian physicians—clerical and secular—demonstrated a breathtaking ignorance of useful medical knowledge that had been around since the ancient Greeks and even before: Egyptian wall paintings depict their doctors performing brain surgery and using catheters to relieve prostate problems.

What pre-Renaissance doctors advocated as protection against plague included bathing in human urine (*drinking* it also was highly recommended), wearing excrement (endorsed by no less an authority than Paracelsus), placing dead animals in victims' homes and drinking all sorts of potions made of everything from gold and ground emeralds to strong wine flavored with pus from a bubo.

Carrying a pouch of potpourri was a popular totem for warding off the disease that—it was generally believed—traveled on a foul-smelling wind, the "miasma." Indeed, the air usually did reek of rotting corpses, uncollected garbage and bonfires of bodies.

Doctors admonished married couples to be abstinent during contagions because of the danger from infection caused by a postcoital diminution of strength. *In peste Venus pestem provocat*, ran the proverb: "In times of Plague the sport of Venus invites it."

The buboes which weren't lanced grew so hard and painful that, throughout Catholic Europe, thousands drowned by throwing themselves into lakes and rivers to seek relief from their boiling fevers. Thousands more committed suicide by jumping from Cathedrals or

stabbing themselves in ghastly attempts to relieve their agonies through death.

Some became demented with pain, running naked through the streets, declaring themselves the suffering Messiah or, in many cases, jumping into graves and waiting there to die.

The deaths were so awful and so swift that one observer wrote:

> This tribulation pierced into the hearts of men and
> with such a dreadful terror that one Brother forsook
> another, the Uncle the Nephew, the Sister the Brother
> and the Wife the Husband; nay, a matter much greater
> and almost incredible, Fathers and Mothers fled away
> from their own Children.

So many entire families, villages and towns were wiped out that poetic annihilation became a bestselling epitaph throughout Europe.

In Nuremberg, Germany, a tombstone from 1533 reads:

> Is it not sad and moving to relate
> I, Hans Tumacher, died with 14 children
> on the same date?

In England:

> Was it not sad and painful to relate
> I died with thirteen of my house on the same date?

In the Swabian Alps:

> Is it not a painful sight
> Seventy-seven in the same night
> Died of the Plague in the year 1637.

To have killed so many so fast, conventional scientific thought believes that, at some point, bubonic plague had to become the pneumonic form, the only plague that is contagious. Dr. Shirley Fanin says:

> It couldn't have spread from country to country like
> it did because pure bubonic plague isn't transmissible
> from person-to-person.

But since the identification of the AIDS virus in the early 1980s, researchers have become fixated on how a virus or bacillus jumps species. Some scientists now believe that the plague bacillus traveled from its principal carrier—the flea X. *cheopis* found on rats and other small mammals—to the flea *Pulex irritans* which has an acquired taste for

humans and thrives wherever hygienic standards are low—which pretty much was the entire planet in the 14th and 15th Centuries. And that, those scientists say, is how the bubonic plague wiped out one-third of the known world.

(Some contrarian researchers have expressed doubt that it really was Black Plague that ravaged Europe in the 14th Century. But, in 2000, French paleopathologists using DNA analyses confirmed it back to 1358).

Plague came to the British Isles in 1348 and killed off half the population—including the daughter of King Edward III and the Archbishop of Canterbury. At Norwich, nearly 60,000 of the 70,000 inhabitants died; while in Bristol only on in 10 survived.

Plague and Reformation

But—according to historian Simon Schama—it was that epidemic that produced the first stirrings of real democracy in England. With half the serfs dead, manual labor became, for the first time in history, a valued commodity. Farmers simply ignored their feudal obligations to their lords and left to become paid field hands for whichever landowner offered the best deal.

Others migrated to the cities where the competition for workers was equally intense.

Although the plague would return in 1361 and wipe about 25 percent of the already shrunken population, Black Death freed England from feudalism. It had the same liberalizing affect in Germany, Scandinavia and the Low Countries—where plague led inexorably to the Reformation.

It was believed that nobles and princes of the Church achieved their station by divine right or, at least, by God's intelligent design. The Black Death proved that *nobody* was immune. It killed French King Louis the Saint and his son; King Alphonso XI of Castile; the Grand Russian Duke Simeon Ivanovitch the Proud; two of the Venice Doges and King Edward of Portugal. Despite consecrating a Viennese cathedral to St. Charles—patron saint of the Plague—the disease claimed Frederick V, the king of Bohemia and Ladislaus, King of Bohemia and Hungary.

Among the clergy felled were the Archbishop of Spalato, the Bishops of Paris and Lubeck, Cardinal Giovanni Colonna, the Minister-

General of the Franciscan Order and 124,434 of his brethren. In England, 25,000 priests perished and in Avignon—temporary seat of the papacy—100 bishops and five cardinals succumbed to the infection.

All of this death had a levelling effect on the survivors.

To the people, it meant that those who presumed to be their spiritual betters had no more sanctified a relationship with God than any base-born peasant.

Of course, many of the dead clergy contracted plague while performing their ecclesiastical duties—such as administering extreme unction to the dying, consoling the grief-stricken and walking beside them in funeral processions.

Then, too, Rome regarded Black Death as a golden opportunity. To its practice of selling plenary indulgences to the poor—designed to shave a loved one's sentence in purgatory at so many years off per shekel—Rome added the sale of so-called "chantries" as a marketing device to fill coffers emptied by the deaths of millions of its faithful contributors.

A chantry was a sum of money given by an individual in advance of his death, a sort of term life insurance. The money was earmarked for a special chapel honoring the donor or—if the amount were smaller—priests would chant prayers for the benefactor's health and long life.

Since chantries couldn't protect against plague any better than drinking urine or wearing excrement, many of the powers and practices of Holy Mother Church fell into disrepute.

Martin Luther preached that prelates were impotent against the work of evil spirits,

> that they poisoned the air or otherwise infected the
> poor people by their breath and injected the mortal
> poisons into their bodies.

Luther used the Plague to argue that not only was Rome not supreme but that the Church's depredations were the cause of God's displeasure.

Donato Dineri writes about friars being stabbed by irate parishioners and "At Assisi ... 14 of them were killed." Clergyman even fought clergyman, each blaming the other for the sins that had so aroused God's wrath that He had sent down the Black Death as punishment.

During the Reformation, Catholics slaughtered Lutherans—while Lutherans slaughtered Catholics—for creating and spreading the Black Death. Both also blamed—and slaughtered—gypsies who seemed im-

mune to the Black Plague mainly because they steered clear of cities and towns where all diseases flourished.

And, as in most cases where people fear something they can't comprehend, they blamed the Jews.

Blaming the Jews

The fearsome disease was the spawn of Hebrews poisoning the wells, it was alleged. And, under torture, Jews in Germany, Switzerland, Italy, Spain and Austria confessed to causing outbreaks. It was "common knowledge" in 14th Century Europe that the order to poison Christian wells was issued by a secret Jewish society in Toledo, Spain, that had whipped up batches of Black Death blending a secret powder with spiders, owls, vipers and other creepy-crawlies to the tune of Hebraic incantations.

The pogroms began in France at practically the same time as the plague. In Burgundy alone, 50,000 Jews were massacred—most of them burned alive. Jews also were murdered to the last child in the German cities of Stuttgart, Cologne and Frankfurt.

Geneva tore a confession of well-poisoning out of a Jewish merchant by racking him. Zurich expelled all its Jews while Berne and Basle prosecuted Jews as poisoners, confiscating their property before trial and then burning them all at one time on an island in the Rhine. Basle then banned all Jews for next 200 years.

At Mayence, residents made such enormous bonfires of their 12,000 Jews that the church bells of St. Quirius melted along with the lead in the stained glass windows—showering the mob in colorful glass shards.

One Sunday in Strasbourg, 1349, 200 Jews were burned alive for causing the epidemic. The mob even tore the clothes off their victims, looking for hidden children and hidden money. In Mainz, the Jews fought back, killing 200 of their tormenters before being overwhelmed. All of the city's 3,000 Jews were murdered. In the German towns of Speyer and Esslingen—and in the Austrian towns of Krems, Stein and Mautern—Jews committed mass suicide, burning themselves and their families in their homes and synagogues rather than be kindling for a blood-witted mob. It was Masada all over again.

The massacres grew so numerous and vile that Pope Clement VI issued two Papal Bulls in 1348 forbidding the killing and plundering of Jews on pain of excommunication. The rule was seldom publicized

and seldom enforced; too many high-ranking clergymen and nobles were themselves thoroughly anti-Jewish. In Provence, the entire Jewish population was annihilated despite their being under the official protection of the Pope.

And, too, many merchants and well-born landholders could cancel their debts to Jewish money lenders if the holders of the notes suddenly died. Jews were practically the only people that the Church allowed to charge interest on loans (which it called "usury").

For example, Duke Frederick of Thuringia-Meisen urged the Nordhausen city council to pass an ordinance mandating the burning of all Jews "for the praise and honor of God and the benefit of Christianity"—by which he meant he wouldn't have to repay his massive debts to money lenders.

It wasn't just fear that provoked Christians to bloodletting. Jews weren't nearly as susceptible as Christians to Black Death so poisoned wells probably seemed a logical inference.

"Jews didn't live with rats!" snorts Dr. Shirley Fanin. "They followed the strict hygiene codes of Judaism and it really had them living in better circumstances." And, forced to live in ghettos, "they were artificially isolated from the people spreading the disease."

During contagions, Jews also covered their wells and boiled their water at the behest of Jewish physicians who already knew that tainted water was a source of typhus and dysentery. Jewish doctors—many schooled in Arabic and Greek—could call on knowledge accumulated for 1,500 years or more. None of those early medical texts had yet been translated into European tongues.

So, naturally, the Council of Aix in 1338 forbade all Christians from consulting the Jewish physicians who could have saved them.

In pre-Renaissance Europe, Jews were blamed for starting Black Plague because they didn't contract it. Six hundred years later, in Los Angeles, Mexican-Americans would be blamed for starting the plague because they did.

Science marches on.

A Seasonal Phenomenon

Plague is something of a seasonal disease; cases go down in winter when fleas are mostly dormant and then soar during the warmer months. The very virulence of the disease also is something of an advantage.

A Slight Epidemic

According to Dr. Frank Sorvillo, epidemiologist for Los Angeles County Health Services:

> When it sweeps through a rat population it can wipe out all the rats over a large area and then the fleas can survive only for three or four weeks after that. Once they've died off, the disease goes away.

But as long as people give rats garbage to eat and warm, dark places to breed, the disease never goes far away.

In general, rat populations tend to increase radically in the wake of natural disasters—owing to the lack of adequate public health services and the abundance of unburied bodies to gnaw. And, when large numbers of rodents meet up with large numbers of humans, the disease swiftly crosses into the human population.

The black rat even has attained mythic status: the Hindu god Ganesh is accompanied by a rat on his travels and, today, rats still are worshiped in parts of India—where there are shrines inhabited by tens of thousands of vermin and protected by priests who believe it evil to kill any creature.

It is thought that the vast number of *Rattus* which emerged in the wake of the great Maharashta earthquake in 1992 were responsible for pneumonic plague spreading so rapidly that a reported 12 million Indians died.

In the hysteria that always accompanies an epidemic, everyone with a fever or who even felt sick in India was considered to have the plague. But, months later, according to research biologist Dr. Ken Gage of the Centers for Disease Control and Prevention, many "plague cases turned out to be typhoid, Dengue Fever and malaria."

A Swiss Scientist Makes Real Headway

Pneumonic plague largely was quiescent during the 18th and 19th Centuries; but, in 1894, it came pulsating out of China through Hong Kong again and from there by ship throughout the world. Over the next nine years, plague had entered 77 ports on five continents and killed an estimated 30 million people.

But 1894 was also was a landmark year in the treatment of plague. That was the year Swiss scientist Alexandre Yersin discovered the plague bacillus in rats and helped trace its transmission to fleas. It also was the year Yersin began his quest for an antidote.

The development of antibiotics during the 1940s finally turned the tide against Black Death ... when the drugs were available.

Yet people still react irrationally to the risk of plague.

From 1966 to 1972, an estimated 50,000 Vietnamese died of plague when their forests were denuded by Agent Orange—driving flea-infested rats, mice and squirrels into populated areas. Also, the North Vietnamese and Viet Cong had to leave many of their dead unburied, a feast for the rats—who reproduced even faster than usual. American soldiers were given gamma globulin injections to stave off plague but the official explanation was they were being inoculated against "measles."

Even in the 21st Century, some 2,000 cases of plague are reported annually to the World Health Organization. But WHO acknowledges that the reported cases probably reflect only a fraction of the actual infections. Some of the underreporting is due to lack of laboratory facilities for diagnostic confirmation; but, all too often, reporting plague is a career-ender for the health care professionals who do so.

CDC biologist Dr. Ken Gage says plague no longer menaces England or the rest of Europe because "there aren't the right mixtures of hosts, of fleas or basic ecology." In other words, weather and land conditions are not suitable for fleas and the inhabitants now wash on a fairly regular basis.

But at least seven countries have reported cases of plague every year since 1960: Brazil, The Democratic Republic of the Congo, Madagascar, Myanmar, Peru, Viet Nam—and the United States.

That America is the only First World nation infected with plague is not a reflection on our diagnostic skills, our willingness to report the disease or our personal hygiene. Plague exists because of our ecology: Temperate, semiarid western states where the population is scattered but where more and more hikers, campers and All Terrain Vehicle riders are invading.

In the U.S. today, people are moving toward the plague, not vice versa.

"New Mexico has the highest rate of plague," says the CDC's Dr. Gage, "followed by Colorado, Arizona and California." East of the Continental Divide, he says, "the ecology is all wrong to maintain the disease."

Journalist and author Diane Dimond recalls citing the previous week's plague cases every Monday during the 1970s on her radio news program in New Mexico. "To the best of my recollection, there never

was a time when we reported 'No new cases' except in wintertime, of course."

Even in the cool mountains of Flagstaff, Arizona, health officials have captured plague-carrying rats. Southern Utah, southern Oregon, and western Nevada also have reported cases of Black Plague during the 1990s and 2000s.

According to Gage:

> In the last three years [2001-2004] we've only had six cases of plague reported, in part because of drought conditions. But once this drought is relieved, it will probably shoot back up.

That's worrisome because in 1985—after a two-year western drought ended—71 Americans contracted the disease and 12 died. And 2006 proved Dr. Gage right: By September 2006, the CDC had recorded the most cases of plague in 14 years—including two fatalities, one in New Mexico and one in...Los Angeles.

Modern Concerns

On May 16, 2007, a hooded capuchin monkey at the Denver Zoo died of bubonic plague after eating an infected squirrel. Five other squirrels and a rabbit found on zoo grounds also tested positive for plague. In July 2007, a plague-carrying squirrel was discovered at a picnic area in Los Angeles County.

Rats may be the most efficient host of plague—but the most *common* carriers in the U.S. are the burrowing animals. Seventy-six species of mammals in the Western states carry the disease, including wood rats, mice, chipmunks, prairie dogs and marmots; but the principal harborers of *b. yersinia* are ground and rock squirrels. Their fleas are the vectors.

The Chuchupate Campground in Ventura County—just north of Los Angeles—was closed from 1982 until 1999 because of plague infestation among 10 different kinds of rodents.

According to the CDC's Gage:

> Even today, it's a lost cause to try to wipe out plague in wild animal populations so what we have to do is concentrate on reducing risk in areas where humans live and we can do that through flea control.

Particularly at risk are those nature lovers who bring their dogs and cats along. House pets can contract the Black Death if they're bitten by a plague flea; house cats can die of plague by being bitten by a flea or by chewing on a plague-infected rodent. Cats also can spread the diseases through fleas, by sneezing—cats are about the only animal which can transmit plague to humans through the air—or if its infected blood or other bodily fluids enter a human through cuts or abrasions on the skin.

Dogs are practically immune to the disease; but they can carry infected fleas.

In 2002, after four consecutive dry winters, the rat population exploded in Los Angeles—particularly on the posh Westside where homes feature fruit trees (roof rats are vegans) and palm trees for high-rise housing. And swimming pools. Rats are great swimmers. Beverly Hills is a great place to be a rat.

From Pasadena to Malibu, swarms of vermin set up housekeeping in 2002. In Santa Monica, six restaurants along the fashionable Third Street Promenade were closed temporarily because of rat infestation. Field rats joined the roof rat invasion after being pushed out of their hillside homes by fires and the building boom.

Fortunately, most roof rats don't carry the right kind of fleas or enough fleas to present the menace that the Norwegian or black rats do. Roof rats, however, can become infected from contact with other wild rodents and their fleas.

In the scariest development yet, the World Health Organization has detected antimicrobial resistance—the plague bacillus is becoming immune to antibiotics. This may have severe implications.

During the 1990s and 2000s, cases of Black Plague have increased dramatically in Africa—which accounts for over 75 percent of the world's total cases and the death rate on that continent is back up to 23 percent.

In February of 2005, 61 workers at a diamond mine in northeast Congo died of the drug-resistant strain of pneumonic plague. Seven thousand other miners fled into the rain forest.

Eric Bertherat, a doctor with the WHO, was quoted as saying, "It's still a large concern because these cases are moving elsewhere."

So the auguries for another Black Plague pandemic are very real.

Despite all the attention paid to anthrax as a likely candidate for bioterrorism, Dr. Gage of the CDC says an airborne release of *b. yersinia* would be a long-term, two-pronged assault.

"People would get primary pneumonic plague," the deadliest form of Black Death and the easiest to transmit to others. "But there is another issue," Gage adds. "After the initial wave of pneumonic cases, there might be the infection of animal populations as well."

New vectors of disease— such as house pets, rabbits and tree squirrels—might be overlooked in the reflexive rush to eliminate rats.

What The Plague Means to Humans

As both a leitmotif and as central character, no other disease has figured so prominently in literature, fictional and scientific. Historical accounts of the plague have been written for 3,500 years.

The first medical tome to deal exclusively with its symptoms and treatments came out in 1507. Marsilio Ficino published what is believed to be the oldest treatise on plague and epidemiology in 1518.

In 1352, Boccaccio wrote in his *Decameron* of people "who had lunch with their friends and dinner with their ancestors." Plague has played an important role in fiction ever since. *I Promessi Sposi* (*The Betrothed*) contains a vivid account of the 17th Century epidemic in Northern Italy. Written in 1842, the novel still is read in Italy today. Also published in 1842: Edgar Allan Poe's *The Masque of the Red Death*, about a killer disease with symptoms identical to septicemic plague.

Arrowsmith by Sinclair Lewis is about the plague in the West Indies and was made into a movie; and so was Albert Camus' 1948 novel, *The Plague*. Connie Willis won major science fiction awards for her 1992 novel *Doomsday Book*, about a time-traveler who inadvertently is stranded during the 1348 plague outbreak in England. In 2001, Geraldine Brooks published a wonderful novel about the plague in England, *Year of Wonders*. There have been several film versions of the science fiction novella *I Am Legend*, which descibes a plague pandemic.

Even the nursery rhyme "Ring Around the Rosies" is purported to be about the plague outbreak in London: The "rosies" refer either to the petachie—small, red pinpoint hemorrhages caused by the plague—or the bloody sputum coughed up by victims. The "pocket full of posies" is the sweet sachet of flowers, herbs and spices which people carried to stave off the miasma, the noxious fumes from decaying bodies and industrial-strength filth.

"Ashes, ashes" is a reference to either the bonfires that were stoked to cleanse the air or to the burnt bodies of the dead, far too numerous to bury. "All fall down" should require no elaboration.

But, it may all be apocryphal; according to the *Oxford English Dictionary of Nursery Rhymes*, "Ring Around the Rosies" doesn't appear in children's games until 1891—some 225 years after the London outbreak.

In what may be the first nonfiction novel—*A Journal of the Plague Year*—Daniel Defoe, writing 50 years after the fact, described London in 1665 before the plague returned:

> Surely never a city, at least of this bulk and magnitude, was taken in a condition so perfectly unprepared for such a dreadful visitation.

The same is true, of course, of Los Angeles 265 years later.

And there are other propinquities, indicating that attitudes and reactions toward the Black Death didn't change much in two-and-a-half centuries.

Defoe repeatedly laments that the official body count was notoriously understated. "If the bills of mortality said five thousand, I always believed twice that." He put the final death toll at well over one hundred thousand. The official report was 68,590.

But the "official report" is an official estimate—most officials having fled the city at the first sign of the plague. In London, as in Los Angeles, many people thought the only defense against infection was to run from it.

Defoe writes, "There was hardly a horse to be bought or hired in the whole city."

In 17th Century London, newspapers and signboards urged people to purchase "Anti-pestilential pills," "Incomparable drink against the Plague, never found out before" and "The only true Plague water."

Sweet-smelling anti-plague water was a popular seller throughout Europe under the name of the German city where it was first introduced: Cologne. If you already had the Plague, you could buy "An (sic) universal remedy for the Plague" or "The royal antidote against all kinds of infection."

The prophylactics and treatments promoted by health services in 1924 Los Angeles were equally ineffective.

The Inevitable Quarantines...

The City of the Future and Olde London dovetail exquisitely at their quarantines. Since most of the middle and upper classes already had quit London, those shut in tended to be poor.

A Slight Epidemic

"The power of shutting people up in their own houses was granted by Act of Parliament, entitled 'An Act for the charitable Relief and Ordering of Persons infected with the Plague," writes Defoe of the noble rhetoric which really meant that the people inside the quarantine zones were considered expendable.

Both cities imposed quarantines-within-quarantines, shutting up the healthy with the infectious. Again, Defoe:

> That to every house there be appointed two watchmen, one be for every day and the other for the night; and that these have a special care that no persons go in or out of such infected houses ... upon pain of severe punishment.

The major difference between the cities and the centuries is that Los Angeles will post more armed guards than London.

The consequence of the double-quarantine in London—as described by Defoe—anticipates what will happen in Los Angeles:

> It is true that the locking up of doors of people's houses, ... to prevent their stirring out or any coming to them, when perhaps the sound people in the family might have escaped if they had been removed from the sick, looked very hard and cruel; and many people perished in those miserable confinements which, 'tis reasonable to believe, would not have been distempered if they had had liberty.

What finally halted the London epidemic is another of history's real-life allegories.

Since the Norman conquest in 1066, London had laws requiring all cooking and heating fires to be doused at night to reduce the risk of conflagration. The French term was *couvre-feu*—literally, "cover fire" —from which we get the word *curfew*. But on September 2, 1666, the baker to King Charles II forgot to extinguish his oven and the sparks from his chimney touched off a blaze that raged for five days and razed a mile-and-a-half of London.

Only six people were reported dead but the flames and smoke killed off all the rats—effectively ending the plague outbreak.

Year of Wonders.

Los Angeles in 1924 did improve on London's 1665 treatment of house pets. Because it was thought that dogs and cats—rather than rats and fleas—spread the disease, the Mayor of London ordered a

general slaughter of 40,000 dogs and 200,000 cats. The tragic irony, of course, is that the absence of dogs and cats allowed the rat population—and the pestilence—to flourish.

But, in one arena, 17th Century London clearly outshined 20th Century Los Angeles. Dafoe writes:

> ...it pleased God to move the hearts of the people in all parts of the kingdom so cheerfully to contribute to the relief and support of the poor at London, the good consequences of which were felt many ways and particularly in preserving the lives and recovering the health of so many thousands, and keeping so many thousands of families from perishing and starving.

Hardship brought out the generosity and good spirit in many Englishmen. In 20th Century Los Angeles, not even God could move the hearts of the city's oligarchs.

9 A Cold Day in Hell

I could not believe that in so short a time a body could become so swollen and black. Had I not known he was my cousin, I would have thought him some abortion of the nether gods. He had no neck! His face had burst with pustules. Boils covered his body. They...burst as I touched them.

—*Lotus Land* by Monica Highland

Tuesday, November 4th

In the evening, the weather suddenly turns unusually cold. Temperatures plunge into the 40s during the predawn hours. As Nora Sterry reports, few homes in the Macy Street district have any kind of indoor heating so "layers of clothes provide warmth. Most people never undress on cool nights."

The quarantine guards take a different approach; they loot the district of anything that will burn. They start with scrap wood and new lumber intended for construction. Then the guards start to burn wooden fences, porch railings, the porches themselves, the wooden siding of houses and—in one case—the entire back half of somebody's home. The investigation of a claim submitted to Quarantine Officer Carl Williams, found that his guards had stolen:

4 pcs. 4x4 Plaster board

3 pcs. 1x12 16 ft. length

8 pcs. 1x12 7 ft. length

5 fence posts, 4x4 4 ft. length

1 step ladder, 6 ft. length

1 door, 6 ft. high

In addition, "half of the rear of the home was torn out by guards." The investigator urges that the homeowner be paid $15 for his loss but no guards are punished for vandalism

Wednesday, November 5th

The early edition of the *Los Angeles Examiner* headlines Calvin Coolidge's landslide victory and other election news. Also in the first section, more glowing reviews about Marion Davies and her new film. Also an admonition that;

> Allegedly bilbous [sic] California students who greet Prohibition enforcers with "Three Rousing Cheers for Andy Volstead" [author of the 18th Amendment—banning the production and consumption of alcohol] will be prosecuted for conduct not conducive to the dignity of either the Federal Government or the Berkeley institution.

The plague outbreak story again is wedged into a well in the entertainment section between "Mark Twain's Life Afternoon Radio Topic" and the "Entertainers" column.

In the third paragraph, the reporter notes that while "six new cases were confined in the isolation ward of County Hospital" last night, they were considered "doubtful" as to having the "malady."

The story is inaccurate: Two of the "doubtfuls" *do* have the plague and the doctors at General Hospital have known it for three days. Elogio Peralto, 22, dies hours after the *Examiner* hits the streets. He was one of the three borders who fled the house on Clara Street before the quarantine. Jose Jiminez, who—with his brother—also left Clara Street to take up new lodgings, will die the next day.

All three borders that tried to outrun the Black Death die of it. Whom they might have infected will never be known, as casualty lists will be deliberately minimized and even official records and newspaper accounts will vary widely.

The *Examiner* is right about the other four patients: They don't have plague. Getting right two out of three "facts" is commendable on a story where dissembling, half-truths and bald face lies are standard operating procedure for both the press itself—owners and reporters—and public health officers.

El Heraldo de Mexico isn't as sanguine as the English-language dailies. Its banner headline shouts that the quarantine has been extended in Belvedere as new cases of "the terrible infirmity" are reported.

In considerably smaller print is the news of Coolidge's election. National politics are largely irrelevant to the residents of Macy Street; the Chinese aren't allowed to vote and the lives of Hispanics remain unaltered regardless who is of president or senator.

Meanwhile, the Associated Press in Los Angeles has done its legwork. In hundreds of newspaper throughout the country, the plague story will run under the headline, "21 Victims of 'Black Death' in California."

That evening, the 500 doses of plague serum arrive in Los Angeles. Its manufacturer, Mulford Laboratories, will later boast in its in-house magazine:

> Science has discovered ... a serum that will stop the Swath of Death and save the lives of thousands. Los Angeles calls for help and in less than 36 hours the vials of serum were brought to the front lines where the battle is on against the Terror. That's the Thriller. That's the 20th Century truth.

But the serum will be administered to only three people. Two of these survive the almost-always-fatal pneumonic plague: 4-year-old Raul Samarano—whose doctor personally requested the serum—and County General Hospital nurse Mary Costello.

That's another 20th Century truth.

Thursday, November 6th

Two women raise the flag over Macy Street school this morning: Nora Sterry is joined by teacher Pearl Milner, who has answered her

principal's call to duty. Milner will remain in the quarantine zone until the all-clear is sounded, helping out wherever she's needed, exposing herself to the plague and exhausting herself on the same 19-hour shifts as Nora.

There is nothing in the *Examiner* this morning about the Black Death—which now has killed 28 people and led to considerable destruction of private property. The bold face headline in the second section—where the plague story usually runs—reads, " 'Buddy', Marion Davies Pet Lost, $50 Reward."

The lead states the dog,

> the cherished pet of Miss Marion Davies, the star of
> "Janice Meredith" is lost and the best efforts of a score
> of volunteer searchers have failed to find him.

The story is accompanied by large photos of Buddy and Ms. Davies.

The *Los Angeles Times* does run a plague story and, for the first time, uses the term "pneumonic plague"—but adds that it's just "the technical term for malignant pneumonia."

Page one of *El Heraldo de Mexico*, however, screams "LAS RATAS CAUSAN LA EPIDEMIA."

The article reports that rats harbor the fleas that spread the disease and it admonishes readers never to approach a dead rat and to call City Health instead.

This is the first time that an L.A. paper states emphatically that the "mysterious malady" is actually the Black Plague.

Later that morning, intensive rat trapping and eradication measures begin in the Port of Los Angeles. Since a quarantine around the Port would have sharp economic consequence, state Health Officer Walter Dickie assigns a special sanitary task force *exclusively* to the harbor. Workers thoroughly inspect each arriving vessel but find no infected rats.

All rats trapped within the harbor are to be given a special red tag to distinguish them from rodents found in the "foreign" districts. However, no plague rats are ever found within the "red zone."

Keeping a Tight Lid on Things

The first order of business at the weekly board of directors meeting is to announce new members of the Chamber of Commerce. Next, the board members lean on Jake Baum, an executive with Harry

Chandler's Times-Mirror Company, to roll back Chandler's rent hike on their offices. Mr. Baum is asked to reduce the 70 percent increase because "The Chamber already is hard-pressed for funds."

Some of the Chamber's resources are earmarked for another so-called "Mid-Winter" edition of the *Times*, an advertising supplement which—under the guise of reportage—"will be sent to prominent newspapers throughout the U.S. to answer criticisms and slurs aimed at Los Angeles in the Eastern press."

The minutes note that, "Mr. Chandler said he would charge only the cost of the paper for the Mid-Winter *Times*." Two other major Los Angeles dailies—the *Examiner* and *The Express*—already have *their* Mid-Winter editions in circulation.

(This kind of promotion never goes out of style. Some 80 years later, the *Times* would come under criticism for its involvement in *another* act of civic boosterism passing as news. It would publish similar "special sections" devoted to promoting the Staples Center sports arena—in which the paper's owners had a financial interest.)

The board votes to change its bylaws so the Chamber of Commerce will close on November 11th, Armistice Day.

At that time, the day commemorated the end of World War I—which President Woodrow Wilson had called "The War to End All Wars." Now, the same holiday is called Veterans Day—to honor the soldiers who fought in all the wars since The War to End All Wars.

Board Vice President D.F. McGary suggests that the December issue of the Chamber's magazine should carry the picture and bio of its new secretary, A.G. Arnol. The motion duly is seconded and approved by acclamation.

Finally, Mr. Arnol's minutes contain two longish paragraphs under the heading, "Pneumonic Plague Situation." The pages note:

> Doctors Dickie, Perry and Pomeroy representing the special committee handling the pneumonic plague situation appeared before the board and sketched in brief the work which the special committee had done to check the infection.

And this is Dr. Dickie, explaining the actions necessary to prevent a reoccurrence of the infection:

> We hope that the city and the Chamber will insist that all of that areas where Mexicans live is [sic] put in sanitary condition and undoubtedly there is a great

deal of that area that ought to be condemned and destroyed".

Dickie is stating yet again that plague is a stepchild of poverty and, by implication, at least partially caused by violations of the housing and health codes. Chamber of Commerce board President William Lacy endeavors to put him straight: "I am not only familiar with the housing conditions of our Mexicans but familiar with the Mexican peon's way of living in Mexico."

Lacy goes on to explain to the doctor that, during a plague epidemic around the city of Mazatlan in 1909, "the Mexican population died like flies."

And, Lacy warns that the citizens of Mazatlan were driven into the countryside before the clean-up began—spreading the plague to the non-peon populace. Here in Los Angeles, he says, the Mexicans must remain in the quarantine districts, whatever their peril.

"As we are bound to have that population," Lacy continues, "we must assume the responsibility of providing them a place to live peaceably." The board supports this explanation.

Vice President D.F. McGary adds that it wouldn't be plausible to move the Mexicans, anyway:

> In many instances, they are there because of cheap
> rent contiguous to their work. They cannot afford to
> live in quarters that would be acceptable to us or
> should be to ordinary citizens.

McGary also endorses the plan to rat-proof the poorest districts while the residents continue to live there:

> This particular plan of eradicating them [it's believed
> McGary is referring here to rats, not Mexican-Ameri-
> cans] from those districts [is] highly proper and wise.

Dr. Dickie responds by pointing out, "Your Mexicans should not be permitted to live next [to] certain industries like food packaging establishments and slaughter houses"—precisely those industries in which Hispanics comprise most of the work force and which are located near their neighborhoods.

Dickie's remark is open to interpretation: Either he's saying that nobody should live near industries which, by their nature, attract vermin—and this would seem to be the most logical inference given Dickey's concern for decent, low-income housing—or he's reversing

himself and falling in with the board's party line that Mexican-Americans produce vermin.

The meeting concludes as president Lacy expresses the board's appreciation to the doctors and assures them of the board's support "in connection with preventative measures in the future."

Later that afternoon, back at Macy Street, nurses searching for fresh victims and quarantine guards walking the rope barriers near the school suddenly are still as the try to define an unusual sound.

It's music. Mexican folk music.

The importance of music to Hispanic culture was something Nora Sterry had noticed early on:

> Under pressure of necessity, a Mexican will pawn all
> his other belongings before he lets go of his musical
> instrument...they do not value things in terms of
> money but of pleasure; this characteristic separates
> them from our comprehension.

During the school year, Nora sponsors monthly exhibitions of the cultures that make up Macy Street. Native food, native clothes, native dances ... but indigenous music is at the center of everything:

> Any event out of the ordinary will serve as occasion
> for festivity ... an orchestra of a violin and guitars is
> secured and anyone who wishes to come is welcome.

And she's decided this situation, above all, call for music. Nora reinstates the *musicales* every afternoon during the quarantine; she and teacher Pearl Milner use the hour to examine residents for plague symptom and to pass out food, clothing and advice about hygiene and exposure.

Like everything else she's done since she ran the barricade, Nora is violating quarantine rules to organize the musical gathering. But, again, no one in government or public health chooses to intervene.

That evening, the death toll continues. Refugio Ruiz, 24, dies of plague; he had lived in the same building as Juana Moreno and nursed her until she was rushed to the hospital where she subsequently died of plague.

Remedios Enriquez dies of plague. So does Juliana Herera, Lucina Samarano's 63-year-old mother. Ironically, she is listed by her maiden name of Guiland so—in the box marked "Race"—the coroner lists her as "White."

By midnight, the official death toll is 30—all from pneumonic plague and all in the past two weeks. Jesus Lajun and his 15-year-old daughter still haven't made the A-list. Or even a list.

Friday, November 7th

El Heraldo de Mexico runs a front page banner headline, "The Truth about the Epidemic." The first paragraph announces that the paper is
>the only daily, not only in the Spanish language press but in the important North American press, too, with the truth about the epidemic which began two weeks ago.

El Heraldo is the only Los Angeles paper to dispute the official version that the epidemic began October 30th.

The article also quotes State Health Officer Dickie saying;
>*El epidemia* is not new to California ... there were outbreaks in San Francisco in 1900 and 1907 [and in Santa Cruz and New Orleans] and they were quickly taken care of.

Dickie never is quoted as mentioning the word *plague* but the reporter does. He writes that "not all the [reported] cases display the symptoms of *la plaga*." The article also quotes Dickie as stating that "la causa de la epidemia" is what the paper calls "the sad hygienic conditions of our fellow people who are lower class."

In the next paragraph, the new City Health Officer, Elmer Pascoe, recommends that "some houses must be burned down to make sure no one goes back in."

Dr. Pascoe does not have any recommendations as to where the newly homeless should go.

Later that morning, Henry Hillman—an Anglo resident of a quarantine district—alleges that armed guards have stolen logs he had prepared for a garden fence and then burned them as firewood "on the sidewalk of my property."

Captain H.R. Heinz of the quarantine guard investigates the claim and says that—due to recent changes in the guard—it is "impossible to determine whether the claim is correct or not."

This must have troubled Captain Heinz, who is a meticulous record keeper. In another report, he notes

Last night about 2 p.m. [sic] there was a man who
changed shoes. He had on high top shoes and changed
to low shoes in the Center Tent. He was talking to the
Doctor's Assistant at the time and said he had lived in
New York. ...These shoes were in the Tent at 4 a.m.
as per information of the Guard assisting the doctor
whom [sic] was sleeping in the Tent.

Saturday, Novermber 8th

El Heraldo de Mexico quotes a school district official advising Macy
Street residents not to congregate—which they do every day to re-
ceive Nora Sterry's hot meals, medical advice and to attend her after-
noon *musicales*. The musicals are the only entertainment available since
the County Health Officer closed the Macy Street district's movie the-
aters and dance hall.

The school official also advises residents to gargle with table salt,
lemon and water "as hot as a person can stand it."

This bit of useless advice crops up in various newspaper and media
reports throughout the outbreak.

Farther down, *El Heraldo* extols the effort to fly in the plague vac-
cine from Philadelphia to New York to San Francisco—and then by
train to Los Angeles:

This is the only way to stop this terrible sickness ...
vaccinate those in poor health, those who may be in-
fected and *personas nerviosas*.

The reporter adds that it's up to each individual to go to the doc-
tor and get the vaccination. But the two doctors assigned to the quar-
antine districts aren't issued the serum—and the residents of those
districts can't leave to see a physician.

By the time plague victims are brought to County General Hospi-
tal—where they *could* receive the medication—it's usually too late.

That afternoon, nine-year-old Merced Rodriguez dies. She has sev-
eral insect bites on both thighs and an autopsy will confirm that she
died of bubonic plague. A few hours later, still during the same day,
her 14-month-old sister also dies of bubonic plague.

Flea and rat bites are everyday occurrences in the "foreign"
districts as Nora Sterry discovered during her canvass of Macy Street:

"The walls and floors of the majority of houses are so infected with vermin as to render personal cleanliness practically impossible."

Nora feared that "disease engendered in such unsanitary quarters does not remain a local menace but may be spread broadcast." She hadn't reckoned on the city's willingness to use armed guards to isolate the suspect districts.

Late that Saturday night—after the weekend rush—the city's most exclusive hotel, The Biltmore, fires its entire roster of Mexican-American workers. Nearly 200 people. The other luxe downtown hotel, the Ambassador, summarily discharges *its* Hispanic work force, too.

 Many of the discharged workers don't even live in the quarantine zones. And those that do have been cleared for work by health officers. Still, other hotels and restaurants soon follow suit.

No English-language newspaper makes any mention of the mass firings.

Sunday, November 9th

The "Saturday Night Massacre" of Hispanic workers is the top story in *El Heraldo de Mexico* the next morning. The story runs under the boldface banner "LA EPIDEMIA CAUSA GRAVES PREJUICIOS."

The epidemic has indeed provoked grave prejudices toward Mexicans, including

> alarming rumors circulating which blame Mexicans working for American companies for causing the spread of the Plague ... people were fired without justification [because] of their nationality.

The article also notes that the Mexican Consul General in Los Angeles—a Mr. Almeda—takes issue with the slander that the disease is Mexican-borne: "These rumors still haven't been confirmed as of the moment this is going to press."

Senor Almeda also has lodged a protest over the firings with the federal government and expects the foreign ministry of Mexico to issue a similar complaint to the State Department.

But what really inflames both the Consul General and *El Heraldo* is that the chief executive officer of the Biltmore, James Woods, is a member of the Chamber of Commerce and that body's president, according to the article

assured the Hispanic community that Mexicans work-
ing in restaurants, cafes and hotels would be bothered
as little as possible".

When Mexico City expresses its displeasure to Washington, most
of the workers are rehired within a few days.

Monday, November 10th

Around 9 a.m., a bulletin—signed by Dr. N.N. Wood, Superin-
tendent of Los Angeles General Hospital (who delayed by days and
perhaps weeks the reporting of the contagion)—lists three patients
who have been "Diagnosed Clinically as Pneumonic Plague," four other
suspected cases of it and two suspected cases of bubonic plague.

Nine cases in all.

That evening, the 400-man quarantine guard detail takes its first
casualty. James J. Fleming is injured, according to the written report,
"while walking post in quarantine area at Belvedere near Brooklyn
and Rowan Avenues." Fleming says he was hurt when he "stepped on
a piece of firewood which had imbedded in it a rusty nail".

Fleming's foot began to swell and he was treated with "some lock-
jaw preventative serum" at City Emergency Hospital.

The report fails to note if the piece of "firewood" originally had
been nailed to the side of someone's house.

Tuesday, November 11th, Armistice Day

One day after the superintendent of County General Hospital re-
leased his bulletin attesting to nine cases of plague, he amends it. The
new figure he signs off on is 37 cases.

Alfredo Burnett, Lucina Samarano's 12-year-old son from her first
marriage, dies after a heroic 13-day struggle with the pneumonic
plague. He has lasted longer than any other patient except for his
stepbrother Raul and nurse May Costello—both of whom have re-
ceived the plague serum.

Three of the four Samarano boys who were on the family porch on
September 28th when Jesus Lajun spun his rat yarn now are dead—
along with their mother and father, two grandmothers, an uncle, a
great uncle and three cousins. Only four-year-old Raul—and his two

sisters and brother who were in school in Burbank—survive in their immediate family of 16. And Raul isn't expected to live.

Around 6:45 p.m., Leon Jewett is the second quarantine guard injured in the line of duty. He suffers "severe first and second degree burns to face and arms, being scalded by hot coffee."

Jewett, a veteran of the Great War, was making the brew when he screwed on he lid of the coffee pot too tightly "and steam had no way of escaping and blew the lid off the pot."

Thursday, November 13th

Another Thursday and, at noon, another meeting of the L.A. Chamber of Commerce board of directors. Attending the weekly meeting are (again) executives from two of the city's morning papers—managing editor George Young of the *Examiner* and Harry Chandler, owner/publisher of the *Times*.

Also present is P.W. Litchfield, general manager of the Goodyear Zeppelin Company. He's there to discuss prospective "Airship Development" in Los Angeles.

Rigid airships, like the city itself, are considered a vision of the future. A month earlier, on October 15th, the 2,472,000 cubic foot Zeppelin LZ-126—partially paid for by German war reparations—had crossed the Atlantic and arrived at Naval Air Station Lakehurst, New Jersey. It quickly was re-christened *U.S.S. Los Angeles*.

Next, the board takes up possible sites for an agricultural college and the "heated controversy between the University of Southern California and Leland Stanford University in the matter of athletics."

Chamber of Commerce members have expressed their fears that athletic rivalries between the two schools could result in "an unpleasant situation as between Northern and Southern California."

The board moves on to another unpleasant situation: the Black Death. According to minutes of the meeting:

> The secretary stated that it had been the opinion of the president [William] Lacy and the secretary [himself, A.G. Arnol] to make a frank statement to the membership of the Chamber of Commerce concerning the Plague epidemic in order that this statement might be used by members in combating unfavorable publicity in the East.

Then, by the time the membership knows there is a plague outbreak, "The epidemic [will be] practically over" and the Chamber of Commerce could urge its members

> to write their friends and business associates in the
> East, telling these people the facts to offset a great
> deal of unfavorable publicity.

The word "publicity" appears in the board's minutes with far greater frequency than the words "plague," "dead," and "children." Combined.

Chandler and Young, of the *Times* and *Examiner* respectively, suggest that the public admission of plague and a letter writing campaign by the Chamber's rank and file "would be desirable after the quarantine of the two infected areas (Macy Street and Belvedere Gardens) had been lifted." Especially since city health officials have to issue such a statement, anyway.

"The secretary was instructed to follow this suggestion."

Now that the outbreak seems to be under control, George Young also sees opportunity in publicizing "the tight squeeze we just had." Once the rat eradication program is complete, Young enthuses, "we could then advertise Los Angeles as 'The Ratless Port'!"

That evening, County Health Officer J.L. Pomeroy lifts the quarantines on Macy Street and the other districts. No new cases of plague have been reported in six days.

There is what one reporter calls "a remarkable demonstration" for Nora Sterry and Pearl Milner as they leave the district for the first time in nearly two weeks: Residents line Macy Street and cheer their Anglo heroes.

Later, the community will pool its gold coins and jewelry to cast a medal for the school principal.

The lifting the quarantine might seem like the end of the story— but it's not. It's far from the end. The sacking of Macy Street and Belvedere Gardens continues unabated. The *overwhelming* majority of the destruction will not be inflicted by quarantine guards. It will be inflicted under the guise of law.

Friday, November 14th

Martin Hernandez, 15, dies of bubonic plague in County General Hospital. He lived several miles from any of the quarantined districts but, again, no one orders an alert. And the plague serum—available

in the hospital—remains in its crate. Some of the people who know about the serum consider it a resource to be saved, in case the outbreak spreads into the mainstream population. But, more than that, most staffers aren't even aware that the serum is available.

Saturday, November 15th

At a morning meeting, local health officers declare the plague outbreak officially over. Dr. Emil Bogen, resident physician at County General Hospital, notes that "sporadic cases of the bubonic type might still be expected to appear occasionally."

And they do.

There are approximately 38 known, active cases of bubonic and pneumonic plague (and there have been 33 deaths) when Dr. Walter M. Dickie from the State Board of Health convenes a special meeting of the Los Angeles City Council and the board of directors of the Chamber of Commerce.

He crafts his words carefully for both bodies:

> Taking care of the bubonic plague is not only a health problem, it's an economic problem. There is no known disease that has such an effect upon the business world as plague. The harbor will be quarantined, boats will not be permitted to dock, goods will rot in warehouses and businesses will go bankrupt. I realize that the dream of Los Angeles and the dream of officials and the Chamber of Commerce is the Harbor. When I came [to Los Angeles], the first thing I realized was the risk to the harbor.

Dickie is pleased to announce that no infected rats have been found anywhere near the Port of Los Angeles.

Nevertheless, he issues a stark warning:

> If this [outbreak] isn't cleaned up it will take very little before half of the commerce of your harbor will quickly vanish.

Next, the State Health Officer articulates his plan for rat and flea eradication: Destroy the breeding grounds and you destroy the vectors, destroy the vectors and you destroy the plague for good. His plan, essentially, is the same one used 20 years earlier in the Chinese district in San Francisco. According to Dickie:

> The quickest and cheapest way of 'rat-proofing', the one we are adopting, is to take everything off the ground in the infected blocks and raise it 18 inches above the ground and take the siding off all sides of the house, except the fronts so dogs and cats [any which have survived the guards' shooting sprees] can hunt rats under the buildings. Earthen floors must be replaced with concrete to "rat-proof" them.

He describes the type of neighborhoods where rats flourish:

> You go over on First and San Pedro [Streets] in a Japanese restaurant on the corner in which we found two Plague rats and you will find the restaurant is covered with old flooring on the ground and holes in the cement that are rat runways. ...Next door we found a suspicious rat. If you look in the center of the block you will find a lot of wooden shacks ... all that has to be gutted out and destroyed.

Nora Sterry already has complained in writing about Macy Street's litany of building and health code violations and that nothing is done about them

> because the interests owning the district, which with its compact buildings is of high rental value, are unwilling to have their income interfered with and are too powerful to oppose.

Eliminating the sources of plague, Dickie argues, will be a massive undertaking. But his solution is radically different than anything Nora Sterry, with her neighborhood-focused outreach programs, could imagine. His plan is much more politically savvy.

The city and county will be responsible for gutting homes, businesses and other buildings in the districts; the owners of the properties are to be responsible for rat-proofing them—that is, building them back up again to comply with the new codes.

He estimates it will require 25 men working a six-day week to clean up a single block. "One time in San Francisco," he says, "we had fourteen hundred laborers working."

Dickie ticks off the key points of the program:

> You first require an ordinance giving the authorities the right to move people out.

> Second, you require a rat-proofing ordinance ... that will compel these people when they fix up that property that they make it rat-proof ...
>
> Third, you require an ordinance requiring people to keep their property clean, to keep garbage removed and all materials that rats live off of ... You need all three ordinances.

Dickie is proposing a sound, vermin-eradication program for that time. But in another time, it might be called "ethnic cleansing" since the three proposed ordinances will apply—*de facto*—only to Mexican, Asian and black neighborhoods.

Dr. Dickie estimates the cost to the city for what he calls "the cheapest way of rat-proofing" at $250,000 for the first six months and then another $500,000 for the next year—gaudy sums in 1924. But only such an expenditure, Dickie admonishes, will restore the world's confidence in Los Angeles.

And in its port.

Councilman Boyle Workman—chairman of the Finance Committee—confidently states: "We can raise the half a million out of city funds." Workman is the son of the late William H. Workman, a founding member of the Chamber of Commerce, a former Los Angeles mayor, a former city treasurer and a developer of rigidly-segregated communities. Like his father before him, the younger Workman is the Chamber's point man in city government.

Calmly Discussing the Taking of Private Property

Boyle Workman addresses a Chamber director identified only as "Mr. Hill" (most likely, A.J. Hill):

> I want to know something about the state laws as far as condemning property.

This is a familiar question. Workman asks what legal recourses home and business owners could take to gain restitution for their destroyed personal and real property. The answer, according to Mr. Hill is "none" since the new ordinances are "emergency measures."

Hill explains:

> It would be perfectly feasible to declare some of these structures a nuisance in which case they could be de-

stroyed without compensation or instituting condem-
nation suits which would compensate the owner for
improvements.

Dr. Dickie builds upon Hill's response:

If you destroy under your health laws, there is no com-
pensation. I wouldn't recommend any compensation.

The power to destroy private property without payment, Dickie
says, is implicit in his third proposed step: "an ordinance requiring
people to keep their property clean."

He cites, as an example, an apartment building in San Francisco
where two children died of plague back around 1909:

We vacated that [building] immediately. We tore the
foundation out of it and cleaned it out, disinfected
the whole building and let the people go back in again.
The owner came around and wanted to know what it
was all about. We told him his plumbing would all
have to be [replaced] and he got a plumber [at his
own expense] and ... put it in shape.

And if he didn't rebuild the foundation—also at his own expense
—to comply with the new rat-proofing code, "that man would be
prosecuted."

But there's no one to prosecute in Los Angeles, where the vast
majority of Macy Street buildings are owned by a highly secretive
front corporation rumored—but never proved—to be controlled by
Times publisher Harry Chandler.

So, once more, Dickie addresses the Council in terms remarkable
in the context of that time and especially in that place:

There is no reason that these Mexicans shouldn't be
housed in sanitary quarters in the environment they
are used to living in and be an asset to this city.

He lambastes the oligarchy for not doing enough to eliminate the
worst examples of urban blight:

When we took these Mexicans [infected with plague]
to the hospital, probably the first time in their lives
they've ever had bathing facilities. They all went to
the hospital baths and were glad to do it. If you give
them proper facilities, they will take advantage of them.
As long as you have foreign populations—Mexicans,

> Russians and various other nationalities—you have to
> take care of them ... you should have decent housing
> for these Mexicans ... at least in Los Angeles.

"I say these things not as an outsider," Dr. Dickie continues, "This is my home and I live here and expect to stay."

The only response in the room comes from Councilman Workman who remarks gratuitously that some homes in Belvedere Gardens— outside the Council's jurisdiction—are "built out of piano boxes".

Again, there is no reaction to Dickie's plea for genuine urban renewal. Instead, board member Arthur Bent asks Dickie about his plan to poison rats and disinfect flea infestations.

"Is there any inoculation of rats that is harmless to human beings?"

Dr. Dickie says, "There is not."

That is not seen as a problem by either the Council or the board. So, Boyle Workman of the Finance Committee gets back to the real business at hand:

> I think the structures ought to be condemned and
> the whole District cleaned out. I think there are very
> few buildings that ought to be preserved.

Resigned, Dickie validates that position:

> This city doesn't want to go to the expense of doing
> away with them. The owner can clean them up or, if
> it's not worth it, let him tear them down. There is no
> reason for the city taking on that expense.

And that concludes the meeting of elected officials, business and opinion leaders, and the state's highest-ranking health officer.

What never is mentioned is the obvious: Since Macy Street is walking distance to the downtown business section, whoever owns property there will enjoy a huge windfall once the building clean-up is complete.

"Clean-up" being a euphemism for "burn down."

10 "We Had to Destroy..."

The situation calls for drastic action.

—Dr. Walter M. Dickie to William Lacy, President of
the Chamber of Commerce, November 3, 1924

We had to destroy a large part of Los Angeles.

—Charles Stewart, Director of Pest Control

Sunday, November 16th

The *Los Angeles Examiner* pronounces an end to the epidemic it
barely acknowledged:

> [The] pneumonic plague ... is no more. It came sud-
> denly, struggled feebly and passed away after a re-
> markably short life.

The article is accurate—in a slavish, technical sense. At least three
more people will die in the next two months; but they will perish
from bubonic plague. Not the pneumonic version. As to how "feebly"
the plague struggled, that would depend on what premium is placed
on human life. Or, at least, on Mexican-American life.

But the article is significant for another reason: It's the first time
the Hearst paper actually uses the term "pneumonic plague."

The *L.A. Times* headline is "GOVERNOR GRATIFIED AT THE END OF PLAGUE MENACE" and carries a black-bordered statement from Governor Friend Richardson:

> Dr. Dickie and his assistants, with the cooperation of county and municipal authorities, acted expeditiously and effectively as soon as the situation was brought to their attention.

His statement doesn't mention that the situation was brought to the attention of state, county and municipal authorities at different times because of the cover-up and most agencies acted only when circumstances forced them.

Neither does Governor Richardson pay homage to federal contributions and that—while it's true that the Feds brought zilch to the table—will turn out to be a most *impolitic* omission.

Governor Richardson concludes that:

> The trouble was confined to the areas in which it appeared and never passed beyond the quarters of the district under quarantine.

That's not true, of course. But it's unlikely Richardson was aware of his misstatement.

The article accompanying the Governor's statement reports that "California State and United States Public Health departments were immediately notified of the outbreak"—which extends the inaccurate reporting to the federal level.

Monday, November 17th

Members of the City Council and health authorities meet to debate how much money is needed to eradicate vermin and how much should be spent on bringing structures up to the newly proposed anti-rat building codes.

The conference is held not in City Hall or the City Health office—but at the office of the Chamber of Commerce, whose board members also are in attendance. Yet another testament to the fact that the Chamber is a parallel government.

Later that day, County Health Officer Dr. J.L Pomeroy receives a letter claiming damages incurred by the rat-eradication program. The letter is sent by Binigno Guerrero and written in the elegant cursive of

one who had the Palmer Method of handwriting beaten into him by nuns.

> My Dear Dr. Pomeroy,
>
> Enclosed you will find the bill of food that I have being forced to destroy. That food was my only capital to keep my business going and I am sorry not to possess your language to impress you with the idea, than such small amount of money was the only means to provide food for my family, my wife and four children; 8,6,3 and 1 1/2 years old. Bring your attention to that situation, my dear Dr. Pomeroy and you will grant that the bill be payed.
>
> Sincerely very truly yours,
>
> B. Guerrero

An attached, handwritten invoice, headed "Quality Tamales Home" at a Belvedere address, lists the food the sanitary officers demanded Mr. Guererro destroy:

> 200 Big Tamales at 10 cents each, 250 small Tamales at five cents each, 45 Los Chile con carne at 30 cents each, 45 Chile & beans at 25 cents each and 45 mixtamal at 5 cents each.

The total bill is for $60. When there is no response from Pomeroy's office, Mr. Guerero will write a second letter, this one to the Board of Health. There is nothing in the surviving record to indicate anyone ever responded or that Mr. Guerrero was ever reimbursed his losses.

Thursday, November 20th

The *Los Angeles Times* announces that the acting City Health Officer, Dr. George Parrish, recently arrived from Oregon, is appointed to the post full-time by Mayor George Cryer.

Parrish has a stellar resume…as a booster. It was he who railed against

> the grossly exaggerated reports published in the Eastern newspapers [of plague in Los Angeles] with the evident intention of stopping the ceaseless migration of tourists to this wonderful city.

He is the ideal successor to the late Dr. Luther Powers—who adamantly refused to believe the conclusion of two separate laboratory studies and his own chief pathologist that the spate of "Mexican" deaths was due to Black Plague.

Later that morning, the Los Angeles City Council appropriates $250,000 for the Health & Sanitation Committee to eradicate rats, squirrels and other flea-carrying plague animals through July—and then votes twice that sum for the next 12 months.

Although this is what State Health Officer Dickie recommended and what Councilman and Finance Committee chairman Boyle Workman promised, the petition for the funds does not come from Dickie or Workman or any other public official.

In presenting the issue, the City Clerk cites the "command communication from the Chamber of Commerce."

One Man, One Vote?

The city government—at the behest of its *alter ego*, the Chamber's board of directors—votes no funds for rebuilding the districts. The money which is used to bring structures up to the new codes will be spent primarily in one place.

"They spent an inordinate amount of time looking for rats and cleaning up the harbor," writes history professor Dr. William Deverell in his definitive book on cultural clashes in Los Angeles, *Whitewashed Adobe*.

Technically, the abatement program isn't limited to "Mexican," Asian and black neighborhoods. A report notes that

> the danger from infected rats exists ... even in residence districts occupied by Native Americans.

Here, the author of the report does not refer to the Yankton Sioux or Northern Cheyenne. He's referring to native-born *white* people.

But when a plague rat is found in Beverly Hills, no one suggests poisoning, burning or tearing down anything. The rodent is removed without fanfare and "Native American" life in and around Beverly Hills continues apace.

The official rat eradication program is extended beyond the Mexican-American districts to those where there is no plague at all—but there are plenty of recent immigrants. According to Prof. William Deverell:

> There's a campaign to destroy Mexican-American and
> Chinese-American housing, Japanese-American hous-
> ing, African American housing. It's a very wide spread
> campaign of destruction.

Indeed. In less than a month—between November and Decem-
ber, 1924—city and county sanitary workers descend on the "foreign"
districts with near-military ruthlessness.

The result: urban firestorms in many suspect neighborhoods.

They raze to the ground houses and businesses, shacks and sheds.
They burn lumber, tarpaper and any other building materials where
rats might hide. But killing rats is only *part* of any plague eradication
campaign—because the fleas will jump from dying rats to the nearest
available host, human or animal. So, to eradicate fleas, the sanitary
workers also burn residents' clothing, bedding and furniture, all with-
out compensating the owners.

To disinfect buildings from rats and fleas, crews spray houses and
businesses with everything from petroleum to sulfur to cyanide gas.
Other crews simply back their trucks up to the structures, run hoses
from the exhaust pipes into the buildings and pump them full of
carbon monoxide.

To justify for the ages this sacking of the colored quarters, the City
Council hires a photographer whose sole task is to take pictures of
"typical interior of a Mexican home" and "typical Japanese home" and
"typical Chinese home" and "Negro shack in business section" before
they're purified by fire. The photos depict shabby furniture jammed
into tiny rooms littered with trash, metal barrels serving as stoves and
backyards and ditches full of weapons-grade garbage.

This is in stark contrast to what the Chamber of Commerce cease-
lessly promotes in its brochures as "typical" Los Angeles: Typical bun-
galows with typical flower bed piping on typically quiet, shady streets;
typically sunny and warm winters producing typical orange groves,
and typical palm trees.

The "typical" Japanese home is a teetering one-story building hous-
ing both the family and the store they own; all sorts of boxes and
detritus are piled high on the porch.

In a "typical" Chinese neighborhood—and in most of the pictures
—there are piles of scrap wood and metal in the backyards. But there
is no accompanying caption indicating if the building material is trash
dumped there by the homeowners or if the materials were torn off the
houses by quarantine guards or piled there by sanitation crews.

A Slight Epidemic

The "Negro shack" with its neatly gabled roof and hand-hewn picket fence looks thoughtfully planned and sturdily built. But right behind the home looms a gleaming white, multistory and windowless cold storage facility, a graphic metaphor for a commercial glacier grinding minority home ownership into splinters.

The photographs are the "evidence" that "foreigners" live in filth and transmit filthy diseases.

Sanitation workers spread a syrup of arsenic on little squares of bread to poison rats and distribute what chief rat catcher Charles Stewart calls the "dainty poison croutons" throughout neighborhoods where there is—and isn't—Black Death. Stewart says, without self-reproach, that:

> Children in the [Macy Street district] often attempted
> to eat our "rat sandwiches." More than once, I slapped
> a piece of poisoned bread out of a kid's hand.

Stewart claims that no children ate any of the 600,000 poisoned *panini* he put out; and there are no official reports of any child being poisoned. Neither is there any account of the bait being eaten by dogs or cats—those who didn't disintegrate in the storm of shotgun pellets fired by bored quarantine guards.

On the other hand, there was no official report of anyone dying of plague, either—not until it was an epidemic.

The so-called "sanitary details" do perform vital functions. They exterminate over 100,000 rats—of which nearly 200 test positive for plague. They knock down poorly-built shacks and sheds where new immigrants are known to have lived and where rats are known to breed. They bury or burn piles of garbage, haul away rubbish and clean, line and spray with poison the ditches which residents use as convenient dumps.

By the end of December, 10,000 plague "abatements" have been carried out—including 498 buildings that are raised off the ground. Another 3,300 buildings are razed to it.

In Macy Street alone, 2500 structures—homes, businesses, garages, shacks, sheds—are torched or pulverized.

In the words of the Director of Pest Control, Charles Stewart, who condemned the buildings:

> We had to destroy a large part of Los Angeles.

This quote, with a kind of madness born of lost perspective, eerily presages another quote—"We had to destroy the village in order to

save it."—that would turn many Americans against the Vietnam War some 40 years later.

Again, it's hard to recount the actions of the local sanitation workers during the period immediately after the Macy Street quarantine *without* drawing comparison to war.

Thursday, November 20th, Noon

At the weekly meeting of the Chamber of Commerce board, the Chairman of the singularly important Publicity Committee

> verbally suggested to the Board that it would be desirable as soon as possible to circularize the membership of the Chamber of Commerce in such a way as to impress upon them the truth of the statement that the plague situation had been overcome and wiped out and giving them the information in such form as to permit them using it in writing to their friends and business acquaintances in the East.

The motion is duly seconded and the suggestion duly approved. But the Chamber will quickly decide that an informal letter-writing campaign will not be enough to control the spread of media coverage about the outbreak—especially among newspapers in the East and Midwest.

The Publicity Committee will have to take more direct action.

Sunday, November 23rd

Teenager Martin Hernandez of Brooklyn Avenue, Belvedere Gardens, arrives at Los Angeles County General Hospital with a raging fever and a bubo on his groin that has been suppurating—closing over, then oozing again.

At the hospital, Hernandez is the third person—and second Hispanic person—to be given Yersin's Serum. But it comes too late; the 15-year-old boy dies a few hours later. An autopsy shows the cause of death is bubonic plague.

Dr. J.L. Pomeroy writes:

> This case was not associated in any way with the pneumatic plague which existed over a mile away and was all contracted in the city of Los Angeles.

A Slight Epidemic

So, there is at least one new case of plague outside the quarantine zone; but, as far as the L.A. public health establishment is concerned, the epidemic is over.

Wednesday, November 26th

Around 8 a.m., Central Time, a flying truth squad arrives in Chicago to combat the "alarmist propaganda disseminated throughout the East under scare head lines," according to developer and Chamber of Commerce member H.M. Nickerson.

> The *Los Angeles Times* reports that the squad is comprised of twenty loyal sons of Southern California, temporarily exiled amid the snows and storms of the East, [who] are preparing to tour the United States this winter in behalf of their beloved Southland.

> Through lectures, radio talks and paid advertising they intend to refute ... a hostile Eastern press which they say has distorted the truth, twisted the facts and maliciously given wide publicity under glaring headlines to a few cases of so-called pneumonic plague....

The entire enterprise is paid for by the Chamber of Commerce and Nickerson says that is

> the only way the United States can be told of the wonderful opportunities of the Southland, its unsurpassed climatic conditions, relative freedom from disease and suffering (emphasis added), untrammeled liberty under law and industrial freedom....

That same day, at noon Pacific Time, the weekly meeting of the Los Angeles Chamber of Commerce board of directors is held one day early—due to the coming Thanksgiving holiday.

> A report was rendered by the Health & Sanitation Committee recommending the appointment of a standing subcommittee to take charge of the betterment of housing conditions of that portion of the of the population so vitally affected by the action of the health authorities in establishing sanitary conditions in the City of Los Angeles and that the committee be comprised of the following members: Rev. Robert E. Lucy, D.W. Pontius Dr. John Pomeroy (County Health

Officer) and four members of the Chamber of Commerce.

There are no representatives from "that portion of the population so vitally affected by the action of the health authorities"—Hispanics, Asians and African Americans. And one member of the committee is James Woods, CEO of the Biltmore Hotel and the man who fired 200 Mexican American workers during the plague outbreak.

But, at least on paper, the Chamber is responding to Dr. Dickie's plea to improve living conditions for the city's working poor.

There may have been a *quid pro quo* quality to this effort. The board's secretary reads a signed statement from Dickie declaring that the plague epidemic is over. Dickie also proffers thanks to the newspapers and business leaders for their "cooperation"—apparently in covering up the story.

The board immediately begins to spin the Dickie note as "just the thing to be good publicity."

Playing up the disease's purported demise is every bit as important as playing down its existence. The cover of the November issue of the *Los Angeles County Employees Bulletin* announces the Christmas Charity Ball and Masquerade will be held at Goldberg-Bosley Hall. Buried on page 14 is an article which begins,

> The presence of pneumonic plague in one of the
> county districts was probably the matter of greatest
> importance in the County Health Department this
> month.

The article notes the number of rats, mice and squirrels killed during the first two weeks of the eradication program but says nothing about the number of dead *people*. The rest of the piece is a salute to county health workers assigned to plague and quarantine duties.

Similarly, in its report for 1924 issued a few months later, the Bureau of Housing and Sanitation will note that the cost of the plague is estimated at $10 million in property damage alone. But, since most of that damage was to "foreign" districts—and never reimbursed—the city got off light.

The human cost of the scorched earth policy is appreciably higher. Even the Housing and Sanitation report acknowledges:

> No new construction has been undertaken to house
> the people thus dispossessed [and] they have been scat-
> tered to other parts of the city and county, many of

them into other houses or quarters that are unfit for home habitation, a menace to the city at large and a barrier to the progress of the life and character of the persons living in them.

Chamber of Commerce President William Lacy is on a different page in an altogether different library. He writes an article for *Los Angeles Realtor* magazine entitled "The Truth About Los Angeles."

In the article, he urges readers not to believe everything they read or heard about a number of urban woes including "a slight drought," a power shortage and a "slight epidemic of pneumonic plague." These, he insists, are not good reasons not to visit or buy in Los Angeles. In fact, it demonstrates what a great city it is because there were so "few cases of pneumonic plague."

That, truly, is a bizarre boast.

The fact is that the plague outbreak isn't over yet. Plague outbreaks *never* die away so quickly or conveniently. The truth is that a steady stream of L.A. residents (both human and animal) will contract plague over the next several months. And this is typical of how plague outbreaks wind down. Slowly.

Friday. November 28th

In early morning, the *Los Angeles Times* carries a story—as news—that Pasadena residents are beginning a three-day letter writing campaign to "Eastern friends." The *epistleros* who organized the event expect 40,000 letters to be written, extolling the wonders of Southern California and also "branding propaganda circulated about the 'terrible Los Angeles pneumonic plague' as 'false'," according to the *Times*.

The paper has evolved from referring to "pneumonic plague as the technical name for malignant pneumonia" to referring to an epidemic of "so-called pneumonic plague" to claiming that Eastern press reports that the Black Death was "terrible" are, in fact, false.

Freedom of the press, journalist A.J. Liebling observed, is reserved for those who own one.

Friday, December 19th

All of the Chamber of Commerce's public relations efforts have little effect on two major factors that lie before the city. One of these

factors is the political positioning within the U.S. Surgeon General's office. The other is a rat.

The rat, infected with plague, is trapped on Venice Hog Ranch—four miles from the Port of Los Angeles. The ranch is speedily demolished and relocated 10 miles away.

But that one rat is the excuse that the federal Public Health Service has been seeking during the past six weeks—a justification to involve itself in the plague fight, despite the objections of state and local health officers.

Dr. James Perry, the Service's Senior Surgeon in San Francisco, has been sent to Los Angeles because Acting Surgeon General White wanted a high profile case to boost his chances of becoming *permanent* Surgeon General. When Perry doesn't come up with a reason for federal intervention into the plague epidemic, White accuses him of dereliction of duty.

White doesn't get the job—it goes to Dr. Hugh Cummings—but Perry, smarting from the abuse heaped on him by his former boss, has his own ambitions. When the plague rat is discovered just a few miles from the Port, Perry immediately wires the new Surgeon General about "his" finding.

Monday, December 22nd

Although an expensive and exhaustive hunt for rodents within the harbor area comes up empty, newly-appointed U.S. Surgeon General Cummings orders the Port of Los Angeles quarantined.

For Cummings, in Washington D.C., the quarantine is a chance to establish his reputation for quick and decisive action.

For the L.A. Chamber of Commerce, it's the worst-case scenario—the one thing the Chamber, city government and local, county and state health officials have been working in concert to prevent. The reason so many houses in Macy Street and other parts of the city burned was to keep the Feds away from the Port.

But the Feds' moves are inevitable—part of a jurisdictional dispute as old as the Constitution, according to Dr. Shirley Fanin:

> The federal government loves to be imperial; they see
> the local people as peons and the federal government
> is like the king.

Under Maritime Law, the harbor is the fief of the Feds. But there are some bureaucratic issues. Specifically, authority over the Port of

Los Angeles belongs to the State Department, not the Public Health Service.

Still, the second busiest port in America will remain closed for nearly three weeks and reopen only after intensive buttonholing in Washington by members of the Chamber of Commerce. Rather than raising any doubts, the incident will steel the Chamber's resolve that nothing...*nothing*...will ever again interfere with business-as-usual.

Six months later, the Chamber will impose an information blackout on another health crisis and this time the board's news management could be the envy of *Pravda* and *Der Sturmer*.

Friday, January 2nd, 1925

Maria Dominguez, age 11, is admitted to Los Angeles County General Hospital with a 105 fever and a throbbing bubo on her left thigh. She's diagnosed with bubonic plague, the bubo is aspirated and drained and she survives her ordeal. But she never receives the anti-plague serum...which is *still available* in the hospital.

Again, it's possible (even likely) that the doctors and nurses treating Maria didn't even known that the serum was ready in their facility—so tight had been the control of plague-related information.

Monday, January 12th

Jose Perez, 14, is admitted to General Hospital with bubonic plague. He will die three days later, the last reported Plague death in the epidemic.

Again, there is no mention in the records of Jose's hospitalization of the Yersin serum. Apparently, none was administered to the boy.

Saturday, January 31st

Head city rat catcher Charles Stewart announces that, so far, his crews have killed 42,349 rats—of which 81 had Black Plague. He also notes that two squirrels are being held "for suspicion of Plague."

Rodents remain the vector of the outbreak. And, despite Mr. Stewart's best efforts, it's clear that the rat population has been carrying the fleas around the Los Angeles basin throughout the quarantines, fire storms (both literal and figurative) and public relations campaigns.

Wednesday, April 1st, 1925

Los Angeles Times columnist J.A. Graves writes a review of L.A.'s Year of Wonders. Halfway through his laundry list of civic achievements, he notes:

> True, during the year 1924 Los Angeles county, with the rest of the State, suffered great losses from an epidemic of foot-and-mouth disease; true, there was a slight outbreak of bubonic plague but both disasters were heroically met and immediately stamped out…. That the newspaper propaganda throughout the East has not seriously injured us is shown by the fact that immigration is flowing to us in increased volume, that the demand for real estate is heavy….

The *Times* isn't merely glossing over a harsh reality, it's even changed the name of the disease from pneumonic plague to the far less deadly bubonic form. Within the year, the association of "plague" and "Los Angeles" will disappear forever from the lexicon of the paper.

That the article appears on April Fools' Day is coincidental.

Thursday, May 21st

Sanitation workers find a plague-infected rat in East Los Angeles. It is the last such rodent to be found in 1925.

Wednesday, June 3rd

The California State Board of Health officially turns over plague control operations to the City of Los Angeles Board of Health. The City immediately transfers the responsibility to the federal Public Health Service.

Now, the plague epidemic is really over.

Thursday, June 18th

Dr. George Parrish—who replaced the dangerously candid Elmer Pascoe as Los Angeles City Health Officer—addresses the recently created Health & Sanitation Subcommittee of the Chamber of Commerce. The 50-man panel is a result of the plague epidemic and is mandated

to improve living conditions in Los Angeles—and specifically in those poverty areas where all contagions are common.

The meeting is presided over by James Woods, chief executive officer of the Los Angeles Biltmore Hotel. A few trusted newsmen are present to witness how well the Chamber cares for the health and sanitation of the city.

Dr. Parrish announces that 20 cases of infantile paralysis—polio— have been reported during the past two weeks. Since summer hasn't even begun officially, Dr. Parrish warns that a full-blown epidemic is likely unless drastic steps are taken. Immediately.

Everyone in the room knows what this means.

Drastic steps are taken. First, W.H. Pridham, the new president of the Chamber, swears all the newspapermen to silence. Then he orders the Health & Sanitation Committee to handle any public announcements of the polio threat and to do it with great care in order to prevent "the bad publicity which could ruin the summer tourist business."

The subsequent polio warning issued by the Committee is a masterpiece of dissembling. It also provides everyone involved with authentic-sounding deniability should news of yet *another* contagious disease in L.A. leak to the "Eastern press."

> Communicable diseases in all communities show a tendency to increase during the summer. There have been sporadic cases of infantile paralysis throughout the entire country, including California. The Los Angeles Health Department therefore recommends that due caution be exercised by parents in exposing their children to possible contagion, but emphasizes that there is no cause for alarm.

There follows some general health tips about personal hygiene. They are as effective in warding off polio as were the earlier suggestions that people gargle with lime, salt and hot water to prevent Black Plague.

Dr. George Parrish, the new City Health Officer, signs the document.

No further mention of polio ever emerges from the Health & Sanitation Committee. Or from just about anywhere else, for that matter. William Boardman Knox, former editor of the *Los Angeles Daily News* will write in the December 1925 issue of *The Nation*:

Not one word of conditions in Los Angeles during the past summer has appeared in print except for one brief Associated Press dispatch from Sacramento and such carefully predigested generalities as the Chamber of Commerce itself from time to time saw fit to print.

October 3rd, 1925

The California State Board of Health announces that 700 cases of polio had been reported in Los Angeles during the past four months.

Those are the *reported* cases.

Dr. Parrish, the City Health Officer, estimates that four out of five cases have been misdiagnosed and/or not reported. Extrapolating Dr. Parrish's estimate would mean there were 3,500 victims of polio over the summer.

And virtually no one except the victims will ever know.

11 Tomorrow's Plague

It is entirely conceivable that this virus is inherently programmed that it will never be able to go efficiently from human to human. Hopefully the epidemic (in animals) will burn itself out ... before the virus evolves the capability of being more efficient in going from human to human.

—Dr. Anthony Fauci, head of the infectious disease division, National Institutes of Health, speaking to the Associated Press, April, 2006

Sooner or later a deadly virus that can jump from birds to people will sweep the globe.

—*National Geographic*, October, 2005

Remember when SARS was the deadly disease *du jour*? Do you even remember what SARS stood for? (Severe Acute Respiratory Syndrome.) In late 2003 and early 2004, mainstream media sources reported breathlessly about the disease with flu-like symptoms that could turn deadly—with little warning. Even the usually stolid World Health Organization referred to SARS as a "silent serial killer."

But the disease killed fewer than a hundred people on the entire planet—and then vanished in April of 2004.

What the SARS scare *did* do was underscore, that once a news medium invests time and money in a story, that story becomes news, regardless of the actual threat it poses.

"Avian Flu Seen as Possible Threat to Humans" doesn't play nearly as well as "The Next Killer Flu: Can we stop it?" (*National Geographic*, October 2005).

So, is the infamous H5N1—commonly called the Avian flu virus—the next silent serial killer, the next Black Death?

Well, if you read or watch news anywhere in the world, it certainly would seem so:

- An official with World Health Organization said in February 2004, "The world is now in the gravest possible danger of a pandemic."
- The February 28, 2005 issue of *The New Yorker* headlined an article about bird flu as "Nature's Bioterrorist."
- The *International Herald Tribune* reported, in December 2005, that Thailand's largest food conglomerate has outfitted its workers on the chicken production line with what look like hazardous materials suits. "We are trying to use the crisis as an opportunity," said the company chairman— hoping the hazmat precautions would convince people that Thai chickens are safe. (Thailand is the world's fifth-largest exporter of chickens.)
- The United Nations health chief warned, in January 2006, that it is "a given that it (H5N1) will mutate into a human-to-human threat."
- On February 20, 2006, the *Christchurch Press* in New Zealand reported that the Rydges hotel chain "is offering to turn its plush rooms into quarantine and treatment centres should a flu pandemic sweep the nation." (Perhaps Rydges should consider the fiery fate that befell much of the quarantine site around the Macy Street district.)
- Twelve days later, New Zealand's *Nelson Mail* noted that "Motels could become bird flu assessment centres under plans devised by Nelson health officials for dealing with a deadly pandemic." The president of the Nelson Motel Association said no one told him about any such plan and opined, "Surely school halls are better than motels."

- While China initially denied the existence of H5N1, the government of New Zealand has mounted a million-dollar "publicity blitz on preparing for a flu pandemic," according to the *New Zealand Herald* in March 2006. Director of Public Health Dr. Mark Jacobs decried that while "there was good general knowledge about the risk of a future pandemic, only a third of people had actually done something about it." (As of late 2007, there have been zero cases of Avian flu among the animals and people of New Zealand.)
- The March 30, 2006 edition of *The Scotsman* ran the headline "Ban on handshakes may help to stop the spread of bird flu." The related article quotes Dr. Dermot Kennedy, an infectious disease specialist at the Royal College of Physicians, saying:

 It would raise eyebrows but it would make a point ... hands are being recognized as increasingly important (in the transmission of influenza) ...If you put your hand on a strap in the underground and then to your mouth, you could be infected.

- On March 3, 2006, CTK—the Czech Republic news agency —announced that 450 Czechoslovakian troops were ready to deploy to disinfect contaminated areas and "liquidate" diseased animals. The task force was selected from rescue battalions and four chemical and biological warfare units.
- The Aberdeen (Scotland) *Evening Express* on February 24, 2006, quoted a "world famous expert on bird flu" as saying truck drivers should be the first people to get vaccinated against a human form of the virus. "If the virus takes out the [truck] drivers, we could run out of food and starve," said Professor Hugh Pennington. "Many supermarket warehouses are hundreds of miles from stores, so truckers are indispensable." He added that tanker drivers also are key workers, to prevent fuel shortages.
- British authorities have their own—secret—plan for keeping the trucks rolling, according to the April 9, 2006, *Sunday Telegraph*: "Off-duty firemen and retired [truck] drivers would be pressed into service." (The word "pressed" comes from the British term "impressments" meaning "to force into public service.") The government is worried that

drivers might be unwilling to make deliveries to infected areas except at gunpoint. The government report confidently predicts 100,000 dead children when the H5N1 virus becomes contagious among humans.

- Earlier, officials in United Kingdom said that the first group to be vaccinated are "health and social workers who will be needed to help the sick." The Birmingham (England) *Evening Mail* announced on February 21, 2006, that those British health and social workers will be protected by armed soldiers from violent mobs desperate for flu medicine:

 Under "doomsday-style" plans by Staffordshire Ambulance service, bosses will move health workers and limited supplies of vital bird flu drugs to [a Royal Air Force base] for protection. Their families are set to join them under armed guard to avoid kidnap and blackmail.

The article also notes that the world-renowned ravens at the Tower of London are now locked indoors to protect them against infection from migrating birds. (As of October 2006, the only confirmed death by H5N1 in the British Isles was a single swan.)

- Late in January 2007, H5N1 *was* discovered on an English turkey farm and the entire flock was culled. British observers say the most frightening fact is that birds don't migrate to England in Winter. So where did the virus come from? A year later, no one could say for certain.
- The *New Straits Times Press* in Malaysia reports that public relations giant Hill & Knowlton is offering (in an echo of some of the L.A. Chamber of Commerce meetings in 1924 and 1925) so-called "crisis management plans" for dealing with bird flu. The director of Hill & Knowlton for Malaysia acknowledged that the country hasn't actually been affected by the disease but added, "Large corporations should not take it for granted and be prepared for the worst."
- "Bird Flu Pandemic Could Lead to Mass Graves," headlined a relevant—and excited—April 2, 2006, article in Britain's Press Association:

 A prudent "worst case" assessment suggested 320,000 could die in the UK if the H5N1 virus mutated into a form contagious to humans" and it could take four

months to bury or cremate them individually. The prospect of "common burial" would stir up images of the mass pits used to bury victims of the Great Plague in 1665.

In the article, Britain's Chief Medical Officer is quoted as saying, "It's not if the pandemic comes, but when."

- An Australian news service reported:
 It's official. The World Organisation for Animal Health yesterday confirmed it is a question of when, rather than if, the bird flu pandemic reaches our shores.

The director of the organization said the swift spread of the disease "showed a pessimistic outlook for Australia, Canada and the U.S."

Exaggerations…and Realities

While Avian flu hasn't actually appeared in Australia, Canada or the U.S.—yet—the director of WOAH wasn't even "cautiously pessimistic"…just pessimistic, period.

The White House, too, seems to have given us up for dead. Speaking to the national governors conference in February 2006, Health and Human Services Secretary Mike Leavitt said:

Anyone who thinks the federal government can come to the rescue at the last moment does not understand the complexities of this situation. A pandemic is different than any other disaster that we've ever managed.

And the *other* disasters which the federal government has managed (remember Hurricane Katrina…as well as Wilma after it) have been managed rather poorly.

Leavitt said bird flu would be worse than terrorist attacks because it would hit "5,000 communities across America." Terrorists, on the other hand, strike at only one or two communities at a time.

Then Leavitt neatly summarized the two key points, which appear in nearly every jeremiad about bird flu:

1) It's inevitable that the world will again face pandemics on the scale of the 1918 flu outbreak and communities must prepare now.

2) It's when-not-if bird flu strikes humans and it will be Spanish-influenza-all-over-again—those two absolutes are guaranteed to lower the blood temperature of even the most urbane and cynical observer.

The Spanish flu pandemic erupted in May of 1918 and killed somewhere between 40 and 80 million people around the world—and sickened over half a billion. Dr. Dermot Kennedy at Scotland's Royal College of Physicians points out that the world's population was only 1.5 billion when the Spanish flu raged "and if you equate that death rate to the current world population, it could be a quarter of a billion" deaths due to Avian flu.

Holes in the Logic of Excitable People

Much is made of the fact that the 1918 pandemic was also a bird virus—H1N1—and was only the first of three avian epidemics that surged across the globe in the 20th Century. Yes, H1N1 was a strain of mutated bird flu and, yes, it was the deadliest disease of the last 500 years.

But the conditions that allowed H1N1 to spread so much death in so little time (about one year) simply do not exist today.

Spanish influenza first broke out in May 1918 along the trenches of the Western front near the end of World War I. Six months later, 20 million soldiers—many already infected with flu or significantly weakened by other wartime diseases and injuries—were on their way home, jammed into troop trains and overcrowded transport ships. Not surprisingly, the first cases of H1N1 in the U.S. were reported on military bases where veterans were mustering out and taking H1N1 back to their hometowns.

Those circumstances never will be repeated.

The other two major pandemics of the 20th Century—as far as killer contagions go—weren't that bad:

1) The "Asian flu" of 1957-58—designated H2N2—caused about 70,000 deaths in the US and 700,000 worldwide.

2) The "Hong Kong flu" of 1968-69—H3N2—caused 34,000 deaths in this country and about a half-million around the world. That strain—along with H1N1—is still around but not doing any harm.

But about 36,000 Americans die of flu *in a good year* and another 400,000 are hospitalized. Most of the victims are over 50 years old

with deteriorating immune systems and they die for pretty much the same reason: Medical attention isn't sought until the flu has become pneumonia.

All of the various Avian flu strains originated in waterfowl, then spread to domestic poultry and from there to humans—but none of the outbreaks was caused by a purely avian virus. They were what the CDC calls "novel" strains, mixtures of mutated human and bird viruses. And all three pandemics—though deadly and economically disruptive—were short-lived, none lasted longer than two flu seasons which in North America is November to March.

Novel strains of Asian flu also appeared in 1997, 1999, 2003, and 2004; and were so weak that they never spread past Asia. The last genuine bird virus pandemic among humans was the 1969 Hong Kong flu.

In a written response to questions, the Centers for Disease Control and Prevention noted that "*All* flu viruses are avian in nature" and have been around much longer than scientists have been studying them. Influenza bugs are constantly evolving—there now are 130 separate strains of H5N1—but most produce no changes in symptoms that the average flu sufferer could discern.

How New Strains Develop

Still, every so often there's a major event—what scientists call an "antigenic drift"—in which a series of small changes in the virus produce a new viral strain that isn't recognized by antibodies to earlier flu strains. It's why people can catch flu over and over and why they need to be immunized every year.

Avian flu is just such an antigenic drift. The CDC said that the first time any bird virus was transmitted directly from animal to human was in Hong Kong in 1997. It killed a small boy and the subsequent autopsy revealed H5N1.

Later that year, H5N1 infected another 17 people in Hong Kong and six of those perished. Panicked by the thought of a recurrence of the 1918 influenza pandemic, the government slaughtered every chicken in Hong Kong—nearly two million of them—and the disease vanished. For a time.

A different strain of H5N1 emerged in Hong Kong poultry in 2001. The government immediately took the same extreme measures; but this time it didn't stop the disease from spreading—because the

origin was just across the border, in Guandong province, China, where millions of ducks, chickens and geese are raised...mostly by families on a small scale. It was there, where birds wander at will and often interact with wildfowl, that the current strain of H5N1 originated.

There was another outbreak of Avian flu in 2003. Again, it started in mainland China and was brought to Hong Kong. Two members of a Hong Kong family who had visited China became infected; one died, one survived. But the Chinese government never revealed how the family members were infected or where they contracted the disease or if there were any other cases. And, when another member of the same family died of a respiratory illness, no autopsy or pathology tests were performed.

Just like in Los Angeles, when plague was first discovered around the Macy Street district in 1924.

The Chinese government initially tried to hide H5N1's existence—as it had with SARS. And it may have had good reason to be concerned. Some scientists blame China for inadvertently *creating* the new strain of the virus.

A writer for *Health & Science* magazine claimed:

> Chinese authorities permitted or encouraged the misuse of the only available human antiviral drugs as a means of increasing production.

The alleged abuse of antiviral drugs in China "is believed responsible for the growth of resistance to those drugs in many viral strains.... Drug-dosed chickens, cows, pigs and another animals grow fatter faster" because the antivirals prevent infections.

But the mainland Chinese aren't alone. There were new and deadly outbreaks of Avian flu in Thailand 2005 and in Vietnam during 2007. In all, there have been 317 human cases of H5N1 with 191 deaths in the 10 years leading up to June 2007. Almost all the victims had direct contact with infected birds' blood or feces.

The American CDC has conceded that some victims contract the disease from people who handled chickens but emphasizes that:

> There have been a few cases of suspected human-to-human transmission. All those cases reached a dead-end after the second person.

So, a decade after H5N1 mutated into the first bird virus capable of jumping directly from animal to person, there is no evidence it has evolved into being capable of jumping from person to person.

Researchers now may know why. The March 23, 2006, edition of *The Wall Street Journal* reported that:

> According to research published this week by teams in the U.S. and the Netherlands, the bird virus primarily infects cells deep in the human lung, possibly making it difficult for the germ to spread.

The reason, according to the researchers, is that H5N1 "must reach the lower respiratory tract to replicate and it's harder to spread by coughing and sneezing."

Winged Vectors

Since H5N1 is spread by migratory fowl, many American scientists fear it is unstoppable. Some wild birds annually migrate thousands of miles from Scandinavia to Africa; for birds to migrate from Asia to Alaska is a puddle-jump of 75 miles across the Bearing Sea. *The Wall Street Journal* referred to those migrants as intercontinental ballistic missiles, capable of eluding all quarantine attempts on the ground. Researcher Robert Webster was quoted as calling them "The Trojan Horse of H5N1."

The United States Department of Agriculture closely monitors bird markets for any avian influenza virus that threatens the poultry industry. USDA also is responsible for monitoring and testing migratory birds and, through January 2008, none of over 30,000 wild birds tested has been H5N1 positive.

So not every researcher is convinced that an Avian flu disaster is inevitable. "One (sick) migratory bird does not a pandemic make," Dr. Anthony Fauci told the Associated Press in April 2006. Fauci, head of the infectious disease division of the National Institutes of Health, said:

> The surveillance is going to be so intense that it is very unlikely that there is going to be the type of situation [in the U.S.] that ... you see in countries where there is no regulation, in which there is no incentive to compensate farmers, in which the people, who are so poor, when they see their chickens getting infected they immediately sell them or they don't tell anyone because they don't want them culled.

Fauci also questioned whether H5N1 even has the potential to mutate into a deadly human contagion. He points out that, the more easily a virus spreads among people, the less virulent it tends to be. The common cold is a good example—it moves around a lot precisely *because* people don't die from it. The carry it to work, on airplanes, into retail markets and other public places.

Still, Fauci concedes the government should prepare for a possible human pandemic because "it would be unconscionable not to."

As to who should receive the first doses of a future vaccine, Fauci favors neither health workers nor truckers nor the chronically ill but what he calls "spreaders"—people who have to travel or meet with large groups. This is, of course, a logical suggestion. But it's not one that public health agencies think of first.

The Nature of Influenza and Epidemics

The word *influenza* comes from a Greek word meaning "to influence." In ancient times, people believed that the alignment of the stars caused diseases. The truth isn't so cosmic or mystical. But it is kind of complicated.

Avian viruses are referred to by pathologists as *Type A* viruses; they aren't, in fact, limited to birds—but are also found in pigs, whales, horses and many other mammals. Most Type A viruses are specific to a single species (plus birds, which play host to all of them).

The viruses are differentiated by certain proteins on their surfaces. The strain of Avian flu known H(hemagglutin, a type of protein)5, N(neuraminidase, another protein)1 is spread by infected birds through their saliva, nasal secretions and excrement.

Avian viruses constantly are evolving; but that doesn't make an H5N1 pandemic a certainty. There are 144 permutations of the H and N proteins—but only four currently have the capacity to infect humans. Whether H5N1 does evolve into a man-killer is strictly a random arrangement of proteins and, therefore, is unpredictable.

Currently, the fear of Avian flu is more dangerous than the disease itself. People who use vaccines as a precautionary measure won't become immune to Avian flu—in fact, they may become *more* susceptible. Dr. David Baltimore, a Nobel Laureate in Medicine, has warned that, if enough people use the four available (in 2007) vaccines, "the virus is almost certain to mutate to resistance, making the drug useless."

And even greater than the current risk of Avian flu is the threat posed by counterfeit flu medications.

Between November 26 and December 18, 2005, U.S. customs agents in San Francisco and New York seized 50 shipments of phony Tamiflu—enough for thousands of courses of treatment—ordered over the Internet from Asian suppliers. Web ads for the drug emphasized a steep discount from Tamiflu's doctor-prescribed cost of up to $65 for a course of 10 pills.

The fake Tamiflu—which was manufactured in and distributed from China—contained a little vitamin C but nothing that would fight off a flu virus. Sick persons taking the imitation Tamiflu would think they were treating their symptoms, while the disease progressed and turned into pneumonia

China is the world headquarters for counterfeit—and dangerous —drugs and products of all kinds. Since it's also the starting point for most Avian flu, there's a "full circle" quality to its bogus drug business.

When the Chinese government pledged to vaccinate all of its billions of domestic fowl, all kinds of phony Avian flu prophylactics flooded the market. In 2005 alone, over 2,000 batches of fake poultry vaccines were seized by Chinese authorities.

Like the fake Tamiflu, most of the counterfeit bird medicines contain no actual medicine—so the animals sicken and die. Some of them contain just enough flu virus to infect healthy birds.

The counterfeits are a loaded gun pointed at all of China's three-hundred million (mostly poor) farmers who raise fowl to eat and to sell. They're spending hundreds of dollars only to watch their one cash crop expire.

Frightened People Turn to Superstition

As during the great pandemics of Black Death, frightened people have come up with their own ways to guard against Avian flu. Most have no more scientific foundation than the anti-plague Cologne water sold in Germany in 1335...or the urine baths recommended in 1665 London...or gargling with lime juice, salt and hot water popular in 1924 Los Angeles.

Most of the Avian flu nostrums are just fundamental hygiene— but some are downright dangerous.

"Seeing all those pictures of people in Asia wearing masks is so sad I can't believe it," says Dr. Shirley Fanin, the former Los Angeles County

Health Commissioner:

> If you don't change the mask every half-hour, you're
> at greater risk than wearing no mask at all—because
> your breath makes the mask wet and, when it's wet,
> it's a highway for bacteria. That's why surgeons change
> masks several times during a surgery.

Fanin also bemoans the fact that people tend to take the masks off when they get inside:

> Influenza is a virus and viruses are such small particles
> that if I stand in front of a lecture hall and cough I can
> probably contaminate up to half the audience because
> the particles will hang suspended in the air for pro-
> longed periods of time.

What You *Can* Do to Protect Yourself

For protection against bird flu, the CDC recommends not eating contaminated poultry or wildfowl—and urges you to avoid surfaces touched by bird feces; don't lick or eat off anything a bird used as a toilet. And, even though it's not a wildly popular dessert in the U.S., people should avoid eating raw duck blood pudding.

A Vietnamese man died of Avian flu after eating a bowl of this Asian dessert and his dining companion was seriously sickened.

The other CDC suggestions haven't changed much since the flu pandemics of the 1950s: Everyone, especially children six months to two years, should be vaccinated every year—preferably two months before the flu season begins, so the drug has time to take effect.

Other common-sense safeguards include:

- avoiding close contact with people in public places,
- staying home when you're sick,
- covering your mouth and nose when you sneeze,
- washing your hands with warm, soapy water frequently, and
- "avoiding touching your eyes, nose and mouth" if you haven't washed your hands in a while.

Since H5N1 usually attacks only animals, humans have no natural immunities to it—but that doesn't make a killer pandemic inevitable, either

Practical-minded public health experts often bring up the so-called "swine flu" panic of 1976. Over 40 million Americans received government-funded inoculations against a new pig virus that never became an epidemic (and never returned for a second flu season). But then-President Gerald Ford—trailing in his bid for another term— had pounced on swine flu as a campaign issue. Vaccine was rushed into production, some of it without proper testing. As a result, over a thousand vaccinated people contracted Guillain-Barre syndrome—a paralyzing, life-threatening side-effect of the drug.

So, conspiracy buffs might be forgiven for suspecting that bird flu—along with the sudden congressional obsession with supposed health effects of immigration—are political red herrings, designed to divert attention from more immediate dangers: war in the Middle East, environmental problems and a crushing national debt.

But here's the *bad* news.

In 60 percent of the known cases of human H5N1 infection, the victim has died. Compare that to one percent in most cases of flu and around 10 percent during the 1918 Spanish flu pandemic—which was by far the deadliest Avian bug ever.

A frightening article by Tim Appenzeller in the October 2005 issue of *National Geographic* quotes Robert Webster, a 40-year veteran of flu research, saying;

> This virus right from scratch is probably the worst influenza virus, in terms of being highly pathogenic [capable of causing infection], that I've ever seen or worked with.

Like pneumonic plague, Avian flu kills with alarming speed. Chickens die within hours—because the virus attacks every organ. Like pneumonic plague, H5N1 goes straight to the lungs causing tissue to die and blood vessels to burst, flooding the lungs and smothering the victim from within.

H5N1 has spread more quickly and among more species than any previous Avian flu. Migratory wildfowl have carried it from China throughout Asia to Egypt, Turkey, Indonesia, Mongolia, Russia, Eastern Europe, Holland and England. And H5N1 has raced through species just as fast. New research shows that the current strains of H5N1 are more capable of causing disease in mammals than any other H5 virus. Pigs in China, tigers and leopards in Thailand and even housecats in Germany, Austria and the Netherlands have all died from the disease.

The CDC warns against thinking of a "killer pandemic" solely in terms of the number of deaths. "A major impact for society will be the number of illnesses in general, not just deaths."

Avian flu already has had a pernicious effect on the economies of some of the world's poorest nations. In his widely-cited *New Yorker* piece, writer Michael Spector noted that in 2005 and 2006, H5N1 killed more than 100 million chickens and hundreds of millions of other animals in 12 Asian countries.

In Vietnam, 40 million birds died or were killed. The disease has impoverished small farmers and forced the layoffs of thousands of commercial food workers. And, in May 2007, Vietnam reported the first case of bird flu in a human in almost two years.

The Cost of an Epidemic or Other Outbreak

H5N1 had an economic impact in the United States even without reaching American shores. The April 20, 2006, edition of *The Wall Street Journal* reported that Tyson Foods—the biggest meat producer in the country—would report its first financial loss in 12 years. Exports—which accounted for 12 percent of Tyson's chicken sales—were way down, as people around the world remained wary of eating *any* chicken, regardless of its national origin.

Bad news for shareholders, however, was good news for consumers, as chicken prices in the U.S. were down over 30 percent from the previous year.

At the same time, mainstream media outlets around the U.S. reported that individuals and organizations (not all of them *health* organizations) were stockpiling Avian flu vaccine—much as they'd stockpiled anthrax remedies after the 9/11 attacks.

This stockpiling ran up the price of the vaccine supply that remained on the market.

All the reports about stockpiling vaccine in the event of a human outbreak stumbled over a rich irony: There is, in fact, no vaccine for the H5N1 strain of Avian flu. The U.S. Food and Drug Administration had approved four antiviral drugs for "treatment or vaccination" of Avian viruses. But public health experts knew that two of them— amantadine and rimantadine—didn't work on H5N1. The third— Relenza—was effective in *treating* the symptoms of Avian flu but was ineffective at *preventing* it. That left only Tamiflu as a sort of universal solution.

And Tamiful was the drug most people were hoarding.

But the *New England Journal of Medicine* reported in December 2005 that a recent, high-quality study had showed even when Tamiflu killed most—but not all—of the Avian flu germs in a person's body, the remaining viruses became resistant to the drug. That would leave infected people capable of spreading the disease, even during treatment, and then later becoming re-infected.

It's the disease that becomes immune, not the person.

Earlier, in the Fall of 2005, the journal *Nature* reported that of eight Vietnamese who contracted a strain of H5N1 and were treated with Tamiflu, four died anyway.

So, the first line of defense has already been breached.

More bad news: Even if yet-to-be-discovered antiviral drugs work, Americans probably won't be able to get enough of them to prevent an epidemic.

Tamiflu isn't manufactured in the U.S.; most vaccines aren't. The American pharmaceutical companies got out of the business because of small profit margins and an epidemic...of lawsuits. *The Wall Street Journal* reported late in 2005 that there was only one major flu vaccine production facility in the U.S.—the others are in Switzerland, the U.K. and France.

Here's the *really* bad news.

The CDC notes:

> The severity of the next pandemic cannot be predicted,
> but modeling studies suggest that its effect in United
> States could be severe.

This is one of their computer models: A "medium-level" epidemic would cause 89,000 to 207,000 deaths; between 314,000 and 734,000 hospitalizations; 18 to 42 million outpatient visits and another 20 to 47 million people home sick.

That "medium-level" outbreak could infect nearly 30 percent of the entire population. The economic consequence is computed to "impact between 71.3 and 166.5 billion [dollars]."

And the prospects get worse. The CDC also predicts:

> Resources in many locations could be limited because
> of how widespread the influenza pandemic would be.
> The pandemic will last much longer than most other
> "emergency" events and may include waves of influ-
> enza separated by months. The numbers of health-
> care workers and first responders available to work

can be expected to be reduced; they will be at high risk of illness through exposure in the community and in health care settings and some may miss work to care for ill family members.

In addition, increased travel, increased density of animal populations, increased interaction between animals and humans, increased density of human populations all contribute to our concern about another pandemic occurring.

How well-prepared is America to fight the most severe pandemic (the highest-level on the CDC's severity scale)? An outbreak for which there is no known inoculation or cure? Not very, says Henry Miller, a founding director of the FDA's Office of Biotechnology. He claims preparation is "grossly inadequate for vaccines, drugs and hospital beds."

Preparing for the Unpredictable

In fairness, no one can adequately plan for the unpredictable, for the "novel strain" of H5N1 that will emerge if the virus suddenly gets the idea to mutate and start spreading from person to person.

Dr. Miller's grim assessment is reflected in an early draft of *Pandemic Influenza Preparedness and Response Plan* published by the Department of Health and Human Services (HHS). The 2004 draft of the Executive Summary is remarkable for its candor. It somberly predicts that a human contagion breaking out in several American communities simultaneously would result in

1) limiting the ability of any jurisdiction to provide assistance to other areas;

2) an overwhelming burden of ill persons requiring hospitalization or outpatient medical care;

3) likely shortages and delays in the availability of vaccines and antiviral drugs;

4) disruption of national and community infrastructures including transportation, commerce, utilities and public safety.

Then, the Plan soothingly adds:

Substantial resources have been allocated to assure and expand influenza vaccine production capacity; increase

influenza vaccination use; stockpile influenza antiviral drugs in the Strategic National Stockpile.

It's true that CDC has speeded up significantly the lead-time for producing a new vaccine but mass producing it is still a long way off. Ordinarily, the live virus that is the active ingredient in a flu vaccine is grown in chicken eggs. But H5N1 is so lethal, it tends to kill the eggs trying to grow it, according to Tim Appenzeller in the *National Geographic*.

The February 2, 2006, online edition of the British science magazine *The Lancet* quotes scientists at CDC and Purdue University announcing they've developed a technology for making vaccines which doesn't require eggs—but the resulting vaccine has only been tested on mice and chickens.

The HHS document says that once an effective vaccine is available, it will be used first to "Implement a vaccination program that rapidly administers vaccine to priority groups ... " but the plan doesn't specify whom those priority groups might include and you better assume you're not in one.

HHS has divided threat assessment into four levels starting with PHASE 0 LEVEL 0—which basically is where there are "no recognized human infections caused by a novel influenza strain." It goes up to the highest level, PHASE 4 LEVEL 0: "A second pandemic caused by the same virus."

Public health professionals ruefully call this the "Kiss Your Ass Goodbye Phase."

Every PHASE and LEVEL in the draft document is followed by references to distributing a vaccine which doesn't actually exist and "when a pandemic first strikes vaccine likely will not be ready for distribution." According to the preparedness study, a vaccine won't exist for at least six to eight months after the "novel strain" of a new virus or syndrome is identified.

What People Can Do

George W. Bush requested $200 million from Congress to prepare against public health pandemics in 2004 and 2005. Some of that money was spent on research and on stepped up surveillance in Asia— where any person-to-person strain of H5N1 most likely will emerge. Much of the money was spent on a slew of new alphabet agencies:

NIC, AHS, NVPO, ASPA, OGHA, HRSA, CMS, NVAC, ACIP, ACCV, ASPHEP and the consonant-heavy VRBPAC (Vaccine and Related Biological Products Advisory Committee).

More government. Marvelous.

Don't Look to the Feds for Protection

In the spring of 2006, the White House released its "National Strategy for Pandemic Influenza Implementation Plan."

The Plan intensified scrutiny of incoming migratory birds and created a sort of Distant Early Warning System by supporting the training of human and animal health workers in a hundred foreign countries. The White House also pledged financial, medical and technical assistance to any country where Avian flu might emerge.

The federal Plan claimed that more than a billion dollars had been invested in new vaccine technologies.

A year later, the White House said it had enough "pre-pandemic" H5N1 vaccine—the vaccines which are, at best, minimally effective— "to vaccinate approximately 6 million people."

By contrast, England and France—each with a quarter of the U.S. population—have 15 million doses. Each.

The Plan also outlines a number of "Non-Pharmaceutical Interventions for Mitigating the Impact of a Pandemic." According to Jeffrey Runge, chief medical officer at the Department of Homeland Security, one of these interventions is that National Guard troops would be dispatched to those cities facing possible "insurrection."

Most branches of the military could have roles to play in the event of an Avian flu pandemic or other disease outbreak.

According to the *Washington Post*, the Pentagon—anticipating difficulties acquiring supplies from the Far East—is considering stockpiling millions of latex gloves. And the already-foundering and disgraced Department of Veterans Affairs "has developed a drive-through medical exam to quickly assess patients who suspect they have been infected."

McMedicine. For people spitting up blood.

But here is the *worst* news of all.

According to the White House, "The Department of Homeland Security would have overall authority" in an all-out war against bird flu. America's defense against a possible killer epidemic will be controlled by the agency notorious for its cronyism, buck passing and

colossal indifference to human suffering—the same agency which controlled the defense of New Orleans against Hurricane Katrina and which believed that the defense of the nation's ports should be controlled by a Dubai-based shipping conglomerate.

Bring out your dead.

12 Judgment Day

Local, state and federal officials who have engaged in Plague work may view with satisfaction and pardonable pride on the results accomplished.

—Dr. Walter M. Dickie, Secretary, California State Board of Health, 1925

I'd agree with that.

—Frank Sorvillo, chief epidemiologist, Los Angeles Dept. of Public Health

In his biennial report to the governor, Dr. Walter M. Dickie notes formally—for the first time—that the symptoms exhibited by Jesus Lajun and daughter Francisca the previous October had been misdiagnosed. The father's "venereal disease" was actually bubonic plague and 15-year-old girl's "lobar pneumonia" was really secondary plague pneumonia.

But that bit of candor was lost in a sea of justification. Elsewhere in the report, Dickie declares that the "management" of the plague epidemic constitutes "the most outstanding accomplishment of California's health officers."

And all of the public health officials interviewed for this book emphatically agree with him.

Dr. Kenneth Gage, research biologist for the Centers for Disease Control, says:

> Here you have the most highly communicable disease known to man and it breaks out in a dirty, overcrowded area and, you say, many officials don't want anybody to know about it. It's a recipe for catastrophe.

> And yet, fewer than 50 cases are reported, fewer than 40 people die, and no one perishes outside the immediate area.

The former Health Commissioner of Los Angeles County, Dr. Shirley Fanin, adds:

> Historically, Plague has taken months or even years to bring under control. That it took Los Angeles only three to four weeks makes it makes it one of the best success stories; it's the shortest outbreak of pneumonic plague anywhere in the world.

She awards most of the credit to County Health Officer Dr. J.L. Pomeroy who imposed the illegal quarantine around Macy Street and probably saved hundreds—if not thousands—of lives by his usurpation of state power. Fanin goes on to say:

> It's very fortunate that it [plague] didn't spread any farther and it's my opinion that is because, when they found out what it was, they took quick and decisive action.

Though Pomeroy's quarantine undoubtedly took lives because it forced healthy people to live under the same roof as those exposed to the disease, Fanin thinks that also was necessary:

> They did not have the ability to tell the difference between those who were exposed and those who were in early incubation. They had no choice; anyone who had been in face-to-face contact with a real case had to be considered an incubating case. To let them leave their homes and go to other parts of the city risked setting up another foci of infection.

This is the hard edge of public health administration—an edge that most people never see. Public health administrators rarely see issues of property rights, civil rights or Constitutional rights. They see disease and vectors...and responses that are judged as effective or not by incidence rates and reported deaths.

From this perspective, the decisions that Dickie and Pomeroy made *were* justified. They contained an outbreak of pneumonic plague.

Perhaps this is a flaw in the public health perspective; or maybe it acknowledges—indirectly—another hard truth: The majority of Angelinos who were not affected by the 1924 outbreak may have approved of the harsh steps local officials took. And the majority may have just as well not known the ugly details.

What Became of the Key Players

J.L. Pomeroy continued to serve as Los Angeles County's top public health doctor until his death in 1941...26 years in all. He is credited with pioneering the development of satellite health centers for the poor, setting hygiene standards for—and inspections of—all restaurants and eating places and with authoring the legislation for the first metropolitan sewage disposal system, an act which substantially reduced communicable disease outbreaks in Southern California.

His *Los Angeles Times* obituary praised him for the county achieving "a reputation as one of the nation's most healthful areas." The story never mentions Pomeroy's role in "managing" the 1924 plague outbreak.

The *Examiner*'s obit, however, lauds him for it:

> In various crises, notably when the bubonic Plague
> broke out in one congested section, Dr. Pomeroy's
> courageous and immediate action saved Los Angeles
> from widespread epidemics and great loss of life.

The paper also notes that Pomeroy often took on big businesses such as "the concrete trust" when he felt their practices were inimical to "the relatively new field of public health [in which] he has been recognized as an outstanding pioneer."

An admirable legacy, considering that for his first eight years in office Pomeroy was the only full-time person in the office.

State Health Officer Walter M. Dickie expanded the quarantine to include Asian and African-American districts but, when a plague rat

was found in Beverly Hills, Dickie did nothing. He also made the ambiguous statement that:

> Your Mexicans should not be permitted to live next [to] certain industries like food packaging establishments and slaughter houses.

Though his actions elsewhere indicate that Dickie was not particularly sympathetic to the socioeconomic plight of Hispanic immigrants to California, this simple observation suggests a concern for their living conditions.

According to history professor William Deverell:

> I don't fault [Dickie] for his moves to quarantine and to do so aggressively because it did arrest the disease. Where the story gets more interesting for me is how the disease itself is made into an ethnic trait—and I think Dickie is guilty of that, as are many people. In that respect, he's guilty of allowing a disease which has no ethnic predilections or ethnic dimensions to its behavior—he's allowing that disease to be seen as an ethnic disease and that's a mistake for a physician.

If anything, the Black Plague epidemic of 1924 and 1925 only confirmed existing Anglo prejudices toward "Mexicans."

But of all the health and political figures identified with the L.A. plague outbreak, Dickie emerged as arguably the most honorable and well-intentioned. His plague-fighting experience in San Francisco served him well in Los Angeles, where he assumed control of the entire multi-agency effort and brought the epidemic under control in record time.

It was Dickie, too, who incessantly—if futilely—harangued the City Council and the Chamber of Commerce to provide decent housing for the city's working poor or at least to enforce the city's own sanitation and building codes. He blasted the power barons for the city's "deplorable health standards" and argued the then-novel position that it is government's responsibility to wipe out communicable diseases.

In a 1934 article in *The American Journal of Public Health*, Dickie wrote:

> It must be admitted that in many parts of the United States, practitioners of medicine, during the past few years, have developed a critical if not antagonistic at-

titude toward preventative medicine and public health administration.

Dickie went on to serve two terms as director of the State Department of Public Health and was a member of the state emergency council. He is recognized for greatly improving public health services in California by expanding sanitation programs, providing maternal and child health care programs, for funding public health nursing and even for initiating cannery inspections.

He published two books about plague and died—much honored and respected—on May 8, 1957.

But Dickie's legacy also must include his—probably inadvertent—suggestion as to when and where the plague cover-up began. In his original account of the outbreak, Dickie wrote this about the first victim, Jesus Lajun:

> Later, toward the middle of the month [October 1924] is when the bubo was still discharging a small amount of pus and the test was made from that. A guinea pig inoculated with this culture ...was reported to have died of Plague.

Reporting even the *suspicion* of Black Plague to all relevant health authorities is mandated by federal and international law. Since Lajun died October 11, it is reasonable to infer that City Health Officer Dr. Luther Powers knew there was plague in his city right after the guinea pig was autopsied—no later than October 13.

That was 17 days before the quarantine was imposed.

Powers discharged none of his legal duties which were to seal off the first two homes where plague broke out and to notify county, state and federal health services of the disease. Indeed, Powers even denied there was plague in the city when confronted with the medical evidence by his current and former chief pathologists on October 30, the day county health chief Pomeroy began doing what the city chief should have done 17 days earlier—quarantining Macy Street.

Had the city health officer initiated the required emergency procedures, at least 25 lives would have been spared.

It was Powers' good fortune to die on October 31, the day after he refused to accept the findings of his own pathologists. Several days later, his picture graced the cover of the *Monthly Bulletin* of the Los Angeles Health Department. Powers was eulogized as "nationally known for his long, uncompromising fight for the best in public health."

The circumstantial evidence is even stronger that Los Angeles County General Hospital Superintendent Dr. N.N. Wood knew there was plague days—if not weeks—before October 30. After all, injecting the lab animal with Jesus Lajun's drippings occurred in Wood's own hospital and surely the result was communicated to him.

Wood did initiate safety precautions within his own fiefdom—setting up an isolation ward for plague patients and shutting down the hospital's morgue—before October 30. But he ignored his other responsibilities, most grievously by allowing a public burial for Lucina Samarano where her husband infected with his incubating plague nearly everybody in attendance.

And then is the troubling matter of the death certificates issued in the early days of the outbreak.

First, there are the missing death certificates of Jesus Lajun and his 15-year-old daughter; under Cause of Death did they read "bubonic plague" and "pneumonic plague," respectively? In that event, the death certificates would be proof that health authorities knew there was plague by the middle of October and did nothing.

Then, there are the illegally altered death certificates of the next three victims; their causes of death were changed to "plague pneumonia" from the original false reports—either "acute myocarditis" or "peculiar pneumonia."

Lucina Samarano's death certificate now says an autopsy was performed on her but, if that were true, then why was her plague-riddled body released to her husband in contravention of all health regulations?

Unlike Luther Powers, Dr. N.N. Wood lived long enough to endure the scrutiny of his peers. And their judgments were harsh.

In 1931, Dr. Wood—who bears an uncanny resemblance to the farmer in the painting "American Gothic" by Grant Wood (no known relation)—was accused of incompetence by a member of the County Board of Supervisors. Some Board members asked Wood to resign as head of County General Hospital. The *Los Angeles Times* account of the matter is emphatic that the accusation against the doctor

> is in no way connected with the asserted wholesale
> stealing that investigators declare has been going on
> at the institution for years.

But even that denial speaks volumes about the nature of the dispute between the politicians and the head physician.

Dr. Wood dug in his heels. He refused to resign the post he'd held for nine years and vowed:

> I am prepared to answer the charges at any time in any official hearing. I can refute them.

But, when it came to making those answers, he couldn't. On July 1, 1932, the Board of Supervisors stripped Wood of all his duties at County General Hospital. The Board also voted unanimously to give a grand jury all the evidence produced against Wood during the public hearings.

Wood wasn't charged with any crimes. But, after his termination, the man sinks into well-deserved obscurity until his death in 1952.

Once again, the evidence against Drs. Powers and Wood is circumstantial. There is no smoking gun. But there is *a lot* of circumstantial evidence.

Boyle Workman, the Chamber of Commerce's go-to guy in City Hall, left politics a few years after the plague epidemic. It was Workman who, as president of the City Council and chairman of its Finance Committee, shepherded though the new "emergency" laws which permitted the city to burn private homes and private property without compensation.

In 1929, Workman ran for mayor—an office his father had held after cofounding the Chamber of Commerce—but was defeated. He left government and started a company (one of the first on the west coast) that managed *other* really rich people's money.

The Chamber Loses Its Clout

The power of the Chamber of Commerce waned as the Great Depression waxed. From the 1930s and into the early 1950s, the shadow government in Los Angeles was its police department—perhaps the most corrupt in America at a time when there was rabid competition for that title. (For a page-turning account of how the LAPD aided and abetted the most notorious sex killer in California history, read ex-detective Steven Hodel's book *The Black Dahlia Avenger*).

But even the police rule declined rapidly after William Parker became a "reform chief" in 1950. From the mid 1950s to the early 2000s, the most formidable behind-the-scenes force in Los Angeles has been the real estate *corporados*, the same kind of developers who invented the city in the first place.

A Slight Epidemic

On January 6, 1926, the *Los Angeles Times* selected three local heroes to represent California at the Sesquicentennial Exposition in Philadelphia. One of them was Macy Street School teacher Pearl Milner. According to the paper:

> Miss Milner was picked for her work in 1925 [actually, it was 1924] during an epidemic in the Mexican quarter. She visited the district every day [actually, she *lived* in the school during the quarantine] with supplies and clothes for the sick and their relatives ... Although she was excused with other teachers for a month while the epidemic was on, she gave up her time to help the stricken people.

> Miss Milner said at her naming last night she didn't think she had done anything but her duty and would not talk about her deeds. She insisted her principal, Nora Sterry, was the heroine and all praise should go to her.

Other than Miss Milner, the pristine heroes of the Black Death numbered just two.

Father Medardo Brualla was the assistant pastor of Our Lady of the Angles Church who brought succor to the doomed in a death-defying *auto da fe*. He rated a two-paragraph obit in the *Los Angeles Times* which celebrated him for giving

> his life that sufferers with the dread pneumonic Plague, which has struck this city, might receive the consolation of their faith in their dying moments... he persisted heroically in his religious duties, although it had been established that virtually every person who came in contact with the sufferer with the plague was doomed to a speedy death.

Requiescat in pacem.

But, among all, it is Nora Sterry who stands out as the undisputed heavyweight champion of humanity. Having done everything imaginable to improve the unconscionable living conditions in Macy Street, she hurled herself into harm's way, sharing the plague dangers of the marginalized community to which she devoted her life and her substance for over two decades. For running the quarantine to feed, clothe, enlighten and entertain "my children," the spinster schoolmarm was

lauded even by the vulgar English-language dailies—which otherwise downplayed the plague danger.

In November 1924, the *Los Angeles Times* credited Sterry's presence in the quarantine zone for the fact that

> there were no arrests for breaking quarantine and that the residents of the quarantine area submitted to the restrictions imposed in a manner that did them credit. ...That this attitude was due in great measure to Miss Sterry's influence cannot be doubted.

Susan Dorsey, the state Superintendent of Schools praised Nora for her relief work in questionable English:

> The Macy community will long remember Miss Sterry and her self-forgetful efforts in their behalf.

Many of her students dead or in diaspora, Nora stayed at Macy Street long enough to accomplish one more goal: A playground for the district in which there was no grass, no trees and no recreational facilities other than at the school. A playground for what was left of the district.

In May 1927, the *Times* noted:

> Boys and girls of Chinatown have a "regular" playground, with the same apparatus and expert supervision of their games that the American boy and girl enjoy at other municipal playgrounds.

The *Times* piece also noted that the five-acre parcel of land for the playground was owned by the Southern Pacific Railway—where Nora's father had been chief counsel, Western Region—and leased to the Los Angeles Public Market Company.

The article went on to say:

> Through the efforts of Miss Nora Sterry, principal of the Macy Street school and heroine of an epidemic siege of several years ago, the market company has tendered the use of land for recreational purposes without charge.

It is the only mention of Nora's role in the plague outbreak that the *Times* would ever make.

The playground was dedicated on October 18, 1927. The *Times* coverage features a big photo of actress Gilda Gray smiling hugely and trying to hold on her lap a squirming, angry-looking Chinese

toddler. The caption reads "Gilda Gray and Young China." The article goes on to state:

> For several months the Chinese children and their parents have been gathering at the grounds to indulge in their quaint pastimes and to help remove debris from the old lot.

Leave it to Nora Sterry; coolie *quid pro quo*.

The story also notes that "the playground is open to all Chinese children from 3 to 5 PM daily.

The Trail of the Heroine

In 1930, Nora Sterry transferred to the Sawtelle Boulevard School, a teachers' training institution sponsored by the University of Southern California. She continued to press upon her charges her ideas for educational reforms—especially for what, today, would called "inner city" schools.

She personally implemented many of those reforms after being appointed to the County Board of Education Supervisors in June 1930 and helped create what was one of the best public school systems in the nation—until 1977, when a property tax reduction measure eviscerated public school funding.

Nora served as Board president until her death from cancer in 1941. She was 62.

Her *Los Angeles Times* obituary, published on April 14, 1941, notes that Nora was a leader in Red Cross work during

> the World War and when epidemics swept through the poorer districts she organized relief work ... Miss Sterry became principal of the Macy Street School in 1913 and was known not only as an educator of that district but as an active leader of welfare work among families whose children were under her care.

Two months after her death, the teaching facility was renamed the Nora Sterry School. In 1954, the school was converted to The Nora Sterry Elementary School.

A newspaper article from February 28, 1954, commemorates the event without ever mentioning Nora Sterry or what she did. The article does exalt the real estate developer Stephen H. Taft—of the Ohio Tafts—who transformed one hundred acres of open land into hun-

dreds of tract houses and donated one acre for the first local school house, which he also built in 1898.

Today, the Nora Sterry campus also houses the Nora Sterry Center for Early Education and a special education unit. The school itself is a mirror image of LA's racial diversity.

A thoroughly unprofessional survey of teachers and administrators who were around one day during the summer of 2005 found that no one could identify Nora Sterry or why the school was named for her.

One Survivor from the Macy Street Porch

It may have been the serum or something as simple as a miracle that 4-year-old Raul Samarano survived pneumonic plague.

In two weeks near the end of 1924, Raul lost both parents, three stepbrothers, both grandmothers and an aunt and uncle and three cousins. Raul was only person left alive of the score or more who gathered on his parents' porch that overheated September Sunday to enjoy Jesus Lajun's tale about finding the dead rat.

Raul grew up hard in a succession of foster homes, where he was regarded essentially as unpaid labor. He seldom saw his two sisters and brother—who were in separate foster care. Raul was the only one to produce issue, a daughter.

Raul spent some of the Depression years in the Civilian Conservation Corps. Then he joined the Navy in World War II. He served in the Coast Guard for three years and was honorably discharged with the rank of seaman first class. In 1944, he married Doris Zimann, a girl of Anglo-German antecedents and in 1952 they had their only child, Donna Elaine.

Raul joined the Army Corps of Engineers in Los Angeles, got his GED at night school when he was 30 years old and rose to Assistant Chief of Civil Defense.

"He was being groomed to be Chief," daughter Donna remembered in 2005. "But his drinking cost him the promotion."

Raul Samarano retreated from life with the frightened wariness of an abused child.

"He totally disassociated from anything Mexican," Donna said of her father—who was an American, having been born in Arizona:

> We didn't even eat Mexican food. I never heard him
> speak Spanish unless my mom mispronounced some-

> thing. All their friends were Anglo except for one man
> and Dad didn't trust him; he'd tell my Mom, "Don't
> get too friendly with him."

Raul's self-loathing was made manifest the day Donna was born.

> My mother wanted to name me Rita after Rita
> Hayworth but my father said, "That's too ethnic." But
> Donna, that sounded Italian and it meant *Lady*.

Raul never talked about the events of 1924; Dottie and Donna learned about the plague from his sister Adelaine after a revealing incident in 1960.

Dr. Elmer Anderson—who had saved Raul's life by ordering the Yersin serum for the boy—found Raul after the Health Department had spent years looking for him. And their reunion made the pages of the (much changed) *Los Angeles Examiner*.

Dr. Anderson was quoted as saying:

> I had always wondered what became of the baby. But
> he seemed to have vanished from the face of the earth.

The reason Raul was so hard to find is simple; he'd changed his name. He changed it from Samarano to Samareno.

"He thought it sounded Italian," Donna says.

> He kept his first name for legal reasons but always
> introduced himself as "Mr. Samareno." Everyone at
> work called him "Sam." My mother said that he had
> been so ridiculed as a Hispanic that he decided to
> make a new life for himself as an Italian.

Since Raul enlisted in the navy a month before his 22nd birthday under his Italianate name, he must have changed it almost immediately upon turning 21.

In the early 1960s, when Donna was still a young girl, Raul's social drinking became obsessive. She remembers:

> There was a bar across from the Federal Building
> [where he worked] and he used to go over there at
> lunch and get drunk. Then he'd go back to the office
> and they'd put him somewhere to sleep it off. Every-
> one liked him including the generals he'd escort around
> town. He could be very nice. A *Dr. Jekyll and Mr.
> Hyde* kind of thing.

Alcoholism is a progressive disease. It's like jumping off a hundred-story building: The first 99 floors are exhilarating. But, as the rate of the body's descent accelerates, so does the amount of destruction to the drunk and to everyone around him.

Donna says:

> He became violent. When I was about 13, I had some Mexican friends from my junior high. That sent him over the edge: He came into my room one night—he'd been drinking—and said, "I don't want you hanging around with those goddamn Mexicans any more." And, without even thinking, I just looked at him and said, "What do you think you are?" "I got slapped across the room for that one.

Later, Raul spent two days in jail for threatening his wife with a .38 pistol. According to Donna, once, when Raul was drunk, "he threw a can full of something at grandmother and it gave her this humongous bruise."

The elder Mrs. Zimann would gather up the liquor bottles Raul thought he had hidden and put them in a box where he would see it.

Donna says:

> She thought that would embarrass him but it didn't. She even went down to the liquor store and asked them to please not sell to Dad, that he was an alcoholic. But they said, "Lady, that's what we do, sell liquor."

Without treatment, alcoholics only get worse—never better. Raul and Dorothy divorced in 1961. But he kept moving back in with Donna, her mother and grandmother whenever he was sick or broke or both.

"I was very fearful of him," Donna says, "until I married at 16 and moved out of the house. That was a good part of my reason for getting married, to move out of the house."

After ignoring Donna's first two marriages, her father was ecstatic about her third:

> I married an Italian and—sight unseen—Dad though that was wonderful! He bought a new suit for the wedding. But the day before he was dead drunk and I told him not to show up that way tomorrow. I said,

"Get yourself together or don't come." And he said, "Then I just won't come." He wound up staying home.

He smashed up cars, lost his license and was knocked down and nearly killed by a car while trying to cross a street in a drunken stupor. That's when doctors discovered he had a liver the size of a toaster.

Once again, he moved in with his ex-wife and her mother to be nursed.

On November 14, 1982, a month after his 62nd birthday, Raul Samoreno (*ne* Samarano) put a pistol to his temple and shot himself to death.

He had miraculously survived pneumonic plague but the racism symptomatic of the outbreak finally killed him.

According to Donna:

> He placed two things carefully on the table in front of the sofa where he shot himself. One thing was the mechanism of a music box and it played this old song from *The Fantasticks*, "Try to Remember" ("Try to remember the kind of September/When you were a tender and callow fellow...").

> The other thing was an old black-and-white photograph of a tiny Christmas tree. There are no people in the photo. I think it was taken in the living room of a house he and my mother shared with my grandmother before I was born.

Rosebud.

The Final Tally

At least 30 people—family members, borders, friends, an ambulance driver and a nurse—contracted plague as a direct consequence of Jesus Lejun's fleabite. And 28 of them perished.

Nevertheless, in 1925, a State Board of Health anthology of government and medical reports on the epidemic, concluded, "That the evidence could not be obtained to connect these two cases" (referring to the first official victim, Jesus' 15-year-old daughter Francisca, and the other 19 people who were at the Samarano house on September 28 and also died). The report theorizes that the uncertainty

may be explained by the reluctance of the Mexican to impart information, especially when he does not fully comprehend the reason.

But the same year—1925—the Los Angeles County Medical Association made the exact opposite assertion about Mexican Americans:

The Mexican, unlike the Oriental, does not attempt to hide his sick or dead. Being a Catholic people, they always, when ill, call the Priest, and generally are prompt in securing medical aid.

True to the pledge of its managing editor, the *Los Angeles Examiner* will not run any plague story "not in the best interests of the city". The paper will not even associate Los Angeles with the disease until a decade later, in 1935, in a feature story called "Black Death on Clara Street." *Two* decades later, it runs a front-page feature about the 1924 plague outbreak under the headline "City In Nightmare." The hideously ironic subhead reads, "Now It Can Be Told."

Buried in the story is a brief reference to "resistance" by some of the Mexican Americans in the quarantine zone. The reporter who wrote the piece was still alive and fully alert when he was interviewed in 2005—but he couldn't recall any of the details.

County Health Officer Pomeroy's annual report for 1924 also refers to that—or another—revolt where the quarantine guards faced "considerable resistance from the Mexicans ... [but] military quarantine soon brought them to terms."

There is no elaboration on this use of force in any medical or government record and no newspaper reported it.

But it does seem that some of the Macy Street residents put up a fight when the soldiers set up the quarantine perimeter.

The *Los Angeles Times* buried and distorted the plague story when it ravaged its hometown—and hasn't published anything since. But the paper trumpeted epidemics *elsewhere*. A screaming, first section headline declared "World Seen Imperiled by Rat Plague" when a single American soldier came down with bubonic plague in Vietnam in 1967.

The *Times* did not, however, report that America's defoliation of the forests drove vermin into the cities where plague killed 50,000 North and South Vietnamese.

Soldiers in Vietnam were inoculated against the disease—but military spokesmen lied about what the troops were being protected from, calling it "hepatitis" and "measles."

A Slight Epidemic

> In 1970, the *Times* ran a story claiming
> the infamous Black Death of the Middle Ages [is]
> making a comeback in ghetto areas and hippie-style
> communes.

What's in the article isn't true; there was no such outbreak any-where. The article seems just another effort to link undesireable people with a disease that suggests poor hygiene. What *is* true isn't in the article; Los Angeles' own life-and-death struggle with the disease 46 years earlier.

No one will ever know exactly how many people in and around the Macy Street district contracted the infection—nor how many died of it. Estimates in records from the state and from the Public Health Service, forbearer of the Centers for Disease Control and Prevention, vary between 31 and 37 dead.

Most of the L.A. County and City health records were thrown out when the two agencies merged in 1963. The records from Los Angeles County General Hospital—where all but a handful of victims wound up—were either thrown out or lost, depending on which spokesperson is speaking.

Newspapers and health department records misspelled the sur-names of many of the dead—and even their relationships to other victims. Jesus and Maria Valenzuela were listed alternately as husband and wife and as brother and sister. Guadalupe Samarano was, at various times, referred to as a male and a female. Mary Costello, the nurse at L.A. County General Hospital, was declared dead in a November 15 newspaper article...but "resurrected" that same day in a different paper.

Juliana Herrera, Luciana Samarano's 63-year-old mother was checked into the hospital under her maiden name of Guiland so, on her death certificate, the coroner wrote down that she was "White."

Dr. William Deverell observes:

> They never figured out how Martin Hernandez—who
> contracted plague somewhere outside of the quaran-
> tine zones—died; he got bit by something and there's
> no telling what happened to that little vector of the
> disease. There may be other deaths associated with his
> kin networks or otherwise that never came to light.

The various surviving reports would indicate at least 41 cases of Black Plague and 37 fatalities. There were seven cases of bubonic plague

that claimed five lives and a single, fatal case of septicemic plague. That leaves 33 registered cases of pneumonic plague which killed 31 people. The only two people who survived that form—which usually is 100 percent fatal—were 4-year-old Raul Samarano, whose doctor requested the plague serum, and County General Hospital Nurse Mary Costello, who also received the drug.

They—along with a 15-year-old Mexican American boy—are the only people known to have received any of the 500 doses of serum ordered by health officials.

The Historical Impact

Los Angeles has the distinction of being the last city in America to suffer an epidemic of Black Death—and the only American city where bubonic plague was allowed to fester into the highly-communicable pneumonic form. Los Angeles' mortality rate of 92 percent also was higher than those attributed to the 14th Century pandemic (50 percent) and the 17th Century Great Plague in London (66 percent).

Macy Street itself was a victim of the Black Plague. Most of its Hispanic residents moved away—their friends and relatives dead, their homes and belongings destroyed without compensation and their American Dreams having been spavined by the venomous indifference of the city's potentates.

Many of the refugees moved east to nearby Chavez Ravine where, in 1953, their homes, businesses and schools were destroyed once again—this time under the authority of "urban renewal."

"The people didn't want to move," notes Dr. Shirley Fanin. "And the land got taken from them in something like Eminent Domain. That was kind of ugly."

As often happens under the noble rubric urban renewal (and has been upheld by the U.S. Supreme Court as recently as its 2005 *Kelo v. New London* decision) , once the residents had been pushed off the land it was sold to private enterprise—in this case, to the Los Angeles Dodgers...the baseball team newly arrived from Brooklyn.

Originally, the Dodgers' stadium had a place name: "Chavez Ravine." But that was thought to be too "ethnic" by some.

(An interesting side note: The man who had given his name to the area was *not*, as widely believed, labor activist Cesar Chavez—but a successful Hispanic miner who'd been run out of Northern California

by an envious white mob during the gold rush of 1849. He'd wandered down the coast and ended up settling in Los Angeles.)

The baseball team's park is called Dodger Stadium.

Even Los Angeles' attempts at multiculturalism often are patronizing and redolent with unintended irony. The nearby American League baseball team is called "The Los Angeles Angels of Anaheim"—which translates as "The The Angels Angels." Of Anaheim.

The twin towers of barred windows and razor wire that are the Los Angeles County Jail now occupy the western edge of Macy Street.

After the Hispanic core moved out of the Macy Street district, the Asian minority expanded and quickly dominated the ethnic makeup of the neighborhood. So completely did the new residents take over that the neighborhood cast off its old name—and the connotations of death and disease that went with it. Whoever owned the land—and it's long been rumored that it was *Times* publisher Harry Chandler—simply sold or leased it again to a new wave of hard-working, politically passive immigrants.

Since 1930, the area has been known to Angelinos as Chinatown.

End Notes
and Bibliography

Books

Brooks, Geraldine. *Year of Wonders*. Viking Penguin, 2001.

Cantor, Norman. *In the Wake of the Plague: The Black Death and the World It Made*. Harper/Perennial, 2005.

Camus, Albert. *The Plague*. Alfred A. Knopf Inc., 1948.

Chase, Marilyn. *The Barbary Plague: The Black Death in Victorian San Francisco*. Random House, 2003.

Davis, Mike. *City of Quartz*. Vintage Books, 1992.

Defoe, Daniel. *A Journal of the Plague Year*. Barnes & Noble Publishing, Inc., 2004. (First published, 1722.)

Deverell, William. *Whitewashed Adobe*. University of California Press, 2004.

Franklin, Ariana. *Mistress of the Art of Death*. G.P. Putnam's Sons, 2007.

Gottfried, Robert S. *The Black Death: Natural and Human Disaster in Medieval Europe*. The Free Press, 1983.

Highland, Monica. *Lotus Land*. Coward-McCann Inc., 1982.

Kelly, John. *The Great Mortality: An Intimate History of the Black Death, the Most Devastating Plague of All Time*. Harper-Collins, 2005.

Lozano, John M., C.M.F. *The Claretians: Their Mission and Spirit in the Church*. (Translated by Joseph Daries, CMF.) Claretian Publications, 1980.

Martin, Helen Eastman, MD. *The History of the Los Angeles County Hospital (1878-1968) and the Los Angeles County-University of Southern California Medical Center (1968-1978)*. University of Southern California Press, 1979

McNeill, William H. *Plagues and People*. Anchor Books, 1976.

Naphy & Spicer. *Plague: Black Death & Pestilence in Europe*. Tempus Publishing, Ltd., 2000.

Nohl, Johannes. *The Black Death: A Chronicle of the Plague Compiled from Contemporary Sources*. Unwin Books, 1927.

Orent, Wendy. *The Mysterious Past and Terrifying Future of the World's Most Dangerous Disease*. Free Press, 2004.

Pollitzer, R., M.D. *Plague*. The World Health Organization, 1954.

Sanchez, George J. *Becoming Mexican American: Ethnicity, Culture and Identity in Chicano Los Angeles, 1900-1945*. Oxford University Press, 1993.

Starr, Kevin. *Material Dreams: Southern California Through the 1920s*. Oxford University Press, 1990.

The National Cyclopaedia of American Biography. James White & Company, 1963.

Who's Who In California, 1942-1943. Who's Who Publications Company, Los Angeles.

Who's Who In California, 1928-1929. Who's Who Publishing Company, San Francisco.

Newspapers

"Advertising Tour Planned" by John P. Gallagher, *Los Angeles Times*, November 27, 1924.

"Ancient Killers Make Comeback Across U.S." *Los Angeles Times*, August 25, 1970.

"As Pfizer Battles Fakes in China, Nation's Police are Uneasy Allies," Nicholas Zamiska and Heather Won Tesoriero. *The Wall Street Journal*, May 24, 2006.

"Avian Virus Caused the 1918 Pandemic New Studies Show," Betsy McKay. *The Wall Street Journal*, October 6, 2005.

"Battling Avian Flu's Spread," Nicholas Zamiska. *The Wall Street Journal*, August 5, 2005.

"Bird-Flu Resistance in Ducks Raises a Red Flag For Humans". Los Angeles Times. (Date Unknown).

"British Avert Threat of Black Plague Spread". Los Angeles Times, August 5, 1962.

"California Boy Treated for Bubonic Plague." *San Francisco Chronicle*, June 30, 1959.

"California Priest Dies Ministering to Sick." *Los Angeles Examiner*, November 14, 1924.

" 'Chicken Flu' Is No Big Peril," Wendy Orent. *Los Angeles Times*, February 26, 2005.

"Chinatown Will Have Playground." *Los Angeles Times*, May 24, 1927.

"Chinese Children Celebrate." *Los Angeles Times*, October 19, 1927.

"City in Nightmare," Ben Zinser. *Los Angeles Examiner*, date unknown. (Dr. Shirley Fanin Collection).

"Death Takes School Leader." *Los Angeles Times*, April 14, 1941.

"Dr. L.M. Powers is Dead." *Los Angeles Times*, November 1, 1924.

"Disease Hazard End Seen." *Los Angeles Times*, November 5, 1924.

"Disease Spread Checked." *Los Angeles Examiner*, November 6, 1924.

"Dr. Pomeroy, County Health Officer Dies." *Los Angeles Times*, March 25, 1941 & March 28, 1941.

"Eaton, Pioneer and Former Mayor Dies," Othemon Stevens. *Los Angeles Examiner*, March 13, 1934.

"Epidemia en La Calle Macy." *El Heraldo de Mexico*, November 4, 1924.

"Epidemia Tenemos," Salvador Gonzalo Becerra. *El Heraldo de Mexico*, November 5, 1924.

"Epidemics of Fear and Mistrust," Professor William Deverell. *Los Angeles Times*, April 24, 2003.

"Europeans Gird to Check Spread of Bird-Flu Virus," Marc Champion and James Hookway. *The Wall Street Journal*, date unknown.

"Evidence of Resistance to Tamiflu," Jennifer Corbett Dooren. *The Wall Street Journal*, December 21, 2005.

"Examiner Story Unites Old 'Pals'." *Los Angeles Examiner*, March 14, 1960.

"Fake Vaccines From China Pose Danger in War on Avian Flu," Nicholas Zamiska. *The Wall Street Journal*, date unknown.

"Fourteen In Funeral Party Dead." *Los Angeles Times*, November 2, 1924.

"14 Perish in L.A. Plague Contagion." *San Francisco Chronicle*, November 2, 1924.

"Governor Gratified At End of Plague Menace." *Los Angeles Times*, November 16, 1924.

"Infections in Squirrels Remind That Victory Over Plague Isn't Complete." *Los Angeles Times*, August 23, 1995

"In Rural Cambodia, Avian Influenza Finds a Weak Spot." *The Wall Street Journal*, March 4, 2005.

"Is Yesterday's Swine Flu Today's Bird Flu?" *USA Today*, March 22, 2006.

"La Cuarentena se Extende Hasta Belvedere." *El Heraldo de Mexico*, November 5, 1924.

"La Epidemia Fue Controlado." *El Heraldo de Mexico*, November 14, 1924.

"La Epidemia Causa Graves Perjuicios." *El Heraldo de Mexico*, November 9, 1924.

"Las Ratas Causan La Epidemia." *El Heraldo de Mexico*, November 6, 1924.

"La Verdad Acerca de la Epidemia." *El Heraldo de Mexico*, November 7, 1924.

"Lacy Refutes Canards." *Los Angeles Times*, January 4, 1925.

"Malady Now Under Control." *Los Angeles Examiner*, November 5, 1924.

"Medal Given to Teacher." *Los Angeles Times*, November 14, 1924.

"Nina de 6 Anos Fue Secuestrada El Dia De Ayer." *El Heraldo de Mexico*, November 6, 1924.

"Nine Mourners at Wake Dead." *Los Angeles Examiner*, October 31, 1924.

"No Plague Cases for Four Days." *Los Angeles Times*, November 11, 1924.

"No New Plague Cases Show Up." *Los Angeles Times*, November 9, 1924.

"No New Pneumonic Cases." *Los Angeles Times*, November 8, 1924.

"No Pneumonic Cases Found." *Los Angeles Examiner*, November 8, 1924.

"No Spread of Disease." *Los Angeles Times*, November 7, 1924.

"Nora Sterry School to Be Rededicated." *Los Angeles Times*, June 16, 1941.

"Nuevos Casos." *El Heraldo de Mexico*, November 8, 1924.

"Outbreak of Plague Unlikely in California." *San Francisco Chronicle*, September 29, 1994.

"Pandemic Timetable," Dr. David Baltimore. *The Wall Street Journal*, date unknown.

"Parrish Chosen Health Officer." *Los Angeles Times*, November 20, 1924.

"Peace Hath Her Heroes." *Los Angeles Times*, November 19, 1924.

"Plague Is Virtually Wiped Out." *Los Angeles Times*, November 15, 1924.

"Plague Would Strike Again and Again After Terrorist Attack." *Rocky Mountain News*, August 26, 2002.

"Pneumonic Plague Seen In 14 Deaths." *New York Times*, November 2, 1924.

"Pneumonic Plague Takes 7 More Victims." *New York Times*, November 3, 1924.

"Pneumonic Plague Starts Near Herrin." *New York Times*, November 9, 1924.

"Quarantine for Plague Area Lifted." *Los Angeles Times*, November 14, 1924.

"Rat Clean-Up In City Urged." *Los Angeles Times*, November 19, 1924.

"Ratting on the Plague." *Ventura County Star*, October 10, 1999.

"Reasons to Be Fearful," Henry I. Miller. *The Wall Street Journal*, October 17, 2005.

"Roads May Hit Back at State Foes." *Los Angeles Times*, January 16, 1925.

"[Ruth] Sterry Funeral to Be Private." *Los Angeles Times*, June 5, 1938

"Se han Dado Nuevos Casos de la Terrible Enfermedad." *El Heraldo de Mexico*, November 5, 1924.

"Seven Are Dead From Pneumonia." *Los Angeles Times*, November 3, 1924.

"Sigue La Campana Contra La Epidemia." *El Heraldo de Mexico*, November 8, 1924.

"Six More Die From Malady." *Los Angeles Examiner*, November 3, 1924.

"Some Reflections," J.A. Graves, *Los Angeles Times*, April 1, 1925.

"State to Fight Disease." *Los Angeles Times*, November 4, 1924.

"Study Offers Clue on Why Bird Flu Is Slow to Spread Among Humans," Antonio Regaldo. *The Wall Street Journal*, date unknown.

"Tamiflu's Widespread Use, Effectiveness Is Questioned," Jeanne Whalen and Betsy McKay. *The Wall Street Journal*, date unknown.

"Tell the World." *Los Angeles Times*, November 28, 1924.

"Three Here Win State Honors." *Los Angeles Times*, June 6, 1926.

"Tyson Again Pares Its Outlook As Bird-Flu Fears Hurt Exports," Scott Kilman . *TheWall Street Journal*, April 20, 2006.

"U.S. Sees Need to Better Prepare Against Avian Flu." *The Wall Street Journal*, October 6, 2005.

"Volveran a Suds Empleos Los Mexicanos Cesados." *El Heraldo de Mexico*, November 11, 1924.

"What You Should and Shouldn't Worry About: Putting Avian Flu in Perspective," Tara Parker-Pope. *The Wall Street Journal*, date unknown.

"Wood Answers Assailants." *Los Angeles Times*, date illegible (early 1930s, around the time of larceny charges against Wood).

"Wood Asked to Resign Post." *Los Angeles Times*, April 5, 1931.

"Wood Loses Hospital Job." *Los Angeles Times*, July 2, 1932.

Other Periodicals

"A History of Plague in The United States of America." Dr. Vernon Link. *Public Health Service Publication* No. 392, March 1955. Library of Congress Catalogue Card No. 55-60019

"Always the Laborer, Never the Citizen: Anglo Perceptions of the Mexican Immigrant during the 1920s," Mark Reisler. *Pacific Historical Review*, Volume 45, May 1976.

"Bird Flu: Is it Headed Our Way?" Macon Morehouse & Margaret Nelson. *People*, October 31, 2005.

"Black Death on Clara Street," Robert S. Cleland. *Westways*, November 1971.

"Border City: Race and Social Distance in Los Angeles" by Greg Hise. *American Quarterly*, Sept. 2004.

"Bubonic Plague Control in California in 1903," Rupert Blue, M.D. *California and Western Medicine*, Volume XL, May, 1934.

"Health Examinations and the Health Officer," Walter M. Dickie, M.D. *American Journal of Public Health*, Volume 15, October 1925.

"Housing Conditions in Los Angeles," Nora Sterry. *Journal of Applied Sociology*, Volume VII, Nov.-Dec. 1922.

"Los Angeles's Campaign of Silence," William Boardman Knox. *The Nation*, Volume 121, December 9, 1925.

Los Angeles County Employees Bulletin. November 1924

Monthly Bulletin, Los Angeles Health Department, November 1924.

"Nature's Bioterrorist," Michael Specter. *The New Yorker*, February 28, 2005.

"Plague in California," Senior Surgeon J.C. Perry, United States Public Health Service. California State Board of Health *Weekly Bulletin*, Vol. 1/No. 36, October 21, 1922.

"Pneumonic Plague In Los Angeles," Emil Bogen, M.D. *California and Western Medicine*, February, 1925.

"Pneumonic Plague Epidemic of 1924 in Los Angeles," Arthur Viseltear, *Yale Journal of Epidemiology and Public Health*, 1974.

"Preparing for a Bioterrorist Attack." *Emerging Infectious Diseases* (published by the National Center for Infectious Diseases), February 1, 2003.

"Present Status of Plague with Historical Review," W.H. Kellogg, M.D. *The American Journal of Public Health*, 1920.

"The Next Killer Flu: Can We Stop It?" Tim Appenzeller. *National Geographic*, October, 2005.

Primary Resources

Absolute Quarantine of a District in Case of Plague or Other Similar Emergency. Compiled by C.R. Williams (Chief Quarantine Officer), April 29, 1927. (Dr. Shirley Fanin Collection)

Anales de la Congreation, Vol.21. Leo Monasterio, CMF, writing about Father Medardo Brualla, 1924.

Annual Report for the Year 1924. Pomeroy, Dr. J.L., Los Angeles County Health Officer. (Dr. Shirley Fanin Collection).

California Statewide Death Index, 1905 through 1929. State of California, Department of Public Health.

Preliminary List of Plague Victims, date uncertain, presumed to be late 1924. Powers, Luther. Los Angeles City Health Officer. (Dr. Shirley Fanin Collection)

City of Los Angeles Ordinances 50.282 & 50.283, November 21, 1924. (Huntington Memorial Library Collection).

Dickey, Walter M., M.D., State Health Officer. Monthly Plague reports from November, 2004 through June, 2005. (Dr. Shirley Fanin Collection).

General Order #2, issued by C.R. Williams, Chief Sanitary Officer, November 8, 1924. (Dr. Shirley Fanin Collection).

Investigation of Claims, issued by C.R. Williams, Chief Sanitation Officer, November 8, 9, 10 17 & 18 and December 4, 1924. (Dr. Shirley Fanin Collection).

Investigation Willit & Green Hog Ranch, Sanitation Officer F.G. Veatch (Undated). (Dr. Shirley Fanin Collection).

General Inventory of Stores, Office of County Health Department (Undated). (Dr. Shirley Fanin Collection).

Last Will and Testament of Nora Sterry. Written in longhand, May 15, 1941. (Sterry Family Collection).

Names & Addresses of quarantine guards. Compiled by the Office of County Health Department. (No signature or date). (Dr. Shirley Fanin Collection).

No Shooting Order, issued by C.R. Williams, Chief Sanitation Officer. (Dr. Shirley Fanin Collection).

Orders from C.R. Williams (Chief Sanitation Officer) to captains of quarantine guards, November 8, 1924. (Dr. Shirley Fanin Collection).

A Slight Epidemic

Letter from A.G. Arnoll, secretary, board of directors, Chamber of Commerce to the City Council describing the meeting of the board and local newspaper publishers and recommending that the Council immediately pass the "emergency" Ordinances recommended by Dr. Walter Dickie, November 17, 1924. (Los Angeles City Archives).

Letter from Benigno Guerrero to J.L. Pomeroy, County Health Officer, November 17, 1924. (Shirley Fanin Collection).

Letter from Capt. H.R. Heinze, Quarantine Detail, to County Health Officer J.L. Pomeroy, M.D. regarding a guard's change of shoes, November 10, 1924. (Dr. Shirley Fanin Collection).

Letter from City Clerk to City Council on "Command Communication from the Chamber of Commerce," November 20, 1924. (Los Angeles City Archives).

Letter from Dr. Walter Dickie to William Lacy, President of the Chamber of Commerce laying out measures to eradicate plague and "rat-proof" buildings and requesting $475,843 to begin the work, November 15, 1924. (Los Angeles City Archives).

Medardo Brualla. Provincial Archives, December 18, 1924.

Memo from State Board of Health epidemiologist C.H. Halliday to Dr. Walter Dickie, Undated. (Huntington Memorial Library Collection).

Minutes of November 15, 1924 meeting between Dr. Dickie, select members of the City Council and members of the Chamber of Commerce board of directors. (Los Angeles City Archives).

Plague Los Angeles 1924-1925, undated. Dr. Walter M. Dickie report to Los Angeles Mayor George Cryer. (Huntington Memorial Library Collection).

Plague in California 1900-1925, undated. Dr. Walter M. Dickie, Secretary California State Board of Health.

Plague in Los Angeles, 1924: Ethnicity and Typicality, Dr. William Deverell, California Institute of Technology, 1995.

Plague Summary—1924. Dr. J.L. Pomeroy, Los Angeles County Health Officer. 1925.

Pneumonic Plague: The Quarantine and Handling. C.R. Williams, Chief Quarantine Officer, November 18, 1924.

Requisition Orders from Eugene Bumiller, Assistant Quarantine Officer, November 11, 12, 13 & 14, 1924. (Dr. Shirley Fanin Collection).

Special Sanitary Detail Report. C.R. Williams, Chief Quarantine Officer, November 17, 1924 (Dr. Shirley Fanin Collection).

Veatch, F.G., Los Angeles Sanitary Inspector. Reports from March, 1925 though May, 1925. (Dr. Shirley Fanin Collection).

Wood, N.N. M.D., Superintendent, Los Angeles County General Hospital, plague bulletins November 11 and 15, 1924. (Huntington Memorial Collection).

Online Media

Ancestry.com. United States Federal Census (Years 1930-1960)

"An Empire's Epidemic." *Los Angeles Times*, May 6, 2002.

"Key Facts About Avian Influenza", "Transmission of Influenza A Viruses Between Animals and People", "Outbreaks in North America", "Questions & Answers: Flu Vaccine". All posted on The Centers for Disease Control and Prevention Web site, 2006.

"Board Plans Using Motels as Centres." *Nelson (New Zealand) Mail*, March 5, 2006.

"Britain Considering Mass Graves for Bird Flu Victims." Wen site of The Press Association, Ltd. (United Kingdom).

"Bubonic Plague: Genes Identified that Are Critical for Transmission." Centers for Disease Control and Prevention Web site, August 12, 1996.

"China Blamed for Bird Flu Crisis." *Health & Science* magazine Web site, October 22, 2005.

"Cumulative Number of Confirmed Human Cases of Avian Influenza A." World Health Organization Web site, September 19, 2005.

Naval Historical Center Web site, Department of the Navy. Specifications on the USS Los Angeles (ZR-3), Airship, 1924-1939.

"Doomsday-style Plans in Place to Keep Vital Staff and Drugs safe." *Birmingham (U.K.) Evening Mail* Web site, February 21, 2006.

"Expert Says Bird Flu No Imminent Threat." Associated Press Web site, April 12, 2006.

"Facts about Plague in Los Angeles County." Los Angeles County Department of Health Services Web site (No publication date).

"First laboratory-Confirmed Case of human-to-human transmission." *New York Times* Web site. June 23, 2006.

"Glasgow Scientist Suggests Ban on Handshakes." *The Scotsman* Web site, March 30, 2006.

"HHS Orders Avian Flue Vaccine Doses as Preventative Measure." U.S. Department of Health & Human Services Web site, September 21, 2004.

"Hotel Offers Beds if Bird Flu Strikes." *Christchurch (New Zealand) Press* Web site, February 20, 2006.

"If bird flu comes—Czech Army Will Send 450 Troops to Fight It." CTK National News wire online, March 3, 2006.

"Information About Influenza Pandemics." Centers for Disease Control and Prevention Web site. April 21, 2005.

"Influenza Viruses." Centers for Disease Control and Prevention Web site. April 21, 2005.

"International Conference on the Justinian Plague." American Academy (Rome) Web site, December 15, 2001.

"Leavitt Urges Preparation for Pandemic." *Little Rock Democrat-Gazette* Web site, February 26, 2006.

"New Mexico Woman Dies of Plague." AccessNorthGa.com, May 26, 2006.

"Our Bird Flu Risk Now 'Very High." *The Gold Coat Bulletin (New Zealand)* Web site, March 10, 2006.

"Outbreaks in North America with Transmission to Humans." Centers for Disease Control and Prevention Web site. April 21, 2005.

"Pathogenic Bacteriology." Lecture notes by Dr. Glenn Songer, Veterinary Science and Microbiology, University of Arizona. University departmental Web site. Undated.

"Plague." Health AtoZ Web site, July 7, 2004.

"Plague Cases Worry Would-Be Visitors to New Mexico." Associated Press Web site, August 4, 1983.

"Plague Kills Scores in Congo Outbreak." Newsday.com, February 18, 2005

"Planetrat." *The Guardian (London)* Web site, February 21, 1988.

"PR blitz on bird flu about to hit nation." *New Zealand Herald* Web site, March 15, 2006.

"Preventing the Flu." Centers for Disease Control and Prevention Web site, April 21, 2005.

"Rare Bubonic Plague Case Reported in Los Angeles." Associated Press Web site, April 18, 2006.

"Recent Avian Influenza Outbreaks in Asia." Centers for Disease Control and Prevention Web site, April 21, 2005.

"Researchers Model Avian Flu Outbreak, Impact of Interventions." National Institutes of Health Web site, August 3, 2005.

"Revealed: the Secret No 10 Plan to Tackle Bird Flu Food Shortages." *Sunday Telegraph* (U.K.) Web site, April 9, 2006.

"Two new cases of Tamiflu-resistant H5N1 virus: study." AFP Web site, December 21, 2005.

"Thai Chicken Workers Wear Bio Suits." *International Herald Tribune* Web site, December 14, 2005.

"The Fourth Horseman." *St. Louis Post-Dispatch* Web site, April 15, 1989.

"The Influenza Pandemic of 1918." Molly Billings, Stanford University. Departmental Web site, June, 1997

"UK Truckers front line workers—first to be vaccinated?" *Aberdeen (Scotland) Evening Express* Web site, February 24, 2006.

"U.S. Plan For Flu Pandemic Revealed." Ceci Connolly, *Washington Post* Web site, April 16, 2006.

"Vietnam: Fighting The Black Death." Wayne P. Olson, Military.com, undated.

"You Dirty Rat: L.A. Infested." *New York Times* Web site, September 21, 2002.

Index